CITY SQUARES

Also by Catie Marron

CITY PARKS

Public Places, Private Thoughts

CITY SQUARES

Eighteen Writers on the
Spirit and Significance of Squares
Around the World

Catie Marron

HARPER

An Imprint of HarperCollins*Publishers*

HarperCollins books may be purchased for educational, business, or sales promotional use. For information, please e-mail the Special Markets Department at SPsales@harpercollins.com.

FIRST EDITION

Designed by Mary Shanahan
Frontispiece by Philip-Lorca diCorcia

Library of Congress Cataloging-in-Publication Data has been applied for.

ISBN: 978-0-06-238020-3

16 17 18 19 20 ov/rrd 10 9 8 7 6 5 4 3 2 1

For my family: Don, William, and Serena

CONTENTS

PART THREE

HISTORY: INFLUENCE ON HUMANITY

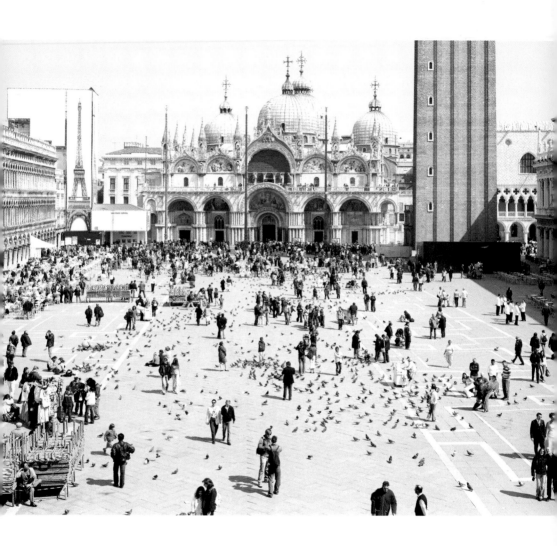

MASSIMO VITALI

INTRODUCTION

Catie Marron

UNTIL RECENTLY, I'D NEVER THOUGHT MUCH ABOUT CITY SQUARES. I've certainly enjoyed visiting some of the most famous, such as Place des Vosges, Piazza di Navona, and Djemaa el-Fnaa, and I have taken advantage of the ones near home in New York City. But their power—in humanity, urban life, and history—had never fully registered with me. A few years ago, that changed.

Whenever I'm in Europe, I find I feel closer to major events occurring on the continent. On a family holiday in Rome in 2013, we stayed around the corner from the Piazza del Popolo, which we often passed through during our stay. Every morning in the hotel, I read all the newspapers and accounts I could find on the mass uprising in the main square of Kiev. The insurgence was quickly coined the Euromaidan, "maidan" being the word for "square" in several languages, including Ukrainian.

Commentators compared the Euromaidan protests to those in Istanbul's Taksim Square two years earlier. I'd spent an

hour there just three months before the protests. As it was commuter time, people were on the move; an old-fashioned cable car passed by. I never could have guessed that very site, like the Euromaidan, would soon become the headquarters for masses of citizens who put their lives on the line in protest against their governments. Suddenly, I thought about the stark contrasts among the spaces: the everyday bustle of Taksim Square, and its political unrest; the classic, peaceful beauty of the grand Roman squares; and the revolt erupting in Kiev's Maidan, another square of Old World character.

I explored further, which led me to putting together this collection: a series of essays created for this book, which considers the square from different points of view, from the intensely personal to the expansively global. Each square stands for a larger theme in history, culture, and geopolitics.

This deeply free and public space plays a vital role in our world, equally important in our digital age as in Greco-Roman times, when they were marketplaces for goods and ideas. As common ground, squares are equitable and democratic; they have played a fundamental role in the development of free speech. When citizens wanted to convey their message to those in charge—in Euromaidan, Tahrir, Taksim, and Tiananmen squares, as well as many others—they flocked to their square. As David Remnick noted, "authoritarians don't realize what a dangerous thing it is to have a city square."

Each writer was chosen with thought and care. Each writer has contributed his or her own special mix of innate talent, prodigious research, and local knowledge. Rory Stewart tells the

story of a square in Kabul, which has come and gone several times over five centuries, due to both the local culture and, equally, the will of one individual, the latest iteration involving Rory himself in the leadership role. Ari Shavit describes the changes of central Tel Aviv's Rabin Square, which began as a forum for rallies and assemblies, then became the symbolic site of a national tragedy, and is now an almost empty void, even as hectic urban life bustles with energy around its edges. Rick Stengel recounts Nelson Mandela's choice of the Grand Parade, Cape Town, a huge market square that was transformed into a public space of historic magnitude when he spoke to the world right after his release from twenty-seven years in prison. In Euromaidan, Tahrir, and Taksim squares, social media—the new virtual square—summoned people to the physical square. Gillian Tett delves into social media's growing significance and the way the physical and virtual meet.

If there's one essential urban space, it is the square. Michael Kimmelman describes the construction of a new square in a Palestinian refugee camp, first questioned, then embraced. It is now where children play, young couples marry, and women feel free to socialize. Everyone uses this newly created public space just as people did the agoras of ancient Greece. Squares have stood the test of time. After all, squares are all about, and for, people.

Overleaf: THOMAS STRUTH

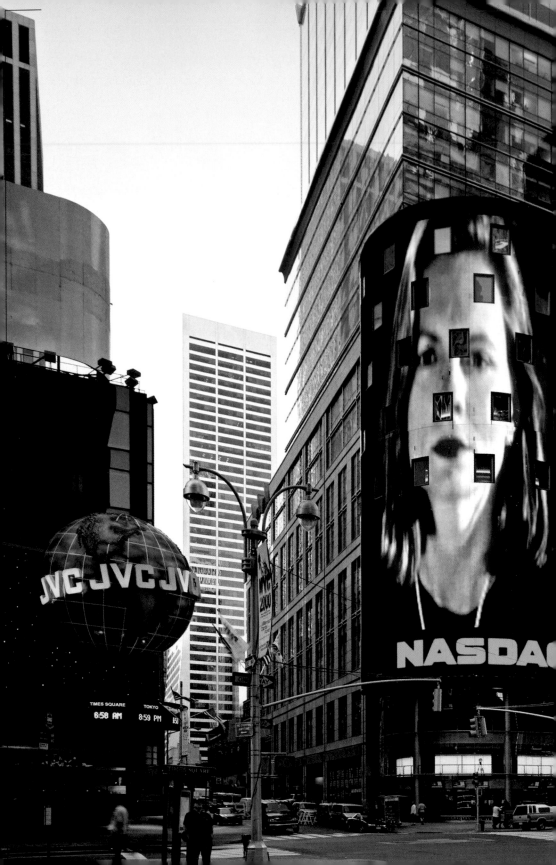

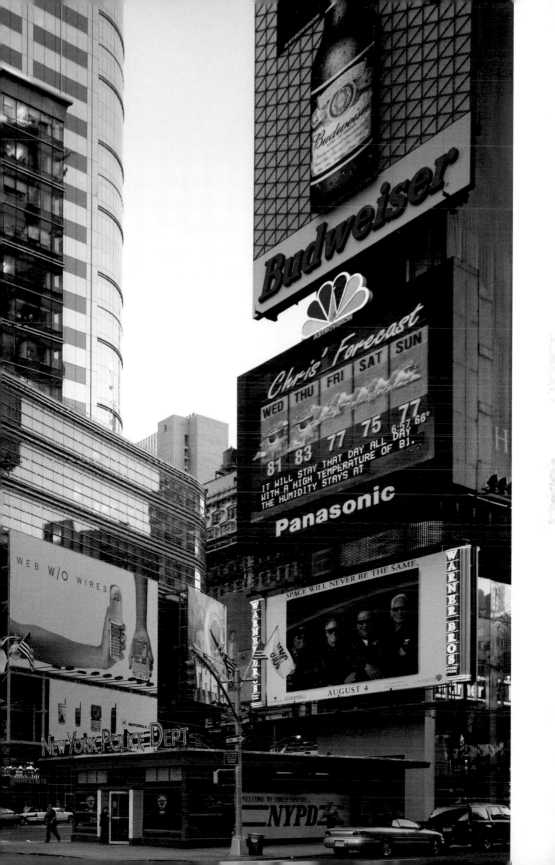

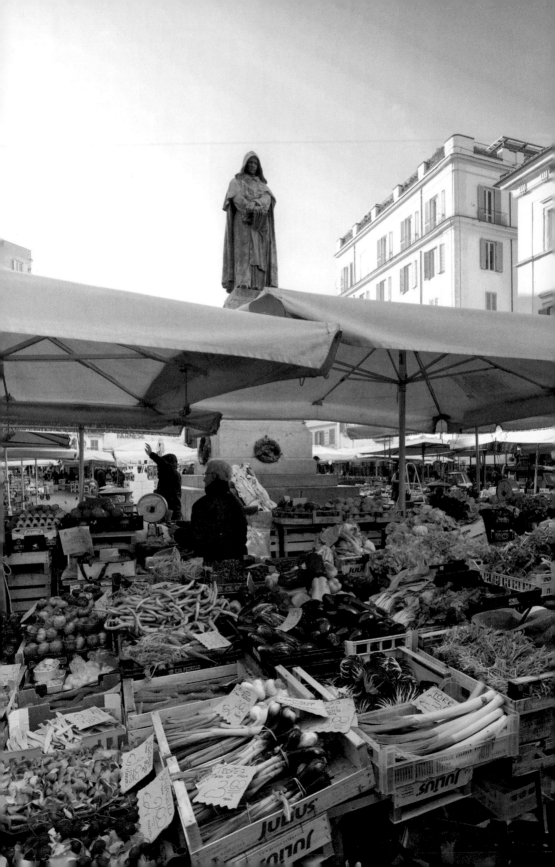

PART ONE
CULTURE: POWER OF THE PLACE

INTRODUCTION
Michael Kimmelman

ON MOST MORNINGS, THE CAMPO DE' FIORI COMES AWAKE TO the shuffle of the fruit, spice, and vegetable merchants setting up open-air stalls under ranks of white umbrellas and the gloomy gaze of Giordano Bruno. Bruno, the Renaissance friar-philosopher-cosmologist, was burned at the stake in the campo in 1600, a heretic according to the Roman Inquisition. Now a martyr to science, he has been memorialized in the middle of the square with a somber monument by Ettore Ferrari, the nineteenth-century sculptor. It is only a little bit of a stretch to see the blessed Bruno in the busy market as a metaphor for Rome's long-standing church-state standoff, as well as speaking to the heterogeneous and serendipitous quality of public life in a great square. The campo is common ground.

What do we mean by a public square? For starters, it is rarely square, like the Place des Vosges in Paris, a Platonic version of the genre. It may be a quadrangle or rectangle or circle or pretty much any other shape, and it can be open or closed. It might even be a park, like Washington Square or Charlotte

Square in Edinburgh, but if so, it tends to be a park through which people pass, going from one place to another, not simply a retreat. A square is porous, balancing its porousness with some focal point, like a fountain or a reliable patch of sun with some benches that marks a break from the cars and streets and invites people to stop, look, exhale, find one another. People escape the city by retreating into Central Park or the Tiergarten in Berlin or the Buen Retiro in Madrid. A square may be a haunting and magical place when empty, like a ghost-lighted theater. But it is often less a retreat than a magnet or a pause or a perch in the midst of things.

It may be dominated by a single great building, like St. Peter's, but the physical virtue of occupying a square is rarely about any one building; its beauty derives from the nature of the void between buildings: the harmony of vertical and horizontal elements, architecture with open space, ground and sky, human scale. The oval arcade enclosing the square of St. Peter's embraces visitors and brings down to a more human scale the heroic space of the piazza. Designed by Gian Lorenzo Bernini, it is a landmark of urban architecture. Even so, it's not really a square like the Place des Vosges or the Campo de' Fiori; it's a ceremonial place. Red Square, as the crossroads of central Moscow, is often bustling, and this energy keeps it from feeling entirely inhuman. Mobs of people pass through and congregate in it, but it is, at heart, a parade ground.

The campo is a more humane and inviting square because it is down to earth, an urban accident, a long, lopsided opening among crowded medieval streets south of the Piazza Navona,

which, by contrast, is a sublime historic space and also a great square, with a more formal layout, a distended oval, derived from its roots as the site of the first-century circus of Domitian. Chariots raced and gladiators clashed there. By the Middle Ages, the piazza had become a marketplace and received one of the fanciest makeovers in history when, during the seventeenth century, both Bernini and Francesco Borromini added churches and fountains that define the glory of the High Baroque. These sorts of monuments are missing from the campo, whose buildings are mostly beside the point. One tends not to notice them, what with everything going on there.

That's because a square is also an organism, not just a work of art and architecture. "Being part of a living organism of a city with its changing socioeconomic and technical conditions, a square is never completed," as Paul Zucker wrote half a century ago in *Town and Square: From the Agora to the Village Green.* "The square dictates the flux of life not only within its own confines but also through the adjacent streets for which it forms a quasi estuary. This accent in space may make itself felt some blocks in advance—an experience shared by everyone who has ever driven a car into an unfamiliar town." That's the case in the campo. By early afternoon, its market stalls have been folded up; the sweepers and garbage trucks are clearing the trash, and tourists are digging into their plates of spaghetti carbonara at the fixed-price restaurants that face Bruno's monument. As they do, Fabrizio Zianchi, the former-hotelier-from-Brazil-turned-Roman-newsagent, who oversees the Collyer brothers–like news kiosk at the square's north end, slips away for a quick siesta. Then,

3

with early evening, he and the campo are back in business, the square now packed with mobs of flirting teenagers; kids toting cups of gelato; florists, the original merchants in the square, selling roses; and dawdling office workers grabbing a Campari or two before heading home for dinner. The crowd spills onto the three short streets that link the campo to the Piazza Farnese, a square Michelangelo conceived to be as stately as the campo is informal. Michelangelo's original idea was that the campo should become a kind of antechamber for the piazza, the first in a sequence of public spaces leading to the Tiber. His plan was never realized, but now campo and piazza are linked like yin and yang by a river of foot traffic. For years I have frequented a café where the Via dei Baullari, one of those small streets, meets the piazza facing Michelangelo's grand, top-heavy Palazzo Farnese and the twin fountains made from immense basins of Egyptian granite, hauled from the Baths of Caracalla. You can glimpse the campo, or part of it, from the café, so the spot gives the feel of being in the middle of things. In the morning, I stand at the café's metal bar and throw back coffee and a cornetto alongside Italians who stop in before speeding off to work; at sunset, I sometimes find a table outside with the tourists to watch the passing circus.

Feeling in the middle of things, at the place to and from which streets flow, where people come not to escape the city but to be inside it: This is usually what defines a successful square. It is a space around which the rest of a neighborhood or town or city tends to be organized. A square may be a gift of public beauty. It may have the exquisite proportions of Michelangelo's

oval, domed Campidoglio, a dozen minutes' walk from the Campo de' Fiori; or of Bedford Square in London, a rectangular Georgian gem with its elliptical garden and symmetrical terrace houses of black masonry and polished hardware. It may have great sculptures. Bernini's, in the Piazza Navona, are spectacles of marble and water, all miraculous stone and sparkling light on splashing pools, celebrating the world's different continents, the dominion of papal Rome, and the virtuosity of a singular sculptor. But a square's physical satisfaction accrues from the mix of light, air, sky, benches or other places to sit, and maybe trees for shade—and of course from the presence of other people. The Campo de' Fiori was paved during the fifteenth century with Sampietrini, simple, rough black stones named after the rock on which St. Peter was presumed to have built his church. This isn't a site of marble and glamour. The square is a treasure precisely because it doesn't masquerade as an outdoor museum. It's a living place, jammed with people, changeable, democratic, urbane.

THE TWENTY-FIRST CENTURY HAPPENS TO BE THE FIRST URBAN century in human history, the first time more people on the planet live in cities than don't. Experts project some 75 percent of the global population will be city dwellers by 2050. Dozens of new cities are springing up in Asia, some from mass relocation programs that have cleared vast swaths of the Chinese countryside. Much of the growth is chaotic, badly planned and informal. Meanwhile, volatile gas prices and climate change have made suburban life costlier and the benefits of a diminished carbon footprint clearer. In the United States, growing numbers of

university graduates and empty-nesters are rejuvenating down-towns. Since the late 1990s, the share of automobile miles driven by twentysomethings in America has fallen from 20.8 to 13.7 percent. The number of nineteen-year-olds opting out of driver's licenses has tripled since the 1970s from 8 to 23 percent. Americans are still a long way from regarding cars as a luxury or superfluous. Electric, self-driving vehicles may revolutionize transportation. But a larger portion of the U.S. population is moving downtown, where deindustrialization, plummeting crime rates, and an increasing population of singles and smaller families have reshaped countless formerly desolate urban neighborhoods.

People are moving downtown for the pleasures and benefits of cultural exchange, walkable streets, parks, and public squares. Squares have defined urban living since the dawn of democracy, from which they are inseparable. From the start, the public square has been synonymous with a society that acknowledges public life and a life in public, which is to say a society distinguishing the individual from the state. There were, strictly speaking, no public squares in ancient Egypt or India or Mesopotamia. There were courts outside temples and royal houses, and some wide processional streets. Only after around 500 B.C. did squares develop. In ancient Greek, the word "agora" is hard to translate. In Homer it implied a "gathering" or "assembly"; by the time of Thucydides it had come to connote the public center of a city, the place around which the rest of the city was arranged, where business and politics were conducted in public—the place without which Greeks did not really regard a

town or city as a town or city at all; rather, it was, as Pausanias, the second-century writer roughly put it, a sorry assortment of houses and ancient shrines.

The agora announced the town as a *polis*. Agoras grew in significance during the Classical and Hellenistic years because they were emblems of democracy, physical expressions of civic order and life, with their temples and fishmongers and bankers at money-changing tables and merchants selling oil and wine and pottery. Stoas, or colonnades, surrounded the typical agora, and sometimes trees provided shade. People who didn't like cities, and disliked democracy in its messiness (Aristotle among them), complained that agoras mixed religious and sacrilegious life, commerce, politics, and theater. But of course that was also their attraction and significance. The agora symbolized civil justice. Even as government moved indoors and the agora evolved over time into the Roman forum, a grander, more formal place, the notion of the public square as the soul of urban life remained critical to the self-identity of the state.

To skip ahead a couple of millennia, I don't think it's coincidental that the now failed Egyptian revolution, early in 2011, centered around Tahrir Square, or that the Occupy Movement later that same year, partly inspired by the Arab Spring, expressed itself by taking over squares like Taksim in Istanbul, the Plaça de Catalunya in Barcelona, and Zuccotti Park in Lower Manhattan. And I don't think it's coincidental that the strangers who came together at Zuccotti, Taksim, and Tahrir all formed pop-up towns on these sites, producing in bite-size form (at least temporarily) what they imagined to be the outlines of a better city, with

distinct spaces designated for legal services, libraries, medical stations, media centers, kitchens serving free food, and general stores handing out free clothing. Aristotle talked about an ideal polis, extending the distance of a herald's cry, a civic space not so large that people could no longer communicate face-to-face. In Zuccotti Park, a contained space only a block long and wide, the police allowed protesters, who were prevented from using loudspeakers, to address the crowd by repeating phrase by phrase, like a mass game of telephone, what public speakers said, so that everyone, as it were, spoke in one voice. Zuccotti became a physical manifestation of democratic ideals embedded, since the days of the agora, in the very notion of a public square.

So, in fact, a successful square is not just about light, air, proportion, and people. It must also give form to some shared notion of civic identity. That is what squares have done in French and Italian towns for centuries. In 2009 the Italian city of L'Aquila suffered a terrible earthquake. The entire historic center, not a must-see in Fodor's but dignified and handsome, was damaged and shuttered. I went the day after the quake and have returned several times since. L'Aquila is a heartbreaker. Due partly to corruption, to incompetence, and to a failure to recognize Italy's own great urban tradition, the Italian government pretty much threw up its hands and abandoned the place. Vast public resources were squandered creating so-called new towns, faceless housing projects with no amenities, no public spaces, shops, or transport, on the fringes of the city, along an exurban nowhere sprawl of highways. Supposedly temporary homes for displaced l'Aquilans, these new towns inevitably be-

Aquila - Piazza del Duomo

came permanent places to dump the elderly and local families cut off from daily life as they knew it, meaning the life of the city's streets and plazas. L'Aquila *was* its street life and network of charming public squares, a working city of some seventy-five thousand that took pride in its lovely Baroque churches, modern architecture, university, and families with local roots dating back to the Middle Ages. What needed to be saved were places like the central square outside the Duomo, a sloping piazza with a fountain where one morning I bumped into Antonio Antonacci and his friends standing amid scaffolding and rubble. Antonacci is a retired lawyer. Like many others, he was displaced by the quake and had to move in with his children an hour away, but he felt lonely and so was driven by his family every week into the city to meet old friends also driven there by their families—and the men would hang out in the now mostly empty public square outside the Duomo, because to them the square, even ruined,

was L'Aquila, and there was nothing to replace it. "It's the only real home we have," Antonacci told me.

I grew up in Greenwich Village, Jane Jacobs's old neighborhood, where Washington Square Park was my version of Antonacci's Duomo square, the place where I met friends, cooled off in the fountain, played catch with my dad, and people-watched. It was the heart of what was then a scruffier but more venturesome neighborhood than today's Village. The city's urban planning czar Robert Moses had wanted to drive a highway straight through the middle of Washington Square. That the Village has become one of the most desirable and expensive places in the world is in no small measure due to Moses's failure and the park's survival. The good life, wrote the other great New York urban writer of Jacobs's era, Lewis Mumford, involves more than shared prosperity; it entails what Mumford described as an almost religious refashioning of values based on an ecological view of the city. Seen whole, in all its variety and interconnectedness, urban health is expressed physically in a natural configuration of built forms across the city. The art of architecture requires not just making attractive buildings but providing citizens with generous, creative, open, inviting public spaces. One of the basic truths of urban life turns out to be that there's a nearly insatiable demand for such places. Under Michael Bloomberg's administration, New York City inaugurated a program to convert streets across the five boroughs into plazas and squares. Making Times Square into a pedestrian mall was the program's headliner. But the mayor's office invited communities everywhere to suggest disused traffic triangles, parking lots, and other forlorn sites in

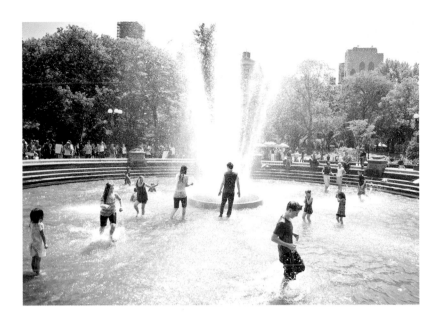

far-flung areas that might also be reimagined. Dozens of new public spaces were proposed. The city carted in some potted trees, benches, chairs, and tables, and voilà, a new square was created. Some of these made an immediate difference in reducing crime, boosting local commerce, and improving street life.

But the big news was just how much people craved public squares. Madison Square Park, lately renovated and one of the loveliest parks in New York City, faces the Flatiron Building, where Fifth Avenue and Broadway cross. The two avenues created for years what was the widest and most unmanageable street crossing in Manhattan. The Bloomberg administration's idea was to turn the middle of that street into a new public square. One day I ran across Michael Bierut, whose design firm, Pentagram, faces the site, and he told me he had thought the square was a crazy plan when he first heard about it. Who in the world

would sit in the middle of the street, he wondered, when you had one of the most beautiful parks in the city right there?

"Was I wrong," Michael recalled, seeing the square mobbed, with its café tables and umbrellas scattered where trucks had rumbled down Broadway and Fifth Avenue. The new square instantly became one of the most successful public spaces in the city, with people toting prosciutto sandwiches out of Eataly, the nearby Italian food market, and Shake Shack burgers out of the park just to sit in the middle of traffic—because from there you can see the Flatiron Building one way and the Empire State Building the other, but also for the reason people gravitate to Trafalgar Square in London or the Piazza della Signoria in Florence as opposed to Hampstead Heath or the Boboli Gardens: to be in the middle of things. As retreats, parks give us room to breathe and feel alone. Squares reaffirm our commonality, our shared sense of place, and our desire to be included. "It's why we congregate near the kitchen at a dinner party instead of in the living room," is how Andy Wiley-Schwartz, who directed the plaza program during the Bloomberg administration, described to me the attraction of the square. "That's where you see people coming and going to the fridge to grab a beer and watch stuff happen."

This impulse to watch stuff happen is universal. I recently visited a refugee camp in the southern West Bank called Fawwar. There, a Palestinian architect, Sandi Hilal, worked with residents of the camp to create a public square, something virtually unheard of in such places. For Palestinian refugees, the creation of any urban amenity, by implying normalcy and permanence, undermines their fundamental self-image, even after

several generations have passed, as temporary occupants of the camps, preserving the right of return to Israel. Moreover, in refugee camps, public and private do not really exist as they do elsewhere. There is, strictly speaking, no private property in the camps. Refugees do not own their homes. Streets are not municipal properties, as they are in cities, because refugees are not citizens of their host countries, and the camp is not really a city. The legal notion of a refugee camp, according to the United Nations, is a temporary site for displaced, stateless individuals, not a civic body. So there is no municipality in Fawwar, just a UN relief agency whose focus is on emergency services. That's whom residents entreat when the lights go out or the garbage isn't picked up, unless they want to deal with the problem themselves. Concepts like inside and outside are blurred in a place where there is no private property. A mother doesn't always wear the veil in Fawwar, whether she's at home or out on the street, because the whole place is, in a sense, her home; but she will put it on when she leaves the camp, because that is outside.

In other words, there *is* a powerful sense of community. And some years ago, Hilal—who then headed the Camp Improvement Unit in the West Bank for the United Nations Relief and Works Agency, along with her husband, Alessandro Petti, an Italian architect—began a conversation with Fawwar residents about creating a public square. The residents, especially the men, were immediately suspicious, not just about normalizing the camp but about creating any space where men and women might come together in public. Fawwar was established in 1950. It's under a quarter of a square mile, just south of

Hebron, crammed with nearly seven thousand people, many the descendants of Palestinians who fled or were expelled from their homes in 1948. "I feel at home here," said one middle-aged resident who was born and reared in the camp. "I want the right of return so I can decide for myself if I want to live here. It's a matter of freedom, choosing where you live." That sounded provocative coming from a Palestinian refugee—questioning an age-old strategy of self-deprivation, and reframing the right of return as something other than simply waiting to reclaim ancestral land, something that had more to do with freedom of choice about one's home.

"It's an architectural issue, in one respect," is how Sandi Hilal put it. What she meant about it being an architectural issue was that identity in the West Bank (although not only there) is invariably tied up with notions of belonging and expressed through architecture and public spaces like squares. Hilal showed me the square she'd designed. She said that pushback was initially fierce. "When we merely mentioned the word 'plaza,' people in the camp freaked out," she remembered. But a counterargument gradually took hold, which entailed abandoning what Hilal called "the strategy of convincing the whole world of the refugees' misery through their architectural misery." Hilal focused on women, young and old. At first they didn't want to oppose the men who were against it. But they feared, in such a conservative enclave, that if the square were built, men would simply take it over, and that if women did try to use it, they would feel too exposed in an open space. They longed for someplace to gather outdoors with a screen or enclosure.

So the challenge became: How could a space be made open—so that men, women, and children might be able to gather together—while also allowing the women some privacy? It was decided that a low wall should surround the square, which was about seventy-five hundred square feet where there had been three disused shelters from the 1950s. The wall created a kind of house without a roof, a space at once open and contained. The architects interviewed residents whose homes faced the site, and negotiated with each one separately on the permeability of the wall in front of their houses. What resulted is a dusty, L-shaped, sun-bleached place, not much bigger than a pocket park, made of limestone and concrete, shoehorned into a warren of concrete and cinder-block houses—which has stirred serious debates among Palestinians about the role of women and the right of return. Its very existence has changed life and thinking in the camp.

The square has given children a place to play other than in crowded streets. Families have begun to use the space as a gathering spot. Young couples are getting married in the square. Mothers who rarely felt free to leave their homes to socialize in public now meet there twice a week to talk, study a little English, and weave, selling what they make in the square, an enterprise that is entirely new for women in the community and that one of the mothers told me "gives us self-esteem and a sense of worth, like the men have."

"For me," another mother said, "the radical change is that men here now look at women in a public square as a normal phenomenon. I can bring my kids. I can meet my friends here.

We are in our homes all the time. We need to get out. We want to be free. Here, in the public square, we feel free."

HER REMARK PUT ME IN MIND OF A MOST PERFECT SQUARE. Some years ago, I moved to Berlin with my wife and two sons in order to start a newspaper column on cultural and social affairs across Europe and elsewhere. We settled into an apartment on a quiet street in the west. We soon discovered Ludwigkirchplatz, a square, two blocks away. It unfolded at the rear of a neo-Gothic redbrick church from the 1890s, St. Ludwig's, one of the few freestanding churches in Berlin. Several streets converged from different angles onto the square, which used to be the center of Wilmersdorf, a leafy cobblestoned quarter whose roots go back at least to the thirteenth century. Georg Grosz and Heinrich Mann once lived not far from our apartment. Not long ago, Wilmersdorf was subsumed by Berlin administrators into a larger borough, Charlottenburg-Wilmersdorf, which includes the Ku'Damm, West Berlin's faded but undaunted version of Broadway or Paris's Champs-Élysées, with its glossy auto dealerships and sprawling department stores. Ludwigkirchplatz is off the beaten path. If several roads lead to it straight from the Ku'damm, they're quiet, and you can still come upon the square as if upon a clearing in the woods. These are slumbering streets of stucco, stone, and concrete apartment blocks with funny little shops selling belly-dancing supplies, gay sex toys, Cuban cigars, and German wine. The square announces itself gradually, from a distance, with the sound of children playing and church bells.

It's not quite an hourglass shape, paved in patterned

stones and shaded by rows of linden trees, with café tables spilling from bars facing the square. A sandy playground squats below the bellowing apse of the church. A raised semicircle of benches looks back toward the café tables and onto a pair of slightly tilted concrete Ping-Pong tables, which do a brisk business in warm weather. A plaza between the café tables and the Ping-Pong tables is the square's main stage, where skateboarders vie with toddlers, dog walkers, young mothers pushing high-priced strollers, and Wilmersdorf widows, the last generation of war survivors, not unlike the Italian matrons whom I recall from my childhood in the Village, and similarly disapproving.

Someday we will lose all this and return home, I told myself whenever I arrived in that beautiful square under the towering church steeple and settled onto the benches beside the playground, where our children loved to play. The square was a home, drawing us daily. With the usual mix of sadness and pride, I watched our older son, just eight when we moved, grow up game by game, learning to play Ping-Pong on the lopsided tables; I watched our younger boy learn to walk in the sandbox near the swings. In December, when the square was silent and briefly taken over by Turkish immigrants selling Christmas trees, we lugged our tree to our apartment after a heavy German lunch in an old corner bar that had an especially lovely view of the slumbering playground and barren branches through steam-fogged windows.

Spring arrived by fiat, as soon as we could clear the snow from the Ping-Pong tables. Wilmersdorfers desperate for winter to end were there, too, wrapped in blankets, shivering at the

outdoor café tables facing the square. If a polis is measured by the length of a herald's cry, a parish extends the distance of a church bell's ring, and the bells of St. Ludwig's, while deafening in the square, filtered through the surrounding streets, binding the neighborhood together.

On our final day before moving back to New York, one of those cruelly perfect, sun-kissed summer Sundays in Berlin, my older son and I returned to the square for a few last games. The square was packed with newly arrived Russian émigrés and with children carrying ice cream cones from the Italian gelateria facing the playground. "Everything is as it should be," Nabokov once wrote. "Nothing will ever change, no one will ever die." The smell of fresh bread wafted from an organic bakery, just off the square, mixing with the perfume of blooming lindens. Skateboards rattled over the stone plaza. The bells tolled for what seemed like an hour that afternoon. We played game after game, vainly hoping to slow time.

The perfect square, it turns out, is also a state of mind.

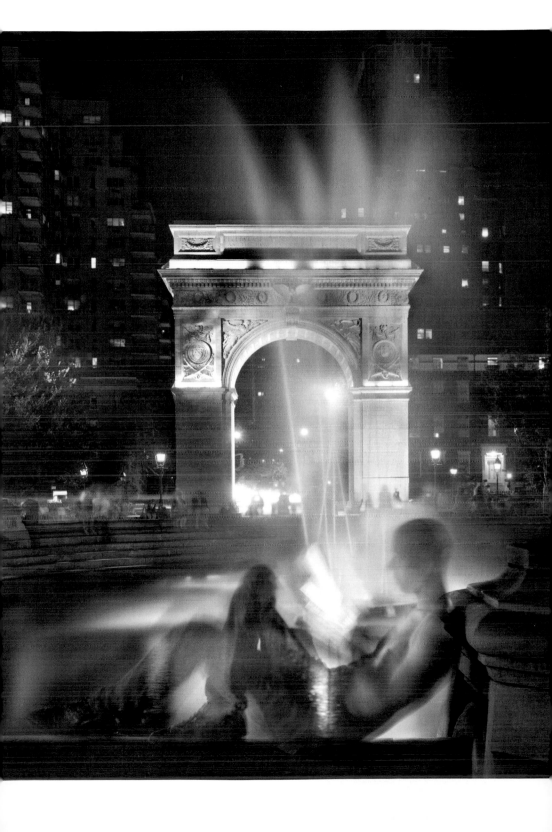

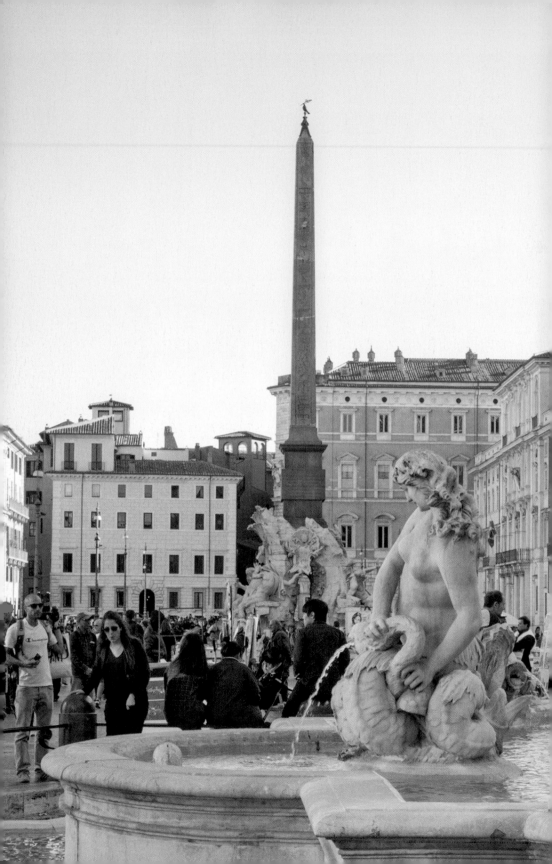

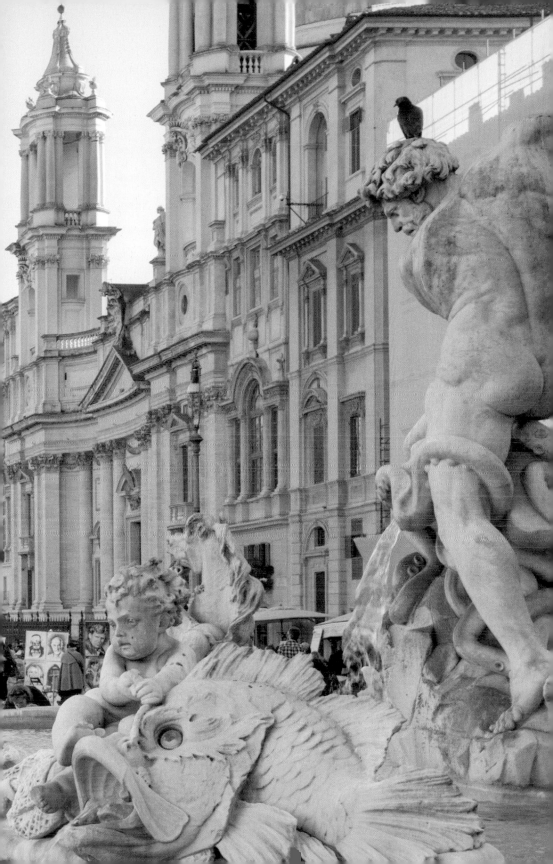

Photographs by ANDREW QUILTY

MAIDAN-E-POMPA, KABUL: RESISTING THE SQUARE

Rory Stewart

OLD KABUL WAS A CITY NOT OF SQUARES BUT OF NARROW LANES. For five thousand years, pack animals shuffled slaves, sugar, and silk between the Mediterranean, India, and China, through the funnel of the Kabul valley. The town blossomed into a winding maze of stables, warehouses, and workshops; wood carvers, jewelers, and calligraphers flourished in the alleys; the street level rose over the centuries; and new houses grew from fragments of wood, straw, and earth, first deposited at the time of Alexander the Great. In Bagram, north of the city, a spade uncovered a storeroom containing porphyry from Roman Egypt, lacquer from first-century China, and Indian ivories nailed to a crumbling two-thousand-year-old chair. But none of this industry resulted in a city square. In 1839 the British soldier James Rattray observed that "the streets are so narrow, that a string of laden

camels takes hours to press through the dense, moving, ever-varying crowds who all day long fill the thoroughfares."

The narrow chaotic bazaar—the commercial space of workshops and stores—around the great mosques, beside the Kabul River, was kept entirely separate from the residential areas. If you had been permitted to penetrate the studded doors, tunnels, and winding passages that led from the bazaar to the residential lanes, you would have discovered generous courtyards, but these were private: inaccessible to all but the most intimate guests. Respectable families stayed behind the high walls of their compounds. They did not stand on the mud roofs like the men who pretend to fly homing pigeons, peering surreptiously into other men's courtyards. And they certainly did not spend their days in the open like the "brave boys"—the *jawanmard*—sauntering in the bazaar or squatting in the open spaces to bet on wrestling, cockfighting, and dogfighting.

It was in 1639 that Ali Mardan, a Kurdish immigrant, first tried to give Kabul the equivalent of a square. He brought the idea from Persia, where his father, Ganj Ali Khan, forty years earlier, had demolished a square kilometer of shops and houses in the city center of Kirman (destroying the homes and livelihoods of thousands of Zoroastrian residents who tried—in vain—to protest to the Shah). In their place he had laid out a new formal bazaar, of fired bricks and glittering blue tiles, and a piazza three hundred feet long and a hundred and fifty feet wide. Ali Mardan followed this model, tearing into the informal sprawl of mud shops in the center of Kabul. He replaced them with four straight vaulted arcades—the Char-Chatta—

arranged in a cross. It was the center of this cross of shopping streets that formed Kabul's first real public space—not at the scale of his father's in Kirman—but a formal secular square nonetheless.

Char-Chatta was famously beautiful, but we don't know what exactly it looked like, because in December 1841 the Kabulis used this public space to display Sir William Macnaghten, the British resident in Kabul, after the uprising that drove the British from the city (his head, blue-tinted spectacles, and black silk top hat were placed on meat hooks, separately from his dismembered body). The British army demolished Ali Mardan's bazaar in revenge. Squares are not natural phenomena, and in the absence of Ali Mardan, no one had the authority or confidence to impose a new architectural plan or stop a dense network of timber-framed shops from recolonizing the space. The Char-Chatta disappeared.

One hundred and thirty years later, in 1971, an East German foreigner chose to emulate Ali Mardan by building another square. This time he planned to place the square not in the commercial bazaar but in the residential neighborhood of Murad Khane. Delighted by the new plan, the government issued a forcible acquisition order for the whole area, paid some limited compensation, and began by demolishing two traditional courtyard houses in the heart of the district.

This demolition was supposed to be only the beginning. Under the master plan, all the other two hundred–odd historic houses of Murad Khane—almost the only part of the city to survive the British conflagration—would be bulldozed. The

Qizilbash community, some of whom had lived for centuries in the ancient courtyards, would be resettled to concrete blocks on the city's edge. A four-lane highway was to run through the intricate cedar columns of the caravanserai. Along the highway would stand concrete housing blocks, designed for 1970s socialist workers in an East German mold. In the center would be the new square.

But before the plan could be implemented, the president of Afghanistan was assassinated by Russian Spetsnaz storm troopers; the Soviet Union invaded; and redevelopment was put on hold. After the Soviet withdrawal, Murad Khane lay on the front line of the civil war. It was shelled from the city walls, residents were torn apart by rocket fire, and Ukbek militia bivouacked in the courtyards and burned the garden trees, wooden shutters, and panels for firewood. When the Taliban drove out the militia in 1995, the houses filled with refugees from outlying villages. During this whole period, no one built on the empty site, and no further houses were demolished. Forty years later, all that remained was the space where the two houses once stood, surrounded by the ancient residential streets of Murad Khane, a square in miniature.

When I first saw the Maidan-e-Pompa, the square of the pump, its surface was a composite of crumbling mud brick from old buildings, layered like a mille-feuille cake with bright blue and pink plastic bags and sprinkled with the feces of men and goats. Its new function as a garbage dump had raised the ground level in a slope, so that the north side was three feet higher than the south. Some of the studded wooden doors were so far below

ground that residents had to climb over courtyard walls to enter their houses.

The entrance to the square was through the arch of a gate leading from the silver bazaar. Behind the gate were bridges built over the alley to prevent anyone from entering on horseback; they were now too low for pedestrians, so you moved up the lane bent double, as though in the entry to a mine shaft. Beyond the tunnels, high mud walls ran along either side of the lane. Set low into the walls were more thick studded gates, entrances to family houses. In the bazaar, just behind, someone once recorded a hundred thousand women in a week (on their way to pray at the shrine for children or for health, to lock a padlock or tie a thread around the railings), but now the lane was almost always silent and deserted.

A high mud-brick wall concealed on either side where one building ended and another began. The only windows were tiny squares twenty feet above the street level that could be used as firing positions. The Qizilbash of this area had been Shia in a Sunni city, Turkic-Persians among Pathans and Tajiks, and once wealthy courtiers when others were poor, and they had built this quarter to protect themselves from attack. Repeatedly in the eighteenth and nineteenth century, the mobs had stormed the Qizilbash quarters, and the Qizilbash had tried to protect their families, firing position by firing position, tunnel by tunnel, studded gate by studded gate. The lane also protected the inhabitants from the other lanes. Each originally protected a separate clan. Access from one lane to another could be had only from the main bazaar street and the guarded gate.

But when the courtyard houses were demolished and the square was created, everything changed. Two very separate lanes were suddenly connected. Or rather, they ceased to exist: when you emerged from the narrow tunnels, there were now no lanes. Instead of facing the blank mud wall of an unbroken terrace, you could stand in the center of the old terraces and see the facades of houses designed to be invisible. The private had suddenly become public.

You could see, how, on every inner courtyard, from roof crest to ground, the houses were faced with carved sliding panels; each panel could be raised in the summer to create an open colonnade; the panels were decorated with flowers; and they were separated by thick cedar columns carved with lotus flowers and acanthus leaves. You could see peacocks carved on every window frame. The opening of the new square had granted these houses identities and facades.

Thus, the Maidan-e-Pompa—this accidental, embryonic space—allowed me to glimpse for the first time the hidden courtyards of the old city of Kabul. Through seeing them, I fell in love with them. I decided to move to Kabul, to get closer to these buildings, to restore them, and to support the lives and crafts of the residents. I began in the square itself, asking whether the residents would allow me to clear the garbage. There was suspicion. Some believed I was searching for buried treasure left by the British in 1841. But eventually, Kaka Khalil, the chief of the lane by the shrine, agreed to work with me, and so did the champion wrestler three lanes farther down.

We established a small charity—Turquoise Mountain.

With a hundred other local residents, we began by clearing the garbage out of the square, dropping the street level by three feet: allowing for the first time, in half a century, people to walk upright beneath the bridges that led into the lanes. People could now enter their houses through the door, instead of climbing over the compound wall. We stripped the mud off the house at the north end of the square till it stood in bare timbers; we jacked it into the air, replaced its waterlogged, wooden foundations, cleaned half an inch of black caramel off the plaster niches— when the princess's family left, it had been used for boiling sugar—and repaired each peacock in the window frames. (We eventually repaired over a hundred such residential houses.) We paved the edge of the square and planted grass in the center and lined it with plane trees, and on the south side we placed a water pump—which was why this wasteland without a name became

29

known as the Maidan-e-Pompa. Children from families on both sides of the square began to congregate at the water pump. The boys used it as a soccer field.

But I never could have predicted how the community would take to the new square. When we opened a primary school on the south side of the square, the two hundred children who turned up on the first day were almost all boys. The fathers said they did not trust what we might teach their daughters. So we invited the fathers to sit in the back of the class (after two weeks they were so bored that they were willing to allow their daughters to attend). When the community asked for a clinic, I resisted because I was worried about insurance, and because a clinic was "not in my strategic plan." But the residents insisted, and offered another room adjoining the square, and I reluctantly agreed. The wealthier residents agreed to pay more for their treatment, in order to subsidize the poorer residents, and the clinic became the most successful part of the square.

After five years of clearing garbage, leveling streets, installing water supply and electricity, and restoring buildings, we had created, around the square, an architectural office, a community center, a tea shop, a woodworking shop, a masonry yard, the beginnings of a school of traditional crafts, a primary school, and a clinic. But most of this was invisible, still hidden behind the high mud walls of courtyard buildings that formed the edge of the square. The schoolchildren trooped in their pale blue uniforms from the bazaar, past the old wooden gate, under the tunnel, then, at the corner of the square, turned through another studded gate and up an old staircase out of sight. You could hear

the sound of their chanting lessons through the narrow window, twenty feet in the air, but that was the only hint of a school.

And then the square fought back. One of my foreign volunteers thought, for example, that a playground would be a good idea, since there were none in the area. But the community would not accept a playground in the square. Instead they offered us an empty compound, just behind the lane gate, on the back of the bazaar. We got the children to design their own slides and swings and tunnels. And for a year they seemed to use it happily. But one day I returned from a trip out of the country and found the playground locked. After three days I managed to enter and found a goat in the playpen and chickens on the broken seesaw. No one could quite give me a straight answer on what had happened. A couple of months later, someone asked if we could relocate the architectural office. Finally, people offered a good alternative site for the primary schools and clinics, just three hundred yards away but no longer in the square. The square was folding back into the private space of the residential lanes, and all the other activities were being pressed beyond the studded gates into the bazaar.

Our long-planned institute for training craftspeople emerged, not on the square but in what once was a merchant's warehouse and mansion on the riverfront. When it was offered to us, goats lived in the upper stories, banana boxes were shoved against the crumbling plasterwork, and lightbulb crates filled the courtyard. We had to restore more than a hundred separate rooms. We created a library in a high narrow courtyard with white-plastered walls; we placed the finance department in a tiny

gallery of first-story wooden balconies; and we put a calligraphy school in a vast courtyard faced with forty-eight separate carved panels, on four sides, with tall cherry trees and an explosion of flowering vines. Sixty jewelers and gem cutters trained in rooms set with tiny shards of red and blue glass pressed into the plaster two hundred years earlier. The rear buildings were taken over by wood carvers and filled with the sweet scent of sawed cedar.

Next the community offered us a caravanserai on the river's edge—originally used to house the horses and goods of traveling merchants—as a site for a ceramics school. We moved the primary school out of the square into another courtyard house beside the bazaar, and we rebuilt a large area of warehousing into the clinic, now treating twenty-three thousand patients a year. In front of this complex of buildings sat the champion wrestler in his plastic chair, squeezing his arthritic knee and telling stories about hoodlums from his youth to calligraphers and fruit sellers. The blacksmiths—standing in special pits so they could keep the anvil on the ground—smiled as they beat molten metal. Students, patients, jewelers, and shopkeepers moved daily through the line of rubber-bucket sellers and brewers of magical potions. We had saved many traditional buildings and were selling crafts, which had seemed doomed to disappear, on three continents. The project of regenerating Murad Khane had never appeared so successful. But all our sites had been gradually shifted into the much older context of narrow streets, trading courtyards, and bazaar alleys beside the river. It was no longer in the new space of the square.

I tried to convince myself that our institutions were in-

spired by that square, even if they had reemerged away from it. I felt that the open space where the wrestler sat was a kind of square: It was a space that brought together men and women, the Qizilbash and others (although in truth, it was simply the place where the bazaar street came out on the riverbank; it looked nothing like a square). I often walked back from our institute, through the bazaar and past the wooden gate, toward the old square. The sounds of children chanting their lessons or the masons knapping flint had gone, but children from both sides still gathered around the water pump. On those visits, the square seemed to me, a European, the quintessence of the ancient city. But I was beginning to realize that what I so loved about that square (and any square)—the glimpses of the private facades, the intersection of the two quite different streets, and the open public space in between—was, for many of the Qizilbash, a scandal.

I realized that, in a decade, I had never seen an adult sit or even stand under the plane trees that we had so carefully planted in the Maidan-e-Pompa. If the trees were there at all, it was because I, not the community, watered them and, more often than I liked, replanted them. The center of the square had reverted to a dirt patch. Kaka Khalil did not greet the people on the other side of the square, because they lived in what was, in his father's day, the separate lane of the Afshar. No one seemed to ever take the shortcut through the middle of the square. Instead, if people were walking from the bazaar, they stayed to the barely visible line of the old streets. Over forty years had passed since those two courtyard buildings had filled the entire space, creating

a solid wall between the two streets. But everyone except the youngest behaved as though they were still there. The community backed our projects, the craft schools and clinic were flourishing, but they were determined that they should stay in the bazaar and never return to the square. The old fortified private lanes seemed to persist in the imagination, although their gates could no longer be closed.

Murad Khane had survived the East German plan and the Afghan government demolition order; it had survived my attempt to bring workshop, school, clinic, tea shop into the square or to make it a place for adults to relax or children to play. And I suspect that it will not be a decade before the space has been colonized again with private houses and the old locked alleys have reappeared. And old Kabul has again lost its square.

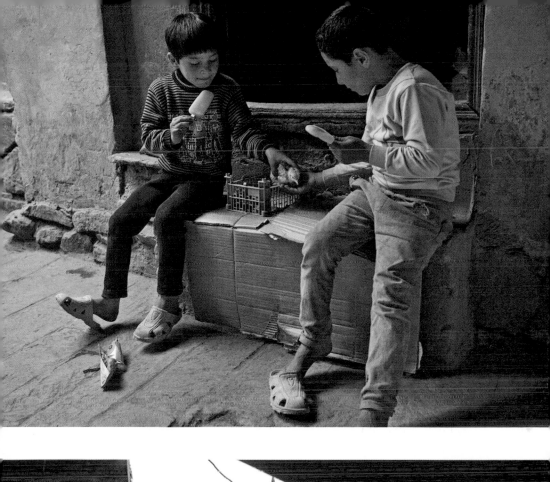

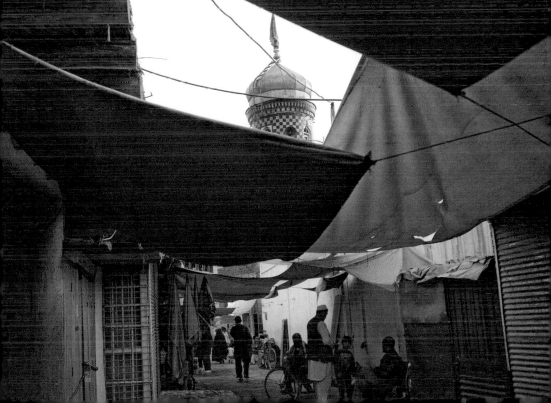

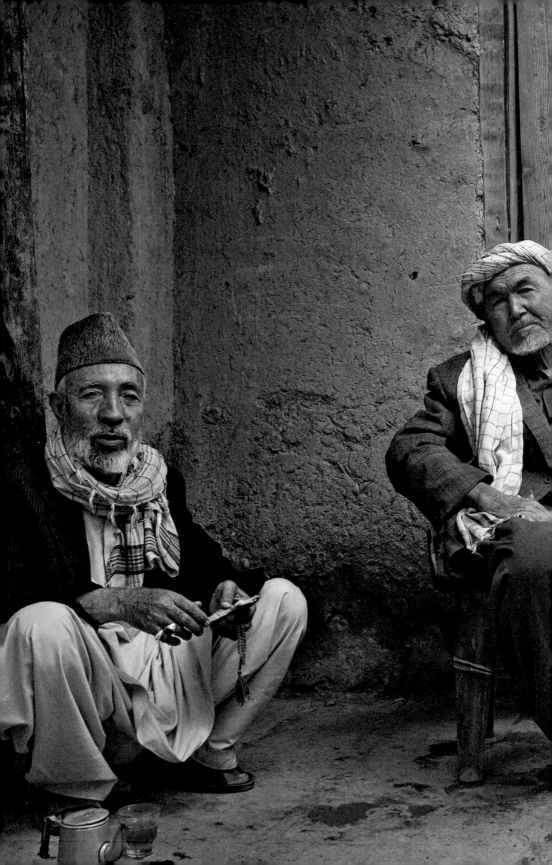

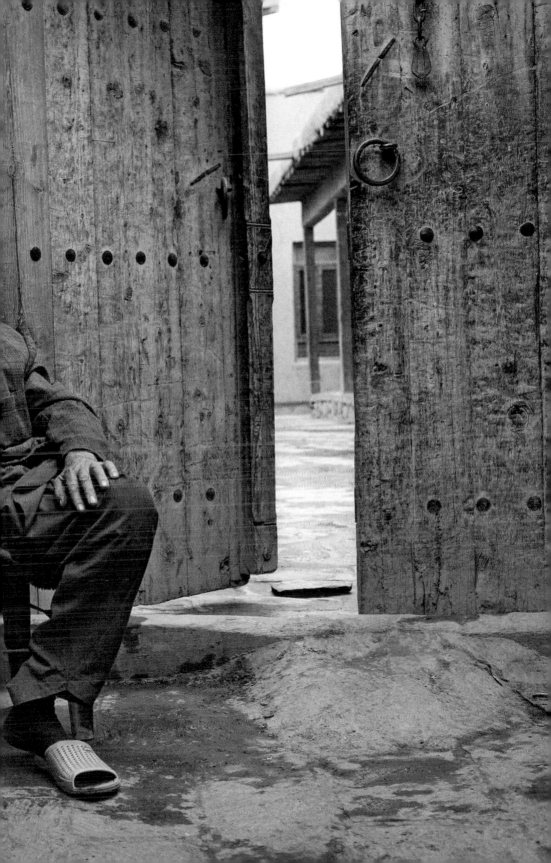

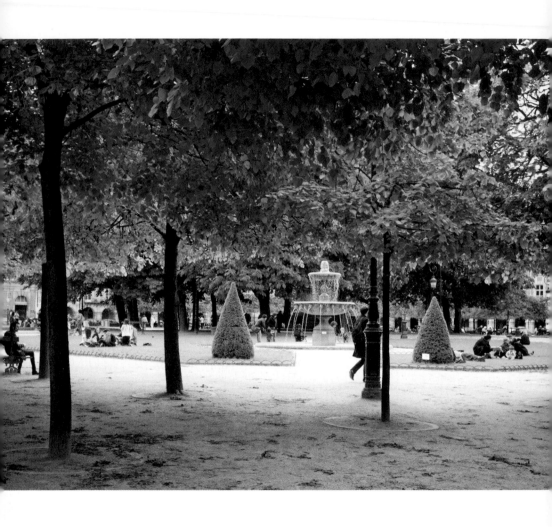

Photographs by OBERTO GILI

PLACE DES VOSGES, PARIS: A PRIVATE PLACE

Adam Gopnik

PUBLIC SQUARES IN GREAT CITIES COME IN TWO KINDS, THE declamatory and the domestic. There are the piazzas and court-yards where heretics get hanged and proclamations get read and crowds get stirred to action—the Place de la Concorde, the Piazza San Marco, the Piazza della Signoria in Florence, and, more decorously, Trafalgar Square all share this character. Then there is the smaller set of those squares that, looking inward, remake public space into a kind of shared *hortus conclusus*, a closed garden, where, even if the area covered is actually quite large, a hush of silence still greets us as we turn the corner, and the square seems to shun the street. Of this second kind, the inner courtyard within the city, the greatest of all must surely be the Place des Vosges in the Marais quarter of Paris. It is the su-preme public space that feels private. While we know that it was made by kings for artisans and once, very long ago, had a special ceremonial place in French life—and even if we conscientiously

walk around it (as this writer just did) and are reminded of how much bigger it is than we quite choose to recall—our experience of it is still intimate in ways that few other famous public places provide.

One of the world's few great squares that really *is* a square, its equable, even spacing perhaps helps quiet it in our minds. A plain square surrounded by streets, each side filled with an identical procession of brick-and-slate dormered four-story buildings, its inner garden gated off and filled with a canopy of plane trees that covers children at play—in memory, it is softer than that. We see its shadowy arcades and hear the twilight sound of heels on granite, we recall children playing on the slide in the inner park beneath the plane trees, and imagine how, centuries before, horses would be put silently through their paces in the sand. Even the literature it has inspired is mostly sad. Inspector Maigret lived here and walked in these arcades, dwelling on the big murderous follies of the human heart, and the smaller, fussy ones of the French fonctionnaire class, with about equal melancholy.

History tells us that it is the Cinderella—or, as the French would say, the Cendrillon—of the world's great squares. It was born to encourage manufacturing, quickly turned into a region for real estate speculation, then given its permanent, completely irrelevant title in one of the most cynical "naming opportunities" ever conceived before the modern football stadium. Its history, like Cinderella's, is one of metamorphoses, from outcast to royalty then to outcast and back. It receded from the world's consciousness of Paris, and from Paris's consciousness of itself,

to become a backwater and something close to a slum, only to return to view today. The Place des Vosges was hidden away in scullery work for centuries; it emerged again royally, or at least as a very high bourgeois, only in our own time. This means that, while it has something in common with such spaces as Ritten-house Square in Philadelphia or Gramercy Park in New York—as a residential square, in first form and continued feeling—it also has something in common with the small cobblestone streets and intersections of the cast-iron district in Manhattan, a great civic gem that for a long while, no one quite knew was there.

The quiddity, the magic spell, the resonance the Place des Vosges casts lies in some mood between the tranquil and the melancholic. Photographers struggle to find odd corners in sunlight to give it the look of the Great Public Space—to fit the expectations of what we expect a great public space to look like. In truth, its special magic is its secrecy and shadow. The arcades suggest less the flaneur's casual encounters than the solitary walker's shadowy stroll. (Paris in summer is very short on shade, and the Place des Vosges always supplies it.) Though not part of the original design, the plane trees' canopy in its center hushes even the noise of the kids within. We are alone in a grand public square.

This play of private and public, so essential to our experience of the square, turns out to be implanted, like a twist of DNA, deep in its history. Where the Place de la Concorde and the Place Vendôme track the history of centralized French politics very precisely—the statue of Napoleon goes up, then it

comes down; guillotines get put in place, then taken away—the history of the Place des Vosges is shaped by commercial forces. Indeed, the very name we know it by is all about money: In 1793 a national competition was held by the desperately indigent revolutionary government to see which department of France could pay its taxes to the people's government most quickly—the first in would have the doddering old Place Royale renamed in its honor. The distant northern department of the Vosges won, and the name—which has, strangely, stuck through restorations and subsequent revolutions—was affixed for keeps.

SO THE PLACE DES VOSGES, NÉE ROYALE—AND FOR MOST OF its first hundred years of life, that "Royale" is essential to its history—began in 1604 with what the Place des Vosges's greatest contemporary student, the French architectural historian Alexandre Gady, has described as a burst of "pre-Colbertian politics"— meaning a royal edict that still depended on private investment, centralized in spirit without being centrally financed. It was then that Henri IV decided to build in Paris a new "integrated" space for the manufacture of silk and linens, modeled on, and meant to compete with, those in Milan. Henri, one of the few completely admirable characters in French history—a man of real public spirit, the author of the Edict of Nantes, which extended limited religious toleration to the Protestants—was an enthusiast for artisanal work as much as fine "art." He planned a vast new square—approximately 460 feet on each face—bordered, in the original plan, on *three* sides only by uniform pavilions of slate

brick and rock, faced with slate. The new buildings were to be models of a multiple-use efficiency that would have dazzled a Utopian urban planner in the first years of the twentieth century. The four-story redbrick buildings that lined the square were meant to house factories on the second and third floors—the spacious scale they offer today to those lucky enough to live in them was, in effect, like those of the loft buildings of New York's SoHo, derived from their original utilitarian purpose. Uniform in design, they were meant to be neatly uniform in purpose: Silk and textiles would be made on the second and third floors, while the workers who made them would live high up on the fourth floor, within the eaves, while shops to sell their goods would fill the ground floor of the arcades. The original plan of Place des Vosges is, in this way, oddly and presciently modern and public-spirited—an admirably "multipurpose" marriage of housing, industry, and retail.

The architect of this beautifully ambitious and unified plan is unknown. Various builders and designers have been nominated, but it seems likely that his (or their) identity was deliberately suppressed, or at least underplayed. The "irritating anonymity" of authorship, as Gady puts it, was purposeful; the king alone was to be understood as the author of his splendors. Indeed, the brick and slate and stone of the pavilions, which may look quaintly cozy to our eyes today, were meant to symbolize high luxury magnanimously spread, brick in the period being a rich man's, not a bourgeois, material. The royal eye was intended to be felt everywhere, with only one pavilion on the place

made markedly different from the rest. Placed on the center of the south side, and serving as a doorway to the rue St. Antoine, was one royal edifice where the king, presumably, could oversee his creation: the Pavillon du Roi.

After the assassination of Henri IV by a crazed fanatic Catholic in 1610, things quickly began to change. Though conceived as a concert of buildings, the ateliers of the Place Royale were built by individual speculation, and it soon became apparent to the twenty-four actual investors, in a manner eerily contemporary, that they were worth more as residences than as manufacturing spaces. The by now familiar process of gentrification, in which the well-off take over what was once meant for artisanal industry, in this case was collapsed into a single generation. Soon the fourth face of the square was filled in, while the central exercise space was gated and grilled and used for public ceremonials, royal marriages, and occasions.

The subsequent decay and forgetting of the Place des Vosges is hard to parallel in urban history. This is a case of a fashionable place falling into a kind of shabby, catch-as-catch-can existence with small, far from luxurious manufacturing businesses filling its spaces.

Though the tale of decline is fixed in place, that long falling away is inseparable from the changing Marais neighborhood around it, and so has its sweet spots. Throughout the nineteenth century, as immigrants flowed in from the east, the Marais became the vital Jewish neighborhood of Paris—more cautious and clandestine and ghetto-like in feeling than equivalent Jewish neighborhoods in America, perhaps, but still dense and rich

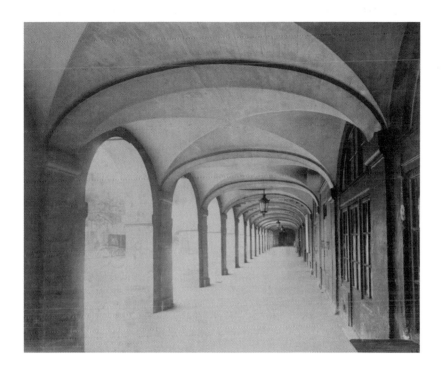

and singular, with its own restaurants and little industries and institutions. Though the Place des Vosges itself took on only some of the Jewish character of its surrounding streets, and so remained in some ways apart from that neighborhood—it was still a "distinguished" enough address to attract (and keep) the great, albeit radical, poet and novelist Victor Hugo—in other ways it took part in the same change. (The Temple des Vosges, an Ashkenazi synagogue, fronts directly onto the entrance of the square.) Eugène Atget's haunting photograph from 1898 of the perspective recessional of the vaulted arcades in the Place des Vosges shows a place utterly empty, anticipating De Chirico in its sense of the melancholy and mystery lodged deep in urban places. We might almost feel, looking at the Atget, that what was

meant as a secular manufacturing space had become a piece of found ecclesiastical building, a church interior brought outside. (This depeopling of places, of course, is more or less constant in Atget's work, but it should not be ascribed simply to technical limitations of his camera; his pregnant emptiness is purposeful, and emotional, too.) A handful of more mundane photographs of the Place des Vosges around 1900 show a place with a not unattractive—if rickety-tickety and run-down—feeling, with used goods for sale under the arcades: in feeling like that of the Marché aux Puces a decade or two ago, dusty but companionable.

The most vivid picture of the Place des Vosges toward the end of its time of decline is in Georges Simenon's Inspector Maigret novels of the 1930s and '40s, where the Place is one of Maigret's residences and the Marais his wandering area. The appeal of the Place des Vosges is that, for its entire faded splendor, it remained a tenement of types. There are working people, wealthier people, small shopkeepers, petit bourgeois, and workingmen, and, of course, a fonctionnaire like Maigret himself. Right up into the modern era, its back gardens were filled with small lotion- and perfume-makers.

The reclamation of the Place des Vosges only really began in the 1960s, under the pressure of Malraux and De Gaulle's ambitious cleaning and restoration project for Paris, which swept off the encrusted dirt and swept in a new aristocratic class. Somewhat earlier, Corbusier imagined destroying the entire Marais, including the Place des Vosges, and replacing it with giant housing blocks. The renewal program has been, if anything, too successful. Now, like so much of Paris, the Place des Vosges is first

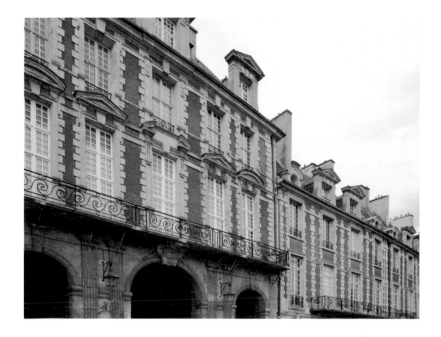

of all a tourist destination—a place to buy an overpriced lunch in cafés filled with waiters who speak some weary bad-tempered English or German.

Yet public spaces, if they're beautiful enough, survive tourism and overuse to retain their own feeling, cast their own spell. While a resident-visitor to Paris myself, another kind of tourist, I passed the happiest day of my life on a Saturday afternoon in the Place des Vosges. My son was five and his baby sister just the beautiful age of eight months, when eyes open wide and insight rushes in. We went to a café for crepes and omelets, then into the Hôtel de Sully, now made into a museum, to see a show of photographs. The baby, in tights and a white flapper-style dress that I had, as it happens, bought for her at a little store just off the St. Antoine exit of the Place—I regularly saw a doctor who

worked and lived near there—suddenly, low to the ground, saw that the terrazzo floor was speckled with small spots of gilt that looked like coins. She clutched playfully at the little coins buried in the terrazzo floor of the beautiful house; the boy, catching on, pretended to dig them out and present them to her. She paused, smiled, and then laughed, her whole body alight with the joke. It was her first real joke seized and shared in company, and she vibrated with the discovery that you could have a false and invented experience that was as thrilling as a true one. He went on placing the imaginary coins in her hand, and she shut her hand again and again upon the nothing that was something because they had declared it so, and laughed confidently, uproariously—I had never seen someone outside the movies laugh at something as she did. I pushed her home in her pousette, her eyes shutting quickly after the joy of her first joke, her small hand still clutching and releasing the imaginary coins. The shadowy arcades lulled her to sleep and then the crisper air, while the bells on St. Antoine sounded in her head.

The king's plan for the city had become a safe spot for her life. None of it, not the hotel or the floor or the arcades or the leafy square, would have been possible without one king's ancient unifying gesture toward commerce and ceremony. It was his space, we had borrowed it. But then in another way it wasn't, for he had borrowed it, too, from time. Now the kings were gone, even the royal name was gone, but other kinds of commerce, new kinds of ceremony, continued. The miracle of cities is that they are both there then and here now. A public square proves adaptable to a new time. We are lucky to live in old cities.

The Place des Vosges, as Simenon knew, is a melancholy place, because history is a melancholy thing. And history remains in this square in ways that cannot be wiped clean by the busyness that daily cleanses the *ardoise* of the Place de la Concorde or the luxury commerce that does the same for the Place Vendôme. More memory takes place in this square than in other places in Paris. Less history, perhaps, but more memory: Henri's Paris, Hugo's Paris, for that matter the postwar Paris that, oddly, still has a hold on us now—the old vanished sooty proletarian Paris that, if you saw Paris for the first time in the 1970s, will always be your first love can be felt here even now, when it has mostly turned into the new Paris, the Paris made up of dormitories for the rich and cabinets for the elderly.

On a winter afternoon, the melancholy that is the right ful mood of the place—as public spirit is the mood of Trafalgar or carnival the rightful mood of San Marco—can still penetrate the visitor. We hear our own footsteps along the arcade, take in good smells from small windows, see a soul or two in the distance, and step again into Ma Bourgogne, Maigret's café, for a *vin chaud*—and a crepe *crème de marrons,* if accompanied by a child —and brood for an hour on the vagaries of history and the beauty of escaping from them, and on the way that city spaces adapt themselves to times their makers never could have imagined, while remaining mysteriously true to type. Declamatory squares change their subjects as their subjects change. Domestic squares keep old secrets, even from themselves.

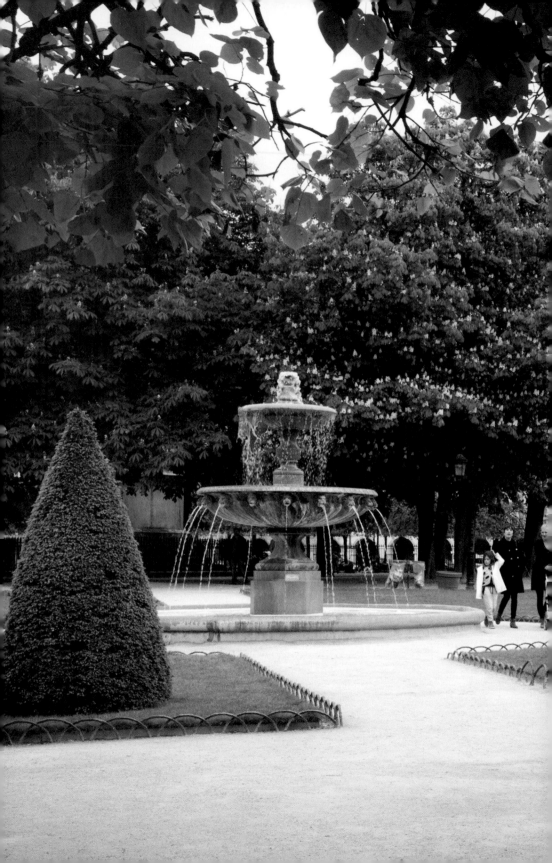

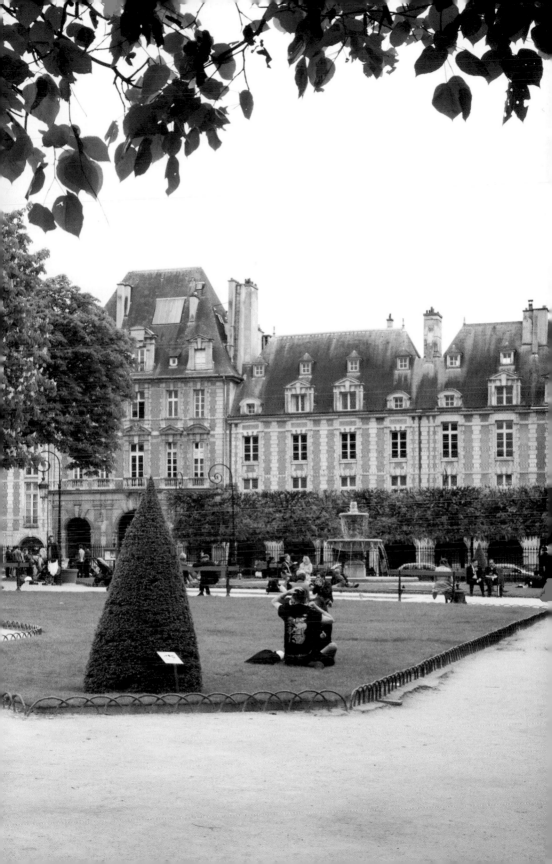

WASSILY KANDINSKY, *RED SQUARE*, 1916

RED SQUARE, MOSCOW;
GRAND MARKET SQUARE, KRAKÓW:
THE PAST IS ALWAYS PRESENT

Anne Applebaum

Two squares: two large open spaces in the center of two cities; two places where people have met, parted, argued, cheered, traded, and paraded for many centuries; two squares in two countries that have been connected by conquest, war, revolutions, and passions for many centuries as well; two squares that are, nevertheless, very different . . .

THE FIRST TIME I SAW RED SQUARE WAS ON A HOT AFTERNOON in high summer. It was 1985; glasnost had not yet begun. Soviet Moscow smelled of exhaust fumes, bad cigarettes, and kvass, the fermented liquor sold off the backs of metal trucks. Red Square was filled with policemen, as well as with people waiting and waiting to see Lenin's tomb. Eyes down, I walked past them. I was with a group of foreign students, and foreign students were

allowed to cut the line. I remember the sense of awkwardness: It was embarrassing to be pushed in front of a crowd of presumably faithful Communists, to have the barriers pulled aside, and to be ushered ahead of them into the darkness and silence of the mausoleum.

That awkwardness was caused not by the architecture of the square but by the politics of the square. And that has a precedent: From its earliest days, Red Square has had a political function. It began life as a shantytown, a cramped space where people excluded from the walled medieval city of the Kremlin could camp, beg, and trade. But at the end of the fifteenth century, the czar decided to clear the space of its inhabitants and set up a parade ground. Prominent public buildings rose up around the vast, empty space: the spectacular St. Basil's Cathedral, the Kazan Cathedral, the town hall. They were meant to impress and they did. The square became known as "Krasnaya," from an old word for "beautiful," which soon became conflated with its homonym, "red."

In the centuries that followed, Red Square became the place where the czars would make their wishes known to the people, whether through pageantry, rhetoric, or violence. Soldiers held drills there. At other times, the space was taken over by unruly mobs. In 1606, angry boyars stormed the Kremlin and murdered the "False Dmitri," a pretender to the throne who had come to power backed by Polish nobles. Angered by rumors that Czar Dmitri was letting Catholics and Lutherans pray in Orthodox churches, they hauled his body out into Red Square so that the people could see he was dead.

The boyars probably threw the pretender's corpse onto Lobnoye Mesto, "the Place of Skulls"—a raised platform in the center of the square that eventually acquired its own significance. Other czars announced their decrees from this same tribune, or presented their heirs when they came of age. Sometimes the relics of saints were placed on top of the platform so that people could come and be healed. Tradition holds that executions took place there, too.

After Peter the Great moved the Russian capital to St. Petersburg, Red Square lost some of its symbolic significance. In the nineteenth century, the old buildings around it grew shabby. The Kremlin itself fell into disrepair. But after the Russian Revolution, the Bolsheviks moved the capital back to Moscow. They preferred the massive, walled Kremlin to Peter the Great's Italianate palaces. Both pageantry and violence returned along with them.

The Bolsheviks let the onion domes of St. Basil's remain, though they destroyed several other churches, both on the square and in the Kremlin fortress. They added their own architecture: Lenin's tomb, a modernist pyramid, was constructed next to the Kremlin. They also gave Red Square a new function: a ceremonial burial ground. Stalin was placed beside Lenin, after he died, then later moved to the Kremlin wall. A small statue of him was erected adjacent to the plaque; from time to time, someone leaves fresh flowers beside it. Buried alongside him there are other Soviet officials—Brezhnev, Andropov, Chernenko—as well as Soviet heroes.

In the manner of the old czars, the Bolsheviks began to

use the square as a place of political theater, a stage upon which to play out symbolic events such as the anniversaries of the revolution or the funerals of great leaders. There were many, many Soviet military parades on Red Square, and in later years these involved not just rank after rank of soldiers but tanks, armored cars, even missiles. Bombers and fighter jets flew above the parades; the Kremlin elite gathered on the tribune alongside. Outsiders watched carefully at every annual celebration of the Russian Revolution to see who was standing next to whom, in order to guess at who was up and who was down.

None of those later parades matched the horror and grandeur of the parade staged on the anniversary of the Russian Revolution in November 1941. The Wehrmacht was under fifty kilometers away, on the outskirts of Moscow. Hundreds of thousands of Soviet soldiers had already lost their lives. Stalin spoke to the gathered men, some of whom had been pulled from the front. "The enemy is not so strong as some frightened little intellectuals picture him. The devil is not so terrible as he is painted," he declared, before rising to his peroration: "Death to the German invaders! Long live our glorious motherland, her liberty and her independence! Under the banner of Lenin, forward to victory!"

The soldiers marched past Stalin across the square—and then kept marching straight back to the front, back to blood and death. I first saw Red Square in the summer, but in truth it makes the deepest impression in the winter, when it more clearly evokes that moment. When empty of people and covered in snow, it most vividly evokes the wide-open spaces of the

Russian east: the steppe, the taiga, the tundra, and the conquering horsemen who have roamed across them.

A FEW YEARS AFTER I FIRST SAW RED SQUARE, I WALKED FOR THE first time into Kraków's Rynek Głowny—a name that translates literally as Main Market but is perhaps more gracefully translated as Grand Market. It was very early on an autumn morning: Poland was still a Communist country, but the ground was already shifting. I had arrived on an overnight train from Prague, having slept badly. I walked to the square from the train station and found a *kawiarnia,* a coffee shop, just opening its doors. I sat blinking in the sunlight, drank unspeakably bad coffee—this was 1988, before the espresso machines arrived—and watched the city wake up. Shopkeepers were unlocking their doors, rolling open their shuttered windows. Waiters were setting up their outdoor tables, picking up overturned chairs and putting them upright. Men with beards and glasses walked swiftly across the cobblestones on their way to work. Nuns in habits scurried off to schools and hospitals.

From the time of its construction, the square was the most important center of commerce and exchange in Kraków, a city that was itself the capital of Poland until the end of the sixteenth century. Kings and princes did march through the Grand Market, on their way to Wawel Castle, which stands on a hill above the city. Royal pageants and executions were sometimes held there. Aristocrats and rich merchants vied to own the houses on its perimeter. But the square was always a rival to the castle, not an adjunct of it. King Kazimierz—who is remembered,

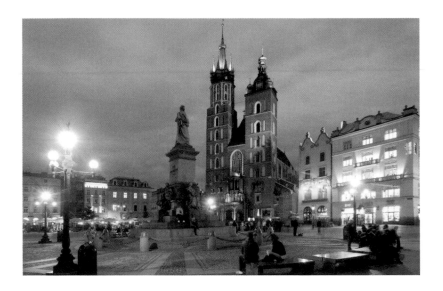

especially in Kraków, as Kazimierz the Great—waived his royal rights to the square in 1358, and ever since its character has been shaped by the people who shopped and traded in it, not by the political forces that ruled over it.

Of course there are powerful church institutions, both around and alongside the square, the most famous of which is St. Mary's Basilica, with its asymmetric brick towers. There are educational institutions, too: Not far from the square is the medieval Jagiellonian University, Poland's rival to Oxford and Cambridge. But at the heart of Grand Market there is no political tribune. Instead there is an arcaded covered market, the Suki-ennice, a marvel of Polish high Renaissance style. The homes of merchants line the square, some named after their idiosyn-cratic architectural details—Pałac pod Baranami, the Palace of the Rams, for example, or Kamienice pod Jaszczurami, the House of the Salamanders. The northern part of the square was

sometimes called, in archaic Polish, "chicken market." Other sections were at different times named for salt, for coal, for fish, for bread. One corner, Zydowski Targ, was named for the Jewish merchants who congregated there.

Indeed, the Grand Market was always a place of many cultures. Jews came to trade there, as did Armenians, Tatars, Czechs, and Germans. St. Mary's Basilica contains a vault built by an architect from Prague, and a vast wooden altarpiece carved by a sculptor from Nuremburg. Italian influence can be seen in the houses around the square, and in the facade of the Sukiennice. During the long centuries when Kraków was a part of the Hanseatic League, an early free-trade zone, merchants from Sweden and Denmark came to swap goods and stories there.

People from all over Central Europe met to exchange things in the market, but they also met to exchange ideas. The cafés around the Grand Market have always been filled with students as well as intellectuals and writers. In the eighteenth century, their chatter brought the Enlightenment to Kraków; after the partition of Poland among three empires in the nineteenth century, they created a powerful cultural patriotism. Though they had become citizens of Austro-Hungary, the burghers of Kraków brought back from Paris the remains of Poland's national poet, Adam Mickiewicz. They buried him in Wawel Castle and erected a statue of him in the square with a plaque below: "To Adam Mickiewicz—from the Nation."

That statue, that symbol of Polish sovereignty, was one of the first things the Nazis destroyed when they marched into Kraków in 1939: Their goal was to destroy not only Polish sovereignty

but Polish culture, too. They arrested all of the professors at the Jagiellonian University, and sent them to labor camps. They built a vast ghetto for Kraków's Jews, who had been integrated into the city's life since the Middle Ages, and sent them to death camps. The Grand Market became Adolf-Hitler-Platz, and in 1940, on the first anniversary of their invasion, a military parade was held there in the führer's honor. Joseph Goebbels arrived in an open black car. Soldiers marched in ranks. Swastikas hung all around the perimeter. But it didn't last: When the war ended, the flags were burned, the soldiers were chased away, and the remains of the Mickiewicz statue were found in a Hamburg scrap heap.

Mickiewicz was triumphantly returned to the Grand Market, but not everything else remained the same. The establishment of the Polish People's Republic after the war didn't change the architecture or the function of the square, but it did remove its wealthy, bourgeois sheen. In the eyes of the Polish Communists, Kraków was an enemy city: elite, intellectual, mercantile, opposed to everything they stood for. And so they built Nowa Huta, a vast steel mill and a social-realist suburb right beside the ancient capital, in hopes that its workers would become the proletariat that Kraków lacked.

Their plan failed—the workers of Nowa Huta became ardent Catholics, and under the leadership of a charismatic cardinal, Karol Wojtyła, they lobbied to build a church in the heart of what was meant to be an atheist settlement. And when Cardinal Wojtyła became Pope John Paul II, he visited that church, said mass at St. Mary's Basilica, and drew crowds of a million people or more. Over the four and a half decades of Communist Po-

land, Nowa Huta had only one important impact on the Grand Market: The smoke fumes from the steel mill gradually blackened the square's delicate facades.

Behind the run-down buildings, the square acquired another life. Just as the intellectuals of the nineteenth century had kept the national idea alive in Krakow's coffee shops, the intellectuals of the 1960s and 1970s preserved an alternative notion of Polishness in the cabaret they built beside the square. Piwnice pod Baranami, the basement below the Palace of the Rams, became famous for political jokes, skits, and innuendo. Dissident actors and singers performed night after night for appreciative audiences who came because they knew they would hear things in the basement that could not be said on the street.

Polish communism had space for jokes, and Poles flocked to hear them. The laughter of those audiences echoed into the night, across the ancient cobblestones, between the baroque facades. When you walk across the square in high summer, you feel almost as if—behind the light buzz of the crowds, the shouts of teenagers, and the mixed notes of street musicians—you can hear it still.

Two squares: two open spaces in the centers of two cities that experienced the transition from communism to capitalism, from isolation to globalization, from Cold War to wary peace; two squares that retain, nevertheless, their original character . . .

SINCE 1989, THE FACTORY SMOKE THAT ONCE BLACKENED THE facades of the Grand Market Square has been lifted. The air is

clearer, the buildings cleaner. The elegant townhouses have been rebuilt and are once again pale red, lemon yellow, soft green, and light gray. Red Square's churches have been rebuilt, repainted, restored: With their delicate onion domes and elaborate turrets, they are finally fit to be admired as well. These days, they are occasionally the backdrop for concert stands, posters, and displays. Like big public spaces in other cities, the great, ancient squares of Moscow and Kraków are now sites for pop concerts and music festivals. Tourists, once a rarity in both cities, crowd both squares. Kiosks sell postcards, souvenirs, and bric-a-brac around the periphery.

Yet no public space can escape its history. In Red Square the past is always present. In 2008, when the president of Russia decided that he wanted to evoke the glories of the Soviet Union, the rhythmic click of soldiers' boots and the rumble of tanks were once again heard on Red Square: At a parade held to commemorate the end of World War II, soldiers once again carried flags with the hammer and sickle. Even on an ordinary day, the square is often empty: There is no reason to loiter in the empty, intimidating public space.

Not long ago, I once again happened to cross the Grand Market Square in the early morning. Shopkeepers were unlocking their doors, waiters were setting up their outdoor tables, serious men were walking to work, and nuns, in the very same habits they wore three decades earlier, clattered across the cobblestones on their way to teach or pray. The coffee is better, but the essence of Kraków's central marketplace has not changed. And maybe it never will.

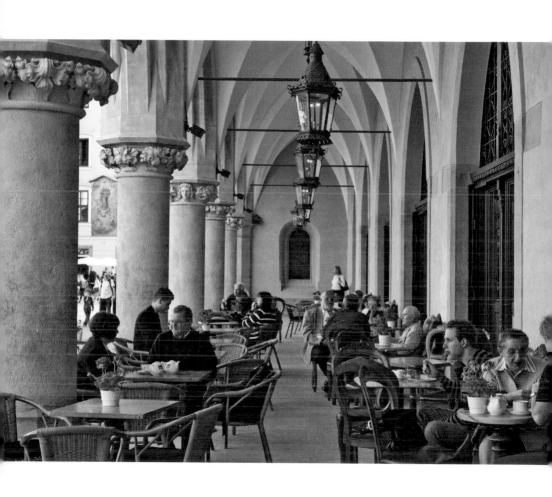

ALDO PAVAN; *overleaf:* SAM ABELL

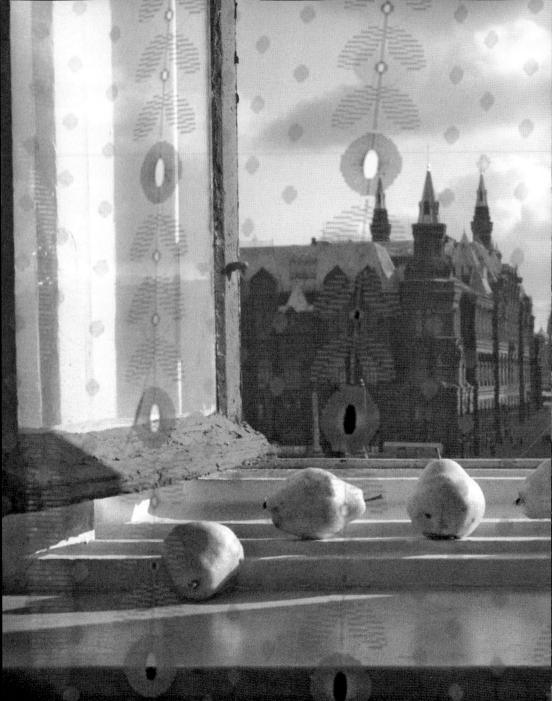

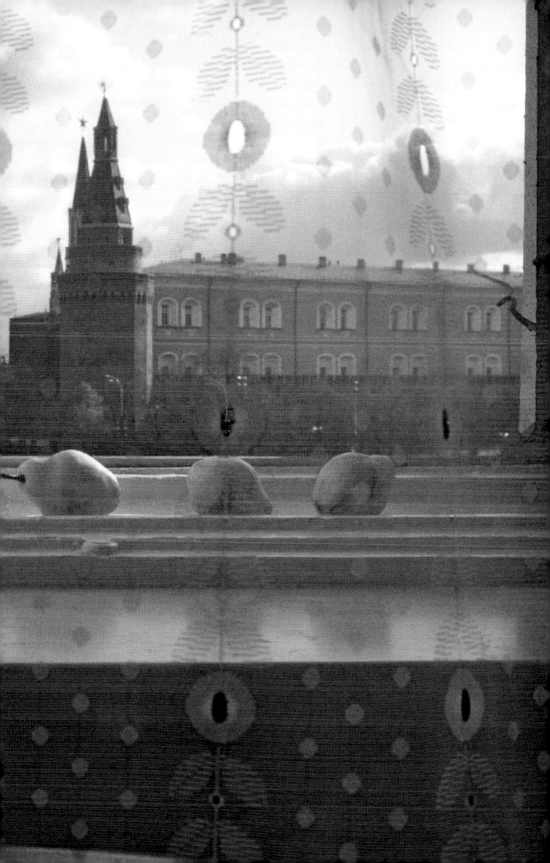

SQUARES OF ROME AND VENICE:
THE SHADOW OF IDEAS:
CIRCLES AND SQUARES

Zadie Smith

Se non è vero, è molto ben trovato.

—Giordano Bruno

PIAZZA DELLA MADONNA DEI MONTI. THERE THE MORNING SUN gives us preferential treatment, casting the church and half the fountain into shadow, striking us instead at our usual table. I have my *integrale*, you have your *spremuta*, the dog is leaping at the waiters, and I am very proud of this little clutch of italicized Italian words, I am reading *La Repubblica*, very slowly, with a dictionary, but very proud. Sometimes people stop and speak to us in this Italian square, using the *tu* form, because we are young or youngish, or known to them, or both. We live in Rome, but I am a tourist. I never stop being one, particularly in the squares. I remained a tourist even in that little square, the one I burned down. Which fire was at the beginning, though in memory it comes at the end, and this is inconvenient, structurally. But my memories of our Italian squares are nonsequential, they jump from here to there, ignoring chronology. They are filed according to a variety of intimate systems—one of which involves the differing intensities of light—and so there is nothing to be done: We begin in Piazza della Madonna dei Monti, east of the river, not far from

the Colosseum. You are reading the financial pages, like a local, whereas I am wondering about Vivaldi, like a tourist. I am aware that a performance of the *Four Seasons* is to happen in a basilica somewhere, at five-thirty each weekday afternoon and twice on Saturday; I hate that I should know about it, but I do. Even if I don't pick up the soggy flyer, stained by coffee rings and sprinkled with tobacco shreds, I register the invitation, knowing that it's meant for the likes of me, for the ordinary tourist, although I am quick to agree when you say, "No fucking way, those things are awful. Plus, Vivaldi is awful." You bend down to pour a little Pellegrino on the dog's panting face. The short waiter approaches, the one without any beauty, though he is *furbo,* he watches everybody, we always leave a euro to stay on his good side. He approaches and the dog leaps up. I yank her lead and pin her stupid head between my ankles. In England this would be considered the right thing to do, but in that Italian square, dogs are beloved and free to wander about by themselves, their leads trailing behind them, while their owners have coffee or buy a dress or whatever. The waiter looks with great sympathy at the dog, the dog stopped being a tourist some time ago; now everybody pities her for being stuck with us. He clears the cups as we look down at the table in silence. Once he has gone we can continue arguing in English. We don't like to speak English in public. The fact that we speak English is for some reason a terrible secret no one in Rome must ever know.

"I just think we should go and see some music sometime."

"Yeah, fine, but not bloody Vivaldi."

It was 2007, or thereabouts. It was probably ten-thirty in

the morning. The day lay wide open before us. We would be al-most fifty before we saw many more days like that one—but how were we to know that? We lived in pure possibility. The pound was strong. We were laying down memories—mainly of Italian squares—and I was filled with a kind of preemptive nostalgia. Why should we go to the basilica when we could do anything? We had no children, we were two youngish writers in an Italian square, we might walk perfectly unencumbered through the city from square to square, never worrying about bottles of milk or the location of changing tables, as contented under an Italian sky as Keats ever was, more so, as we were both entirely free of tubercu-losis. The dog was no handicap, we could take her anywhere, into churches, butchers, the post office, restaurants. We were free! In memory, freedom is obvious. In the present moment it's harder to appreciate or recognize as a form of responsibility. Anyway, with my freedom I did very little, almost nothing. You, at least, read the financial news (and were consequently less surprised by what followed). I only walked from square to square, often mopey, even a little bored, oblivious, waiting for something to happen.

NOW WE MOVE ACROSS TOWN, FARTHER WEST. THERE GOES THE usual Vivaldi flyer, unpeeling itself from whichever basilica, blowing through the cobbled streets to Campo de' Fiori, and end-ing up, I was intending to write, "slicked to the hem of Giordano Bruno's cloak," but Google Images says I am a liar, or a tourist with an indifferent memory: Bruno stands on a plinth at least twelve feet in the air. I peel it off the base, then, while you read the inscription.

" 'To Bruno' "—you are translating—" *'the century he predict-ed. Here is where the fire burned.'* Here," you add, "and over there." You point to the square where we used to live, a few streets away, before I burned it down.

"But I survived my fire."

"Well, to be fair, you weren't tied to a stake."

"Giordano got lucky! I've got problems Giordano never had!"

"Of course."

"Like what to do with the rest of my life."

"Right, because Giordano had it easy compared to you. You've got *writer's block*. Whereas he was just burned at the stake for speaking truth to power."

"Listen, it was all over for him in a couple of minutes. Existential ennui lasts forever."

SOME TIME PASSED. NOW WE WERE IN VENICE, IN PIAZZA SAN Marco, the water was rising. It was during the Biennale—everyone's fancy shoes were ruined. Rain pounded on the white decks of the yachts, rain slid off the basilicas. It rained until the square itself became a giant swimming pool through which the international art crowd did wade. Cigarettes floated by, and empty bottles of Peroni, and wraps of cocaine, no doubt, and some sheik's daughter. I took off my shoes and lifted my skirts, hugely pregnant, head-wrapped: I felt I was reenacting ancient memories of a West African ancestor, heavy with child, crossing a river, except I was not seeking food or shelter or a dry place to

give birth, I was just trying to get to a party on the other side of the canal, in the empty house of a banker. His son was having the party; it seemed to be happening without the banker's knowledge. We paused beneath the colonnades. Here, the previous day, we had paid twenty-one euros for orange juice, twelve euros of which turned out to be a music surcharge: Someone nearby was playing a violin. And here, now, stood an artist, and her husband, a filmmaker, they were also seeking shelter under the arches, they were also up to their ankles in water. We were all exactly the same age. Youngish. Not so young. The day before we had visited Il Giardino delle Vergini, a natural Italian square, a piazza-shaped hillock covered with grass and fringed with flowers, to see the artist's installation, it was called *Eleven Heavy Things*. We stood behind a series of large white slabs—they looked like stone tablets—and each had a hole you could put your head through so that the inscription referred, at that moment, to you. We took turns standing on three empty plinths: *The Guilty One, The Guiltier One,* or *The Guiltiest One*. It was an Italian square and we, the people, were the statuary. I put my head through a sign that said: *What I look like when I really mean it*. I put my head through a sign that said: *What I look like when I'm lying*. Now we stood with the artist herself in the colonnade, hiding from the rain, and discussed our time of life, the question of children, the rain, and the quayside yachts that seemed bigger than I'd ever seen them, they looked like an invading force, and yet only nine months earlier, if memory served, Lehman had capsized. How could something so large go under, on the

other side of the Atlantic, without sending the slightest ripple this way? But these yachts were unperturbed. They looked like permanent installations.

The rain began to ease. We waded through San Marco and got on a vaporetto packed with art hipsters, heaving with linen tote bags. We looked back at the scene, at the square of St. Mark's, at the Tintoretto lights. Four hundred years earlier, Giordano Bruno, who had been lecturing abroad, found himself tempted back to Italy by an invitation: to teach his Art of Memory right here in Venice. But when he arrived, he was immediately betrayed, perhaps in this very square, and turned over to the Inquisition. You can find his memory techniques in a little book called *De Umbris Idearum,* in which Bruno demonstrates how to memorize anything—long lists of facts, speeches, languages, histories—by attaching to whatever subject you want to recall certain referents of personal force, which he calls "adjects." An adject is simply a strong image that comes easily to your mind. It can come from life, from literature, nature, anywhere: "Those things to make the heart pound, having the power of something wondrous, frightening, pleasant, sad; a friend, an enemy, horrible, abominable, admirable, prodigious; things hoped for or which we are suspicious of, and all things that encroach powerfully on the inner emotions—bring these to bear." Of course, Bruno was burned for more important heresies, but his memory system is especially interesting to me: heretical not only in content but also in form. For a Brunoesque memory bypasses collective official memory and ignores chronology, and it's the opposite of ritual, which is the guise memory takes on within religion. It's a radi-

cally subjective way of remembering, in which the real and the fictional, the personal and historical, can all be combined. Still, it was very foolish of Bruno to come back to Venice to talk about memory at that fraught historical moment, although you see exactly how it happened. Venice is beautiful, seductive. If someone invites you to the Biennale, for example, you can't resist it, you go for the beauty and get stuck. As we began to cross the canal, I got a glimpse of that fancy hotel the art crowd favors, the Bauer l'Hotel, just off the square, where a few nights earlier we had seen and heard a man holding up a bottle of vodka, laughing, announcing: "Twenty minutes ago this was a hundred euros—now it's two hundred!" It was the summer of 2009. It was the last days of

Rome. Except this time, as the empire fell, there remained a class of people who did not feel in any way weakened; on the contrary, they appeared emboldened, engorged, stronger than ever. Next to me sat a young man who had heard what was said; I noticed him wince. We started talking. He was genuinely young, our knees were touching; there was a strange intensity to the way we spoke, perhaps because we were from the same class and corner of London. Conversation flowed and quickly became intimate, he told me that ten years earlier, still in his teens, unhappy at school, gay, isolated, he had become obsessed with contemporary art, he had no money at all but he knew that looking at art was all he wanted to do, and he sensed he had taste, or at least "knew what he liked," and so he began attending all the degree shows, going to anything free, befriending artists, especially artists who felt as he did at the time—abject, alone, out of place—and he became devoted to them, and many of them returned his affection, they became involved in each other's lives, and in the end people began to give him pieces, and for years he never sold a single one, even when these artists became world-famous, he kept it all in his collection, hanging or installed in a tiny flat in Swiss Cottage. (Meanwhile the international contemporary art market boomed. Meanwhile a piece of contemporary art from a blue-chip gallery came to seem one of the safest investments in the world.) And when I did begin to sell some things, he said, I only ever sold to buy more, all I wanted was beauty, I just wanted beauty in my life, maybe it was all because of my older brother—he mentioned this as if it had only just occurred to him—my beloved brother, he took a single ecstasy pill and died, and yes, thinking about

it, maybe it was his death that made me want beauty so much, want it above all else, to really crave it, actually. The young man stopped talking and picked up his drink. We were drawn into the general conversation at the table, and unfortunately I didn't get to speak to him again. I've been to a few art fairs since, but that was the only real conversation about art I ever had at one.

IN PIAZZA NAVONA ON A VERY HOT DAY, WE SAT ON THE IRON barrier around a fountain, dipping the dog in the water, and watching the Guardia di Finanza chase a group of African bag sellers past one Bernini fountain, then past the fountain we sat on, which was designed by Giacomo della Porta but to which Bernini made a late, great addition. They were awfully fancy-looking, those guards: Their uniforms were closely fitted and light gray, with belts and epaulettes, and they had little gold buttons and jaunty green berets and a gold medallion *on* the beret, and you could tell that in their opinion none of this was even remotely funny. Off they went, in hot pursuit. They had sworn a holy oath to protect the brand purity of Prada and Fendi and Moschino and the rest, and defend their country's sacred right to produce overpriced leather goods in the Tuscan hills. The guards never seemed to catch up with the Africans, but the sight of their chase through the city became as familiar to us as a priest man-splaining to a group of nuns or a taxi driver swearing at a cyclist. Having no purpose, as I have mentioned above, we tended to spend our days wandering from square to square, but these Africans—they ran. And on this occasion they ran right by us, and one came so close that his big fabric sack—made

of a knotted bedsheet and filled with counterfeits—knocked my knee. I saw him look back to see what had almost upended him, and for a moment his profile came in line with the profile of Bernini's late edition, the Moor, who stands in a conch shell in the center of the fountain. It reminded me of one of those accidental acts of mirroring between art and nature of which Nabokov makes so much. The African ran on. The Moor stayed. I stayed, looking up at the Moor, admiring him. He is a Moor full of purpose, wrestling a dolphin, every muscle alert and straining. Most people who pass him think he is Neptune, understandably, because of that dolphin, but no, in fact he is a Moor, not in the literal sense of being a Berber Muslim, he is one of those decorative Negroes common in Renaissance art, and looking up at him, I had a strange feeling. I saw myself as some kind of a decorative Moor, the kind who does not need to wrestle dolphins or anything else, a Moor of leisure, a Moor who lunches, a Moor who needn't run for her livelihood through the public squares. A historically unprecedented kind of Moor. A late-capitalism Moor. A tourist Moor. The sort of Moor who enters a public square not to protest or to march (or, in an earlier age, to be hanged or sold) but simply to wander about without purpose. A Moor who has come to look at the art. A Moor who sits on the lip of a fountain and asks herself: "What, if anything, is the purpose of the artist today?" A Moor with the luxury of doing that.

IN PIAZZA SFORZA CESARINI THE PROBLEM WAS A HALOGEN bulb; it was extremely hot and built into a bookcase. Perhaps the page of a book had strayed over it, or the corner of a cush-

ion, I'll never know. I was due in New York the next morning
for a reading in Brooklyn, my bag was packed, my dog was fed,
my passport was in my back pocket, and then a friend phoned
and said, "Why not come for one last drink," and I said yes, and
thought, I'll leave the dog, no, I'll take the dog, no, I'll leave the
dog, but the dog came on heavy with the guilt trip and the sad
eyes, so at the last minute I brought the dog, and lucky for the
dog, for otherwise she'd be dead. I went out for half an hour. You
were in Washington, reading poetry aloud. You say I burned the
square down, but a person doesn't leave a halogen light on for
half an hour and expect an Italian square to burn down. And
I didn't burn the entire square, only one building, though it's
true that for two years afterward, while they rebuilt the facades,
the square effectively disappeared, to be replaced by huge sheets
painted with a trompe l'oeil—itself a sort of adject: a memory of
the square as it once had been.

I didn't see the fire until I was quite far up the stone steps.
Actually, even at the door I didn't see it, I only felt it: the heat
and the smoke. I got to the window of the communal hallway
and searched my memory for the word for fire. "*Incendio!*" I
cried. (This is something like leaning out a New York window
and screaming: "*Conflagration!*") People looked up, but nobody
moved. The dog was screaming. I opened our door to look for
what might be saved. I reached out for my laptop: burned my
fingers, dropped it. But there was no novel in there, only many
photographs of the dog. In the background I could see my
clothes were already gone, and the suitcase that had contained
them, all books and family photographs, the phone, the fridge,

all furniture, every knife, fork, and spoon. I understood at last what it means to have money. By then it was seven years since I'd had some money, but the day of the fire was the first time I understood what it had done to me. The terror at the cashpoint, the anxiety in the supermarket, the argument at the bank teller's desk, the family-five-alarm row because *someone* has left a light on, because *someone* thinks "we have shares in the electricity company"*—all of that, all of the daily battle with money, was over. When money's scarce life is a daily emergency, everything is freighted with potential loss, you feel the smallest misstep will destroy you. When there's money, it's different, even a real emergency never quite touches you, you're always shielded from risk. You are, in some sense, too big to fail. And when I looked at my life on fire, I had a thought I don't believe any person in the history of my family—going back many generations on both sides— ever could have had or ever think of having: Everything lost can be replaced. Yes, in the history of my clan, it was an unprecedented thought. And what will happen, I thought, if my future children grow up with this idea, not as a revelation but as part and parcel of their natural inheritance? What if this idea were to be embedded in them at birth, like a genetic memory, which they then passed on to their children, who passed it to their children in turn, and onward and upward, into the next century and beyond? These future descendants—what kind of people would they be? How would the world look to them? What would they choose to remember? What would they choose to forget?

*A catchphrase of my mother's and a powerful adject for me.

I grabbed the real dog and ran downstairs. Outside was a very Roman scene. Everyone had gathered to watch an *incendio* in the public square; they were having a ball. The firemen were coming but in no great hurry. The kindly waiters of Luigi's gave the dog water and tried to stop her screaming, but the dog was completely hysterical, she seemed aware of the loss of her digital archive and to be taking it personally. Finally the Vigili del Fuoco turned up in outfits almost as dashing as those of their friends in the Guardia di Finanza. They put the fire out, established that no one was dead or wounded, and when I asked what if anything was left, they shook their heads sadly: "*Tutto distrutto.*" Our first and last Italian square. Ashes. I turned to the firemen. I begged to be let in. The firemen said, "No, no, it's not safe." I begged some more. The firemen looked at each other, sighed, and said, "*Va bene.*" Only in Rome. As I climbed the stairs, I remembered a line from an old Negro spiritual: "God gave Noah the rainbow sign / No more water but the fire next time." I entered the ruins of our apartment. I inhaled enough smoke to keep me coughing for several days. And they were right, it was all gone, your things, my things, your life, my life, it was our own little financial crash, that is, until I went around the corner and found your book still sitting there, it was in the laundry loft, that dark corner where you worked—you'd had the foresight to print it all out on paper—and there it remained, on your chair (also preserved) under a picture of the Madonna, to whom, in respect of a miracle, the firemen took off their hats.

Overleaf: OBERTO GILI

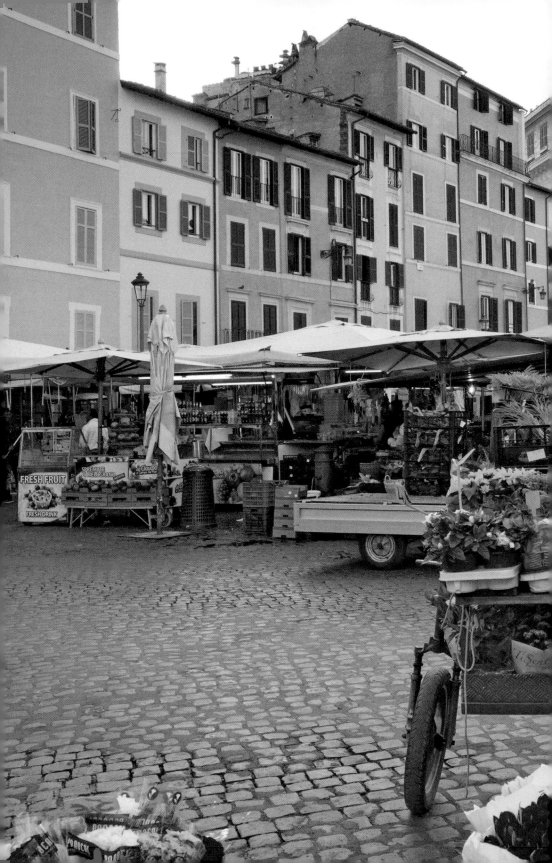

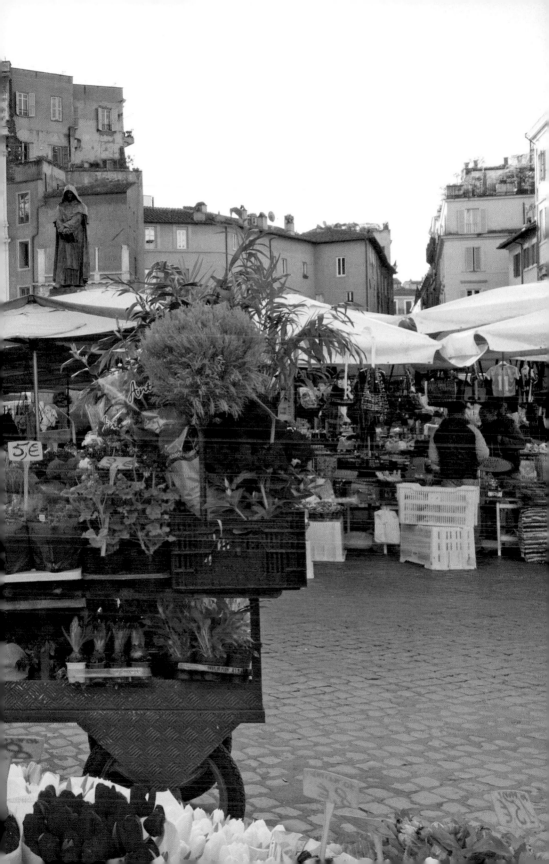

DJEMAA EL-FNAA, MARRAKECH: ENGAGING WITH COMPLEXITY AND DIVERSITY

David Adjaye

NEARLY FIFTEEN YEARS AGO, I DECIDED TO GO BACK TO AFRICA, where, due to my father's profession, I had spent my formative years crisscrossing the continent. By fourteen, I had lived in nearly every region. I wanted to return and explore it not through the lens of my parents or through any kind of formal experience like tourism, but as an adult and a practitioner with my own set of experiences and negotiations with its people. Over the course of a decade, I traveled to nearly every country on the continent, photographing the rich and regionally specific diversity that I found there. From the mosque of Djenné to the rock churches of Lalibela, I was repeatedly confronted with breathtaking and emotionally resonant designs. One of the most indelible experiences was my first visit to Djemaa el-Fnaa in Marrakech, which illustrates its significance more immediately and viscerally than any other city square I've encountered. Few places on earth offer

such a holistic sensory experience, where the scent of mint tea joins the competing sounds of mopeds and the rhythmic drumming of local musicians against a colorful palette of umbrellas from the nearby bazaar.

Located at the entrance to the old medina town, Djemaa el-Fnaa is the bustling heart of the city, an artistic, commercial, and religious hub where tourists and locals alike engage with the rich and dynamic heritage of Marrakech's distinctive culture. Upon my first visit a decade ago, I was immediately struck by the seamless dance of activity across the span of a day: local merchants selling fresh orange juice arrive at dawn, followed by garden merchants, lamp sellers, and musicians who arrive progressively throughout the day. By the afternoon, henna painters, medics, fortune-tellers, snake charmers, musicians, and storytellers enliven the square, attracting throngs of locals and tourists. The bustle of the square is punctuated by frequent calls to prayer from nearby mosques. The transition from day to night is particularly dramatic, with daytime merchants packing up and filing out in under an hour, replaced by rows of gas-lit food vendors whose charcoal-roasted kebabs or spicy harira soup send fragrant plumes of smoke into the air. Entertainers, from dancers to musicians to acrobats, lead the square to reach its busiest after dark, transforming the space into a thriving temporary village, which in turn is fully reinvented the following day.

Inherent in the square's character is a narrative about Marrakech's history within the unique context of North African urbanism. One of the goals of my travels has been to dispel Western myths surrounding Africa, those stereotypes that

tend to oversimplify the continent into singular master narratives that obscure the vast diversity of its histories and identities. The Africa I grew up with has an incredible lineage of urban design, running the gamut from near-rural villages to bustling cosmopolitan cities. Yet when I began to practice architecture, I came to discover these images are largely absent from the global architectural conversation, and the continent is misunderstood by Western practitioners. Through my work, I have focused on the relationship between modernity and indigenous culture, emphasizing the importance of geography rather than political boundaries to the DNA of African cities.

Djemaa el-Fnaa speaks to the unique character of the Maghreb region of North Africa. Due to the Mediterranean coastline, the urban character of this region is quite different from the others. These are complex cities with layers of history, both distant and recent, with a more complete architectural record of their history than most African cities. The built environments of these cities give you a palpable sense of their vast trajectory through different kingdoms and different times. Cities in this region contain some of the few examples on the continent of indigenous architecture that have survived the tide of modernity. These preserved buildings provide great insight into how, prior to our current culture of globalization, groups used local materials and original designs to respond to the specificities of their climate and geography.

In Marrakech, this indigenous lineage is most visible in the medina, whose earliest buildings date back to the Middle Ages and represent the oldest part of the city. They provide an

infrastructure for the daily life of the city, where rich and poor occupy similar houses in different quarters. Due to their historic role as centers of trade, they also offer a sense of protection, like citadels. The domestic architecture of the medina, rarely higher than three stories, turns away from the streetscape and instead orients itself around private courtyards and terraces hidden from public view. In response, the streetscape creates an experience of increasing interiority as you move farther into residential areas, with networks of narrow winding passages. This was an intentional attempt to ensure a sharp division between the private, domestic life and public, communal life. Early Islamic urbanism relied heavily on this highly segregated balance. Even as subsequent French colonization redefined the shape and structure of the city, the medina was left largely untouched and its unique logic was allowed to prevail.

Djemaa el-Fnaa is thus the complementary condition: a bustling mixed-use public space designed to bring commercial and religious function into close proximity and to serve as the nucleus of community life. This is behind the square's rich lineage of artistic expression, which can be traced back to the eleventh century, and which continues to be visible in Djemaa el-Fnaa's storytelling tradition. These orators have been greatly drowned out by the din of modernity, but they still loom large over the character of the square. They are living libraries, keepers of local knowledge and artists in their own right, who still represent the beating heart of Djemaa el-Fnaa for locals and tourists alike. Djemaa el-Fnaa is perhaps the most prominent of this type of North African urban city square, which is unique

on the continent. In most other regions, colonial powers deliberately avoided large gathering spaces to dissuade locals from assembling and protesting.

What particularly engages me about the square is how the multifunctional character allows the complexities and nuances of the urban environment to unfold. In my practice, the driving philosophy is that of responsiveness: the idea that architecture should emerge from the needs of the communities it serves. My goal is to create designs that can offer individuals a sense of ownership over their environment, that encourage people to use their surroundings, and that reduce barriers to access.

To create architecture of this nature, one must first analyze and understand how people use space according to distinctly local patterns of the everyday. Djemaa el-Fnaa is an incredible

learning opportunity in this sense. The square's identity emerges not from the architecture that surrounds it but from the individuals who occupy it, from the merchants wheeling in carts, from the flood of tourists, from performing artists who bring the heritage of their craft into the present. This is not to disregard the importance of the surroundings. In fact, it was the proposal of a glass tower block that eventually resulted in the square becoming a protected UNESCO Site of Intangible Heritage. Rather, it is to view the square as a representation of what Rahul Mehrotra calls the kinetic city: a vision of the city that is rooted not in static symbols but in the constant motion of its inhabitants, in their cultural practices and daily habits that flood various spaces and give them their character.

Djemaa el-Fnaa is the kind of heterogeneous space that comfortably houses a plurality of perspectives; it is a place where democratic thought is fundamentally possible, where diverse groups are forced to interact and engage. This is ultimately one of the core promises of the city square, and certainly one of roles that has seen huge attention in North Africa following the vital role that Tahrir Square played in the Arab Spring. During this period, the capacity of such spaces to become fully public, to facilitate idea sharing and community activism, was powerfully made visible. The recognition of this was almost certainly behind the 2011 bombing in Djemaa el-Fnaa, which seemed to be an attempt to dissuade similar upsprings of democratic action in Marrakech. The attack highlighted how crucial the square is to Marrakech's character and its discursive life: a figure of rich history whose vibrancy has come to symbolize the city as a whole.

As Djemaa el-Fnaa demonstrates, spaces that at first may appear to reflect a simple condition are much more complex when the actions of individuals and groups are factored in. These unique patterns of movement through space can and should guide the architecture we build to serve them. For space only becomes truly public when people recognize it and utilize it as such. Great public space cannot be built as much as curated; it is architecture's responsibility to craft space in response to specific needs and unique practices. As Djemaa el-Fnaa shows, it is not the space itself that is meaningful; it is the way space facilitates diversity, interaction, and new negotiations that makes it meaningful.

Overleaf: FRANCESCO LAGNESE

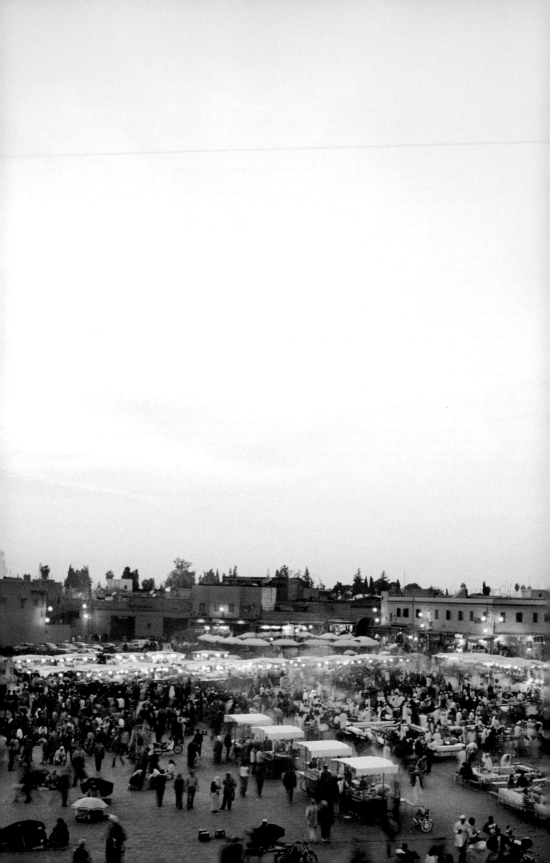

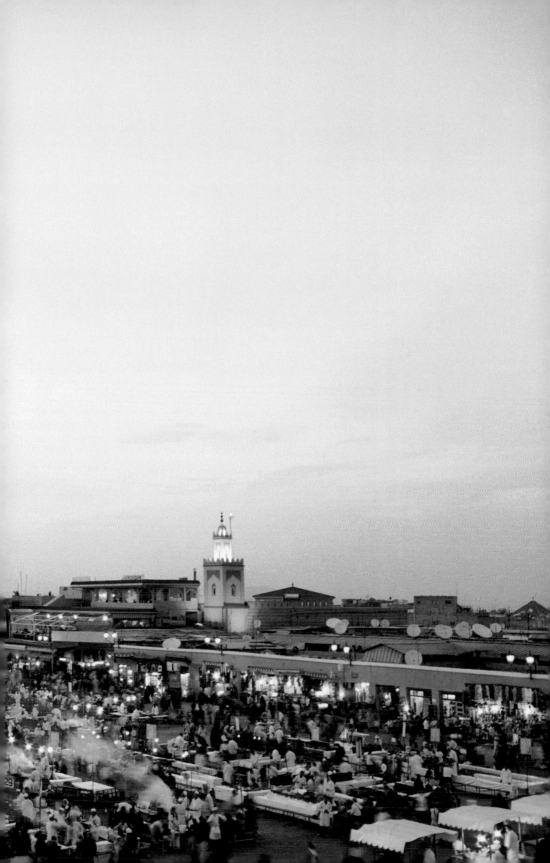

JOSEF KOUDELKA

PART TWO
GEOPOLITICS: STRENGTH IN NUMBERS

INTRODUCTION
David Remnick

WHENEVER I VISIT A GREAT FOREIGN CITY, I AM DRAWN TO ITS public squares, the scenes of ancient horse trading and market gossip, military coups and populist uprising. Even in Moscow, where I lived for years and still visit frequently, I cannot resist the pull of Red Square, the ultimate agora. Over time Red Square has been the scene of Orthodox worship; vigorous commerce in livestock, food, housewares, and books; public executions; the declarations of the tsar; political agitation; military displays; and mass protest rallies. The tourists who come from the Russian Far East, from the Caucasus, from the Polar North, can sense on Red Square a ghostly parade of Soviet history, bloody and tumultuous, drifting across the cobblestones.

Sometimes there are startling, and amusing, changes. In the 1990s, after the fall of the Soviet Union, GUM—the enormous department store and arcade that was commissioned by Catherine the Great and that faces onto the square—was

suddenly filling with Western luxury brands so expensive that wry Muscovites referred to it as "an exhibition of prices." In 2013 even the most ironical and cosmopolitan post-Soviet citizen was taken aback to arrive at the square only to find there a Louis Vuitton trunk two stories high. The square had been a kind of sacred place: For people of a certain age, it was the scene of high Sovietism, not commercialism. The gigantism of Louis Vuitton's luggage museum seemed a Western capitalist step too far. After absorbing countless messages of protest, a spokesman for Vuitton said the company had agreed to remove the trunk "so as not to upset any sensibilities."

The Kremlin and Red Square outside its walls was designed to be the center of a great political and spiritual power. Ivan the Terrible, then agents of subsequent tsars, read their decrees from Lobnoye Mesto, the Place of Skulls, a stone platform not far from St. Basil's Cathedral. On Palm Sunday, the patriarch of the Russian Orthodox Church would ride a donkey on the square as a reenactment of Calvary. A praetorian guard known as the Streltsy used to guard the Kremlin and were considered a cherished military elite—until 1698, when they staged an uprising against Peter the Great. The executions were grotesque: hangings, the roasting of flesh, the ripping apart of men with iron hooks.

After the Bolshevik Revolution, Lenin returned the capital to Moscow from Petrograd. Red Square resumed its centrality. Lenin began the Soviet tradition of military display and Communist exultation. But to get a sense of the sacral centrality of Red

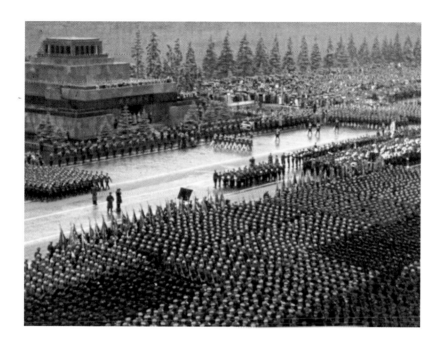

Square, dig up (on YouTube) the twenty-minute color film of the Victory Day celebration on June 24, 1945. It is a gray, drizzly summer morning. The clock on the Kremlin bell tower strikes ten; representatives from every division in the Red Army and Navy have assembled on the square. And standing on Lenin's Tomb—the salmon-colored polished granite structure known to the military and secret police as Post Number One—is Stalin. A great parade of men and hardware begins. In the thirties, Stalin ordered that the cobblestones of Red Square be made thick enough to absorb modern weaponry, and now row after row of tanks, machinery that helped crush the German army, grinds across the vast plaza. Then comes the most dramatic moment of all: Soldiers from various divisions bring various Nazi military

flags and standards toward the tomb and throw them into a heap. This was the apotheosis of Red Square as the scene of Soviet triumph.

THE SOVIET LEADERSHIP EMPLOYED RED SQUARE AS AN ARENA of awe. The few who dared to challenge the Soviet leadership saw it as an arena of confrontation. This is the case for many capital squares on earth—the square is the arena of political confrontation.

In August 1968 Soviet and Eastern bloc tanks rolled into Prague, crushing the Prague Spring, Alexander Dubček's Action Programme of political liberalization, which had brought far greater civic liberty to Czechoslovakia. Soviet troops and intelligence agents arrested and brought the Czech leadership to Moscow; the cars rumbled across Red Square and through the Kremlin gates. A new period of "normalization"—meaning full-blown state repression—returned (and would stay in place for the next nineteen years). The Soviet press instructed the population on the ideological waywardness of Dubček, accusing him of regressing to capitalism, just as it had done during similar uprisings in Berlin and Budapest.

At that time, there was no "dissident movement" in the Soviet Union, but there were tiny pockets of people, mainly in Moscow and Leningrad, who met in kitchens to talk about politics, culture, and the world beyond the Soviet Union. Aleksandr Solzhenitsyn, who had been able to publish during the post-Stalin "thaw," was working secretly on *The Gulag Archipelago*. In June 1968 the physicist Andrei Sakharov wrote what would

become his most famous essay, "Peace, Co-existence, and Intellectual Freedom." And Natalya Gorbanevskaya, a poet well known among Moscow and Leningrad intellectuals, went about conceiving something audacious.

On August 25, 1968, Gorbanevskaya (with her three-month-old son in tow) arrived at Lobnoye Mesto, on Red Square, at noon with seven others, including Viktor Fainberg, a philologist who had spent a year in prison in the 1950s because he fought back against an anti-Semitic attack; Larisa Bogoraz, a linguist who was married at the time to the jailed dissident writer Yuli Daniel; and Pavel Litvinov, the grandson of Maxim Litvinov, who had been Stalin's first People's Commissar for Foreign Affairs. Very calmly, the group sat down on the stone platform where Ivan the Terrible once spoke, and they unfurled a series of signs: "Hands off Czechoslovakia!" "Shame on the Occupiers!" "For Your Freedom and Ours."

After just a couple of minutes, agents of the KGB arrived on the scene.

One officer belted Fainberg mightily, knocking out his front teeth. A van pulled up to the scene, and the officers hauled the protesters away. Some were sentenced to labor camps, some to internal exile. Presumably because Gorbanevskaya had an infant, the authorities waited a year before arresting and punishing her. In April 1970 she was (falsely, absurdly) declared a "chronic schizophrenic" and thrown into psychiatric prison, first in Moscow, then in Kazan, and given a debilitating course of drug "treatments." She was released after two years. (In 1975 she emigrated to Paris.) But something had been achieved.

As Gorbanevskaya told the dissident journal *The Chronicle of Current Events,* "We were able for a moment to break the flow of unbridled lies and cowardly silence and to show that not all citizens of our country agree with the violence that is happening in the name of the Soviet people."

In private, the Soviet authorities very coolly assessed the Red Square event—all five minutes of it—and sensed that there was behind it a growing sense of opposition to their leadership and to the regime. Yuri Andropov, then the head of the KGB, went before the Party's Central Committee to report on this relatively amorphous-seeming phenomenon of dissidence: "They do not have a definite program or charter, as in a formally organized political opposition, but they are all of the common opinion that our society is not developing normally."

The men and women who came to Red Square to protest against the invasion of Czechoslovakia went barely noticed by the vast majority of the population, and yet they provided inspiration to Czech democrats, including Vaclav Havel, who heard about them through underground channels. "For the citizens of Czechoslovakia," Havel said, the demonstrators who came to Red Square out of a civic sense of duty represented "the conscience of the Soviet Union."

Mikhail Gorbachev, the future (and last) leader of the Soviet Union, was a young man in 1968, but he had Czech friends who had believed in Dubček and Russian friends who very privately expressed dismay at the regime even as they climbed the Party ladder. In 1987 Gorbachev was asked the difference between Prague Spring and perestroika. "Nineteen years," he said.

———

IT HAS BECOME COMMONPLACE TO ASK WHY DICTATORS AROUND the world simply don't replace their city squares with skyscrapers, or barbed wire, or garbage dumps—anything to dissuade the restive masses from assembling and voicing their demands. Does Hosni Mubarak regret not having run a highway through Tahrir Square? How long before Recep Tayyip Erdogan builds the Taksim Mall in Istanbul? Even in a democracy, you wonder if leaders don't sometimes regret their own city squares. Isn't it possible that, during the Occupy Wall Street demonstrations, the mayor might have wished he'd built an arts center in Zuccotti Park?

The central square, once the locus of power, of military display and political parades, is a constant point of anxiety. Tiananmen Square in Beijing. Independence Square in Kiev. Freedom Square in Tbilisi. Ala-Too Square in Bishkek. Azadi Square in Tehran. Dignity Square in Daara, Syria. Pearl Square in Manama, Bahrain. In every one of these places, and in many more, there have been major upheavals, set pieces of political drama.

In 1989 my wife, Esther Fein, and I were working in Moscow as newspaper reporters, she for *The New York Times* and I for *The Washington Post*. (We had done plenty of reporting from Red Square; Revolution Square, in Leningrad; and various central squares around the Soviet Union, particularly in the Baltic capitals: Tallinn, Riga, and Vilnius.) We arranged to meet some friends in Prague for Thanksgiving; they were coming from Germany, where they had just covered the epochal breach in the Berlin Wall and the onset of revolutions everywhere.

The night before we arrived, there had been a demonstration on Wenceslas Square, largely students. Riot police had cleared the square, and the rumor was that someone had been killed in the melee. Wenceslas Square had been the scene of tragedy before. In January 1969 two students, Jan Palach and Jan Zajíc, burned themselves to death to protest the Soviet repression of the Prague Spring. Now the square was filled with students handing out leaflets, arranging demonstrations and teach-ins. Day after day there were demonstrations on the square, and the Czech Communists, lacking any commitment of support from Moscow, and seeing what had already taken place in Germany and Poland, began issuing concessions.

But it was too late. Soon Havel, accompanied by the once-fallen leader, Alexander Dubček, spoke from a high window above the square and vowed to bring freedom to Czechoslovakia. Down below, the people shook their keys and shouted, "Havel to the Castle!" as if this were the musical-comedy version of Kafka. A dissident playwright, a former political prisoner . . . to the Castle! And, of course, that is precisely where he went, via democratic election.

In my experience, the drama on Wenceslas Square was one of the very few set pieces that led, more or less, where one might have wished. A kind of historical enchantment. Havel went from being a dissident to running the nation, and as president, he never lost his sense of moral direction, his modesty, his sense of the absurd. Yes, the set piece on Wenceslas Square ended well and stayed—at least for now—on a desirable path.

"What happened in November 1989 is well known," wrote

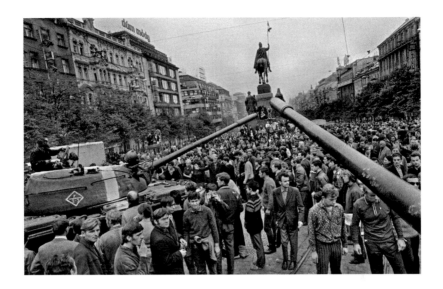

Ivan Klíma, a novelist who was a prominent player in both the Prague Spring and the events twenty years later. "Not a window was broken, not a car damaged. Many of the tens of thousands of pamphlets that flooded Prague and other cities and towns urged people to peaceful, tolerant action; not one called for violence. For those who still believe in the power of culture, the power of words, of good and of love, and their dominance over violence, who believe that neither the poet nor Archimedes, in their struggle against the man in uniform, are beaten before they begin, the Prague revolution must have been an inspiration."

NO REVOLUTION HAS A SINGLE SOURCE. THE REVOLUTION I WAS witnessing in the late 1980s and early '90s, in Moscow and beyond—the implosion of communism and the Soviet Union—had many sources: the widespread cynicism about ideology; the collapse of the economic system; cheap oil; the rise of a

technological age; dissent of various forms around the empire; the independence movements in the Baltic states and, later, Ukraine and the Caucasus; pressure from the West, including Reagan and every other president since the end of World War II; the moral suasion of the human rights campaigners; the demands of a new generation; and above all, the well-intentioned but ultimately futile attempts by the reformist wing of the Party, led by Mikhail Gorbachev, to rescue the situation.

And to see this drama play out, one could do worse than witness the set-piece dramas on Red Square. When I arrived in Moscow in 1988, May Day was in its final throes of Sovietism. On my first trip to the celebration, I saw all sorts of Party-approved reformist slogans: "*Uskorenie!*" (Acceleration!) "*Perestroika!*" (Rebuilding!) The parade was more a late-Soviet version of halftime at a bowl game than a Stalinist propaganda fest. The Party had stripped away, as much as it could afford, any sign of Cold War confrontation. There was no sense of threat or swagger.

The following year, 1989, with uprisings on the horizon throughout Eastern and Central Europe, the slogans grew even more benign and cloying: "Peace for Everyone!" "We're Trying to Renew Ourselves!" It was almost as if one would eventually find a sign, in the name of the Party, reading, "Please! Don't Be Angry with Us! We're Trying! We Really Are!" Or "Have You Noticed That We're Letting Eastern Europe Go Its Own Way?"

By May Day 1990, Red Square was ripe for upset. It was Tocqueville's insight, while writing about the French Revolution, that the most vulnerable and dangerous moment for any regime

is the moment when it liberalizes. In many of the Soviet republics and in some Russian cities, May Day had been canceled. The central authorities decided to go ahead, but with concessions. In the weeks before the event, the head of the Moscow Communist Party organization announced that factory workers could march or take the day off, their choice. Very relaxed. The Party leadership also allowed various opposition organizations, including Democratic Platform and Memorial, to join in the festivities so long as they did not carry any seditious banners.

My colleagues assembled on the reviewing stand. It was, by Moscow standards, a fine spring day. There was minimal traditional agitprop. One of the first sounds to come blaring out of the loudspeakers was Pete Seeger crooning "we'll see that day come round," from "One Man's Hands." The members of the Party politburo, in addition to well-known liberals like Gavriil Popov, the economist-turned-Moscow-mayor, took their places atop Lenin's Mausoleum to review the parade. (Boris Yeltsin told me how Gorbachev handed out the assignments on where everyone should stand; at the luncheon afterward, people sat at the table according to their rank.)

The first hour was uneventful, benign, like the previous year. Gorbachev alternated between a pleasant smile and a studious boredom; he had been to so many of these parades before. In fact, some of the early signs carried by factory workers— "Enough Experiments," "A Market Economy Is Just Power to the Plutocracy"—seemed to indicate a conservative anxiety about the future of economic reform. (A well-founded anxiety, as it

turned out. The post-Communist plutocracy and the way they lived would make the privileges accorded to the Party elite look trivial by comparison.)

But somehow the tenor of the parade, and the marchers themselves, changed suddenly, unaccountably, the way the temperature of the ocean can change suddenly as you swim from one depth to the next. Now there were flags from Estonia, Lithuania, and Latvia—a clear and impudent display of support for the independence of the Baltic states. Then we saw the old red, white, and blue Russian tricolor. Was this the first time anyone had seen such a flag on the square since Nicholas II?

Now came the more daring banners: "Socialism? No Thanks." "Marxism-Leninism Is on the Rubbish Heap of History!" "Seventy-two Years on the Road to Nowhere." "Ceauşescus of the Politburo: Out of Your Armchairs and into Prison!" There were portraits and tributes to Boris Yeltsin and Andrei Sakharov. And perhaps most terrifying of all to the members of the Party leadership, red Soviet flags with the yellow hammer and sickle cut out—an echo of what had been seen in places like Bucharest, where the Party leadership met a bloody end. Gorbachev never betrayed any emotion, no outrage or even surprise. He did not flinch even when a Russian Orthodox priest stood in front of the mausoleum, hoisted a huge crucifix and bellowed, "Mikhail Sergeyevich, Christ has risen!"

Yegor Ligachev, Gorbachev's conservative rival in the ruling politburo, writes in his memoirs that the alternative groups on Red Square were "crazies."

After about twenty minutes of this, when the anti-Kremlin slogans could no longer be ignored or absorbed by the politburo as the harmless outpouring of democratic faith, Gorbachev turned to Ligachev and said, "Yegor, I see it's time to put an end to this. Let's go."

"Yes, it's time."

Later, after they had descended from the mausoleum and left Red Square, Ligachev, in front of other politburo members, scolded Gorbachev, telling him that such events were "confusing the country." Ligachev did not get a positive reply. Gorbachev, he writes, "waved off my warning and reproached me for harping on the same old thing."

There would not be a May Day demonstration on Red Square for over a decade. There were, however, other sorts of demonstrations. In 1991 fourteen members of a performance group calling itself ETI, or Expropriation of the Territory of Art, lay down on the cobblestones in front of Lenin's tomb and spelled out the word "khui" (cock). These artist-provocateurs were, as the Russian slang goes, "giving the cock" to Soviet power. Which is immensely more obscene to the Russian ear than a raised middle finger.

REVOLUTIONS DO NOT END WITH THE RALLY AT THE SQUARE. IT is not even clear that revolutions end.

One of the most remarkable things about Jehane Noujaim's documentary *The Square* is the way that it refuses to hand itself over to romanticism—the legitimately thrilling outpouring

105

of liberating emotion and the momentary sense of triumph—
that surrounded the events of 2011. By staying on the scene
month after month, year after year, Noujaim and her team por-
tray not only the heroism of the demonstrations but also their
complexity, their contradictions, and the forces arrayed against
the goals of pluralism and democratic practice. History is not
played out solely on the square. The institutions of power are too
often impregnable. And even if the focus of protest falls—Hosni
Mubarak, in this case—that is hardly proof that the institutions
he represents will shrivel and disappear.

The early huge demonstrations on Tahrir Square were
both shocking and exhilarating. They were demonstrations of
will. But Wenceslas Square, and then the long and transforma-
tive presidency of Vaclav Havel, is the rarity, the exception. The
Czech historical experience was such that it had relatively recent
historical memory of democratic practice and a market econo-
my. They suffered terribly for a half century under Soviet rule,
but that history was a kind of resource—a political, economic,
and spiritual resource lacking in so many other places. Similar
set-piece dramas on squares in Beijing, Tripoli, Bishkek, Ma-
nama, Yangon, and so many other capitals have met with re-
sistance, blood, counterrevolution, and deepened repression,
not least to make sure that no movement comes to the square
again.

Sometimes a regime even moves the square. In 2005 the
military junta in Burma moved the capital to the inland city
of Naypyidaw. Sometimes a regime makes sure that its pub-
lic space is reserved solely for the display of its own power: In

Riyadh, Deera Square is known (to those who dare) as "Chop Chop Square" because it is used, most notoriously, for the executions of murderers and adulterers, to say nothing of people deemed to be practicing witchcraft.

But just because demonstrations on the square—in public space—do not lead, in most instances, to the swift democratic election of a wise and gentle philosopher king (or queen), the sheer act of congregation surely has lasting effect. Egypt today is back in the hands of an authoritarian regime, led by General Abdel Fattah el-Sisi, that is, arguably, worse than that of Mubarak. But Egyptians are not likely to forget Tahrir and their brief period of empowerment. As has been said, democracy is not a one-day event, a sudden uprising of popular will commemorated with subsequent annual parades; democracy is a process, an evolution.

THE DREAMY NARRATIVE OF WENCESLAS SQUARE DID NOT COME to Red Square, nor to Tiananmen or Tahrir or so many others. And to anyone who watched the May Day outpouring in 1990, or the resistance to the August 1991 coup, Putin's Russia must feel like a profound disappointment. Russian history, which spans a thousand years of autocracy and totalitarianism, could not be overcome quite so easily. The pursuit of both democratic politics and a free market in the 1990s was so chaotic, so untethered from a legal structure, so riddled by greed and corruption, that Russians came to scoff at the word *demokratia* and use the derisive *dermokratiya* ("shit-ocracy"). Putinism is the nationalist-authoritarian reaction to those years.

But even while the regime is said to be enormously popu-
lar (thanks in large part to the state's grip on television and, in-
creasingly, the Internet), the urge toward the public square does
not fade. In January 2012, as an anti-Kremlin, anti-corruption
movement was brewing in Moscow, eight members of the
radical-feminist anti-Putin collective known as Pussy Riot, wear-
ing identity-concealing balaclavas, climbed Lobnoye Mesto,
chanted, "Putin is scared shitless," and began singing their song
"Raze the Pavement!" Before the authorities could drag them
from the stone podium and arrest them, they sang:

> Free, free, free the pavement!
> Egyptian air is good for the lungs,
> Turn Red Square into Tahrir!
> Have a great day among strong women,
> Tahrir, Tahrir, Tahrir, Tripoli!

After pulling off another protest action, this time in the
city's largest cathedral, the seat of the Russian Orthodox Church,
two members of Pussy Riot—Nadia Tolokonnikova and Maria
Alyokhina—were arrested, endured a modern show trial, and
were sentenced to a prison camp. Before they were sent to jail,
Tolokonnikova delivered a closing statement that echoed the
spirit of the men and women who first went onto the square
forty-four years before, in August 1968.

"I don't consider that we've been defeated. Just as the dis-
sidents weren't defeated. When they disappeared into psychiat-
ric hospitals and prisons, they passed judgment on the country,"

she said. "Don't twist and distort everything we say. Let us enter into dialogue and contact with the country, which is ours, too, not just Putin's and the patriarch's. Like Solzhenitsyn, I believe that in the end, words will shatter concrete."

The members of Pussy Riot were young, and they had the daring of youth. They took their acts of protests to the very center of Russian power: Red Square and the altar of the most famous Orthodox cathedral in the country. As Tatiana Volkova, an art curator and activist, writes, "The center of power is inaccessible." Until Pussy Riot dared to ascend Lobnoye Mesto, the protests had been held across the Moscow River on another square, Bolotnaya Square (or Swampy Square). Any attempts to cross the Great Stone Bridge and march toward Red Square were prevented.

While the duo from Pussy Riot languished in prison camps, Putin, who had returned to the Kremlin for a third term as president, cracked down on all dissent, all opposition media, on any institution or individual who dared to question his judgment or the structures of the state. He crushed the popular movement that Pussy Riot had come out of, and he even followed the Chinese example in cracking down on social media. Russia is now an immensely more isolated and oppressive place.

The battle over society—its direction, its temper, its organization, its character—is often played out on the square. But the battle rarely ends; it does not easily resolve.

Overleaf: OBERTO GILI

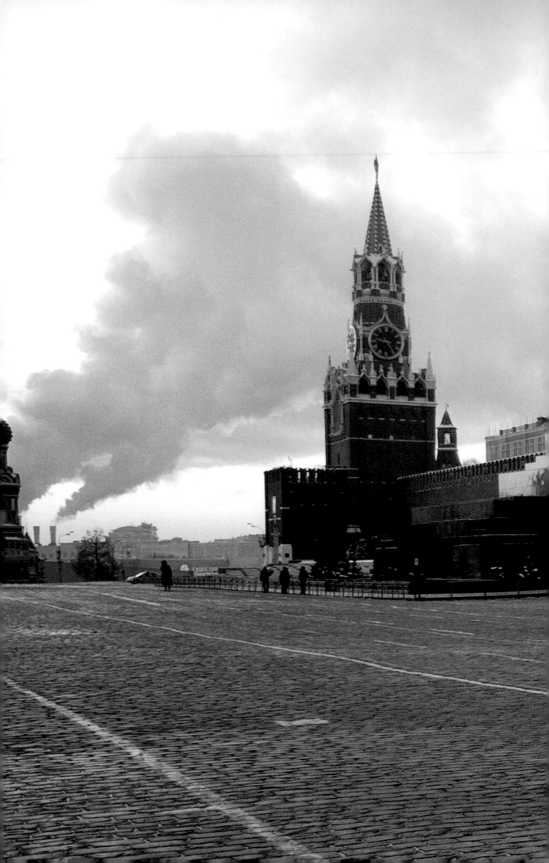

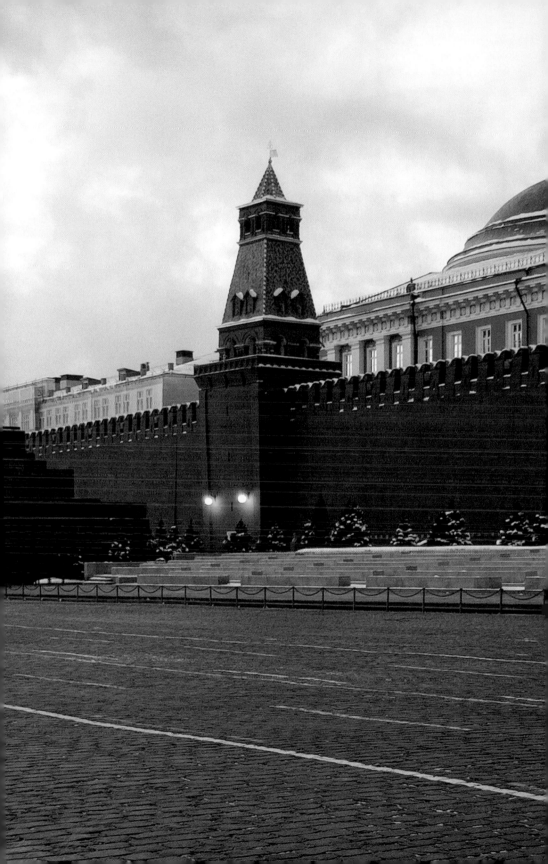

TAHRIR SQUARE, CAIRO: LOST AND FOUND IN THE SQUARE

Jehane Noujaim

JANUARY 2011

Four A.M., my parents' house. I had just arrived home in Cairo from London. The Idan, the call to prayer, was about to sound. The streets were empty. Early morning is my favorite time in Cairo; it is still quiet and peaceful. No sign of the deluge and chaos, the current of humanity that gives the city so much of its character. In a few hours, the honking would begin. I wanted to make my way to Tahrir Square while the world was still sleeping. It was less than ten minutes from my house.

It had been a long night. My Austrian Airlines flight landed at the Cairo airport at seven P.M. The airplane was nearly empty. When I arrived, the airport was also deserted, except for the journalists flocking to Egypt to cover the story of the Arab Spring. We made for an uneasy crowd, standing around the conveyor belt as if in purgatory. The exit signs mocked us. They knew that no one could leave the airport without their cameras.

The conveyor belt was not moving. And there was no telling for how long. Its utter indifference felt like a terrible joke, an affront to all that was happening outside.

Finally, the beast belched. It started to disgorge our cameras, wrapped in their muscular body bags, a cortege of silver and black cases, a tangled mass, one barely distinguishable from the next. Except, of course, for our name tags. I grabbed my cameras and felt the distance between me and the square finally close.

We followed the exit signs. Only to come to a stop at customs.

One by one, the journalists in front of me had their equipment confiscated by the customs agents. It is all a matter of definition. One minute the camera is yours. You are a filmmaker. The next it is theirs. It is contraband. And you are a suspect.

My bag was opened. My camera joined the large pile being hauled away. They missed my Canon 5D in the smaller bag. Outside, my friend Youssef, whom I have known for a lifetime, was waiting to take me home. His warm smile betrayed the unease he felt with my decision to come home in the midst of all the unrest. Our car was stopped at a checkpoint about twenty minutes in. It was the first time I had ever seen army tanks on the streets of Cairo. An undercover officer directed a search of the car. He asked for my passport. I made the mistake of handing over both my American and Egyptian passports. This began the questioning: Which one do you think you are? You cannot be both.

They started searching the car. Rummaging through my bags, they found DVDs of my old film, *Egypt, We're Watching You.* Not the best film title to be found by military intelligence as the country erupted. They wanted me for further questioning. We were forced to follow a police car. It came to a stop at a large nondescript government building. Inside I watched dozens of blind-

folded people being led into a room. I was terrified. Then it was my turn. There were two interrogators in plainclothes. No badges. They asked if I had ever made a film in Egypt. I denied everything. I denied ever having made a film that had to do with protests.

I excused myself to go to the bathroom. I broke the DVDs into pieces and shoved them down the toilet, a hole in the cement floor. The plastic edge of the DVDs cut my hands. I went back into the interrogation room, contraband-free. Relieved. Five minutes later, the janitor entered the room. We all looked up. The snitch was holding the broken pieces of DVD high in the air for the interrogators to see. The evidence and sentence wrapped in one.

At a certain point, you stop making excuses. I began to tell the truth without thought of the consequences. And with that came a sense of freedom. "Look," I said, "I made a film that I'm proud of. It was about three incredible Egyptian women fighting for change. They loved their country, just as you love your country, just as the people in the streets love their country. Please watch it. There are more DVDs in the car." With the refusal to lie, the refusal to hide, came strength. Perhaps at that moment, I felt a small piece of what the people who went down to the square felt. I knew the price I had to pay to buy my freedom, and I had paid for it. With my dignity. I had not just shattered and buried a DVD in that toilet. It was the janitor who had saved me. He had detected the lie. And retrieved the evidence. I had a second chance. I could reclaim what was mine.

A few more hours of questioning, and I was let go.

Once I was at home, I lay down in bed and closed my eyes,

breathing in the familiar smell of my childhood bedroom, stealing five minutes of peace before heading down to the street.

Six A.M., the square. The entrance to the square (or Al Midan, as Egyptians call it) was flanked by rows of people clapping and welcoming newcomers in, chanting, "Hold your head up high, you are Egyptian!" I felt as if I had just completed a marathon. I felt Egyptian, and it had nothing to do with my passport. It had to do with the pride I felt coursing through my heart. I walked through the welcoming chorus. I had never seen such large numbers of people sitting, talking, sleeping, setting up tents as if staking new ground in a promised land, summoning a new Egypt back into the world. It was a ragtag affair, a sea of tents, a huddle in a square, at once utterly fragile and yet ready to brave any gust, weather any storm. The place crackled with spontaneity, with improvisation, and yet the very idea of a tent hinted, if not of permanence, then of endurance, of stitching the hours together, of stretching the day into the night, the night into the day. A camp was sprouting out of the square.

People were sitting in the square by the thousands, dreaming about a new future, refusing to leave. And not just in Egypt. For my Iranian friend Amir, a filmmaker and writer, as for me, there is a universal language of protest, a body language, neither Persian nor Arabic, that dignifies the protests in all our squares. It comes down to the act of sitting: There is such power to sitting. As a destination and a place. But also as protest. As in refusing to move. So many and so much converged in the square.

Sitting was not the only form of protest. People were

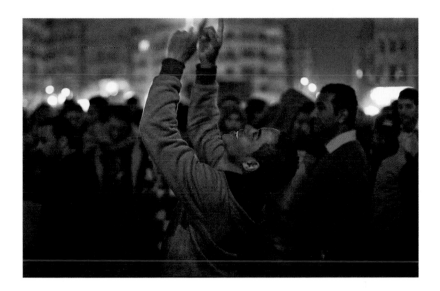

transforming the square into a living canvas—the revolution has its own body language, an emerging hieroglyphic built around new figures, movements, symbols, dreams, and desires. I saw people in the square—people who, days before, felt like absolutely nothing was within their reach—suddenly realize that everything might be possible. There was expression everywhere: I walked by clotheslines stretching across the square where people had pinned cartoons, essays, thoughts, visions for the future. Egypt was no longer a series of ancient scripts wrapped around coffins and confined in tombs. It was an open book. Expression prevailed.

I met a kid named Ahmed. He was in his early twenties, with kind brown eyes and a contagious laugh. He was standing outside his tent, instructing a group of men of all ages on how to pat people down to ensure that no weapons would enter the square, and where they would stand at the five entrances.

He was full of energy and optimism. We sat down and started talking. There was such light in his eyes. I saw the purpose that this movement had given him. He projected a dignity and faith in the future. It was true that he had been handed a restricted script for his life. But he now identified with the worldwide revolution gathering strength around him. In the square, Egypt belonged to him. He felt a responsibility for its future. The country lived through him, spoke through him, breathed through him. He carried its despair, its burdens, its hopes, and its desires. In the square, Ahmad counted. His story mattered. His presence shaped history.

Little did I know then that Ahmed would become a dear friend and the main character in the film I would make, *The Square or Al Midan.* That in a matter of months, he would learn to use the camera himself. And with the camera, he would amplify his voice and reflect his dreams.

Seven A.M. I met Buthayna, a person with whom I had spent days and nights making my film about the protest movement in 2006. Buthayna greeted me with a gigantic hug and said she would give me a tour of the square—a world that had been created in just a few days. There seemed to be a collapse of the class, gender, and sectarian divisions that had long splintered Egypt. Individuals were stepping forward, pooling their skills, and offering whatever they could, whether it be medical services, food, removal of waste. There was a social bond between people, a feeling of equality and solidarity.

We passed a medical area where a makeshift hospital was

set up. A doctor was shaving and rebandaging the head wound of a young man. He winced and then smiled up at us as we passed by. Every so often a group of men would circle the Midan, running to keep fit and warm and chanting, "Bread, freedom, social justice!" You could see their breath in the cold air. And as morning was breaking, the lumps of people and their blankets were starting to move. I took out my camera to film. Buthayna took me to the lost and found. An old man pulled out a big old faded blue sack and dumped out wallets and keys and money and phones. "This is the lost and found," he said, "if people find anything dropped in the square, they bring it here." The bundles of money and the variety of phones spread out on the table— knowing that many of these items cost at least a couple months' salary—evidenced the respect for fellow humans. In the Square, thanks to this man, what was lost could be found. We moved on, but the blue lost-and-found bag stayed with me. It said it all.

As a filmmaker, I knew that I had to film this vision of Egypt so that it was preserved somehow, even if it, too, might soon be lost. It was not just phones and wallets that could be lost. Everything before us—a moment in history—could be lost. My camera was no different from the old man's bag. I had no idea what I would end up collecting, but I had no doubt that it was a trust. Whatever we collected was created by, belonged to, and had to be returned to the people in the square.

The square is actually not a square—it's a circle. And until January 2011 it was primarily a traffic roundabout to many Egyptians. Strategically and architecturally, it was an important roundabout. On one side was the Mogamma government building,

which was where you had to go if you wanted any kind of paper-work filed or ID issued. The irony was not lost on the protesters, who were transforming the square into a place for issuing Egypt a new identity. On the other side was the Egyptian museum, also ironic because Egypt's history was now moving out of the muse-um and into the square. Flanking the other sides were the Amer-ican University and one of the main bridges of Cairo. Blocking the square meant interrupting government paperwork, stopping tourism, and blocking travel from one point of Cairo to another.

Tahrir Square has been the site of political struggle for free-dom for almost one hundred years. In 1919 large protests took place against the British occupation of Egypt and the Sudan. In 1946 the square was used to call for the British forces to evacuate the Nile Valley, and the protests were violently dispersed by the British occupation. In 1951 political forces united in the square to call for a militant resistance to British occupation. In 1967, when Gamal Abdel Nasser stepped down after military defeat by Israel, Egyptians took to Tahrir to demand his return. In 1972, during Sadat's time, students called for war against Israel to re-turn the occupied Sinai. In 1977 the bread riots happened in the square. Years later, in Mubarak's time, Tahrir was used to protest the occupation of Palestine, the U.S. invasion of Iraq, and the Israeli invasion of Lebanon. In 2008 demonstrations in support of workers' rights and textile workers spread across the country. In 2010 people protested the violence of security forces, ignited by the unjust arrest, torture, and killing of Khaled Saeed. The photographs of Khaled's torture were spread virally across the Internet, causing outrage in Egypt. These protests culminated

in the uprising of January 25, when security forces were beaten back and protestors overtook the square.

IT IS NOW ELEVEN A.M. ON FEBRUARY 12. I AM IN A FRIEND'S apartment overlooking the square. I have not been home in six days. Spread across the floor in sleeping bags are kids with their laptops, posting videos, tweeting what they are experiencing. The showdown with Mubarak continues. Out on the balcony, a huddle of journalists is filming. I look out on the incredible view below. It is the first time I have seen the square in its entirety. The overhead shots are being beamed to people around the world. The showdown in Tahrir is reaching its climax. Would there be more violent attacks? Was it time to evacuate the square, or would Mubarak finally step down? And if he did, what would happen next?

At around seven P.M. I decide to go home and shower and change my clothes; I plan to hurry back for Mubarak's much anticipated speech. The fate of Egypt seems to hang in the balance. I am in the shower when I hear a roar in the streets. I rush out and turn on the television. An army general on screen is saluting the protestors, commending them on their bravery. I realize that the pharaoh has stepped down. As I step into the street, all around me, people are dancing on the cars, chanting, "Hold your head up high, you are Egyptian!" The marathon is over.

NOVEMBER 2011: THE BATTLE OF MOHAMMED MAHMOUD
Seven A.M., downtown Cairo. It has been nine months since Mubarak stepped down and since I started filming. As I enter

the square with Ahmed, I pull a scarf over my nose and mouth to avoid the onslaught of tear gas. For five days a battle has raged across the square between unarmed protestors and the Central Security Forces. Thousands are injured and more than forty are dead. The square is full of empty tear-gas canisters—at least three people have died from asphyxiation. Many here know I am part American. They show me the empty canisters and point to the Pennsylvania address.

The heart of the dispute is the legitimacy of the upcoming election. Parliamentary elections are about to begin, but the blood in the streets threatens to delegitimize the elections. The Brotherhood has not joined the protestors. Even though they claim to be part of the revolutionary forces, they have disconnected from this battle. Ahmed says that they have another interest: winning Parliament. The protestors feel that the elections have been hijacked and the choices are between corrupt parties—that when the power structure no longer represents the people, the vote is no longer a tool for change. So the battle rages on. Cement walls are going up at the entrances to the square to block the protestors in. A new reality is setting in.

There were times when I was in the square along with only three or four tents. The rest of the country and media pundits could be heard saying, "Why are you still here? The country needs to move forward." But the protesters were resolute. They said they had to stay because the secret police were still in power, random arrests were still taking place, and there was no sign of transition to civilian rule. The protestors were not willing to lose the dream of Egypt that friends had died for.

A few short months earlier, I would have looked at these scattered individuals sitting in a square and questioned their sanity. How could they actually believe that their presence would effect change? But I begin to learn. When the world around us gets very dark, the determination of the human spirit will shine through the darkness, pushing on even when all seems futile. That is when you see how change could happen. A consciousness pervades the square. There is a mystique to the place that carried the memories, the nobility, and the pride of the people who stood their ground to create a new Egypt. They created a conscious space that pulled people in and made them see beyond their limits.

We often see the greatest hits of change. We see Martin Luther King, Jr., lead a march on Washington; we see Nelson Mandela freeing South Africa. But we don't see the process of change. We don't experience the agony of King's family over the years, and we don't spend twenty-seven years in prison with Mandela. In the square, I saw the quiet, determined, and relentless fight for change.

Change does not happen overnight. One speech doesn't change things. Other movements have taken a very long time. But a certain consciousness is what has been found and what will grow. The events of the square will be a reference point. They will be the lost-and-found bag. Ahmed found his camera and, like many others of his generation, found his voice in that square. That moment is not lost. The square formed, and will continue to form, the consciousness of an entire generation.

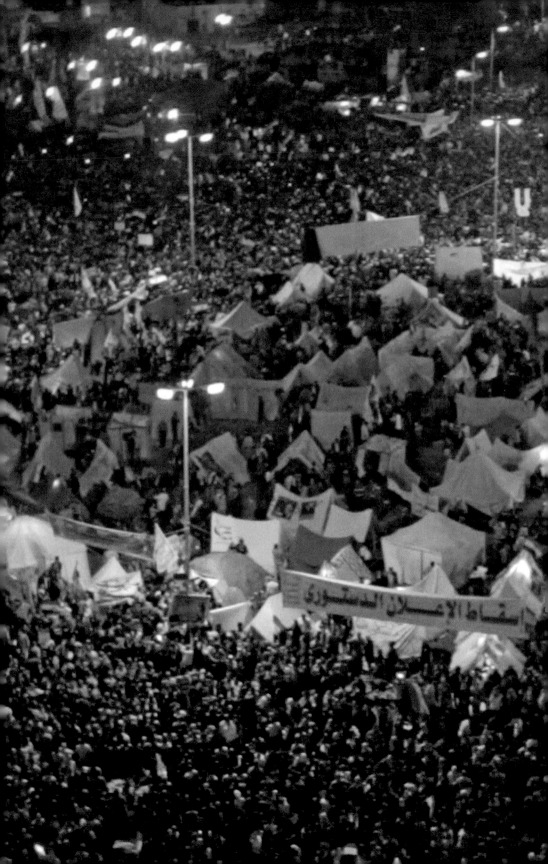

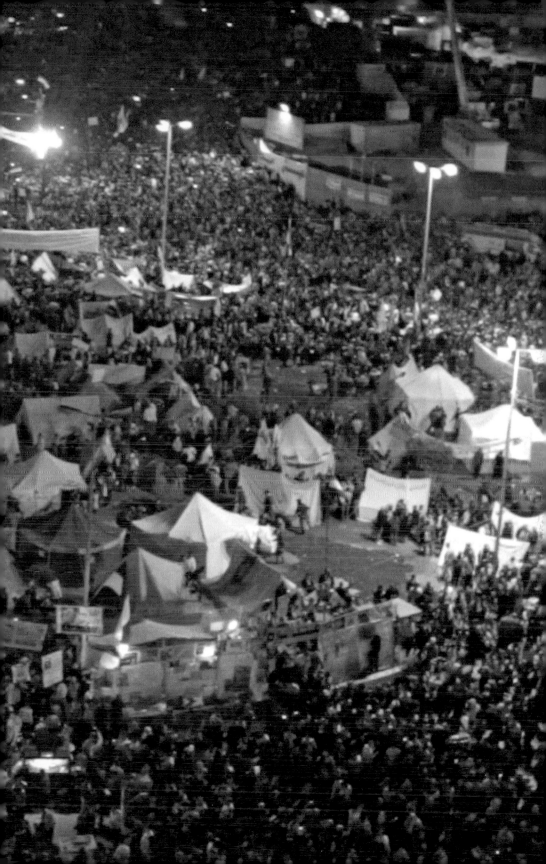

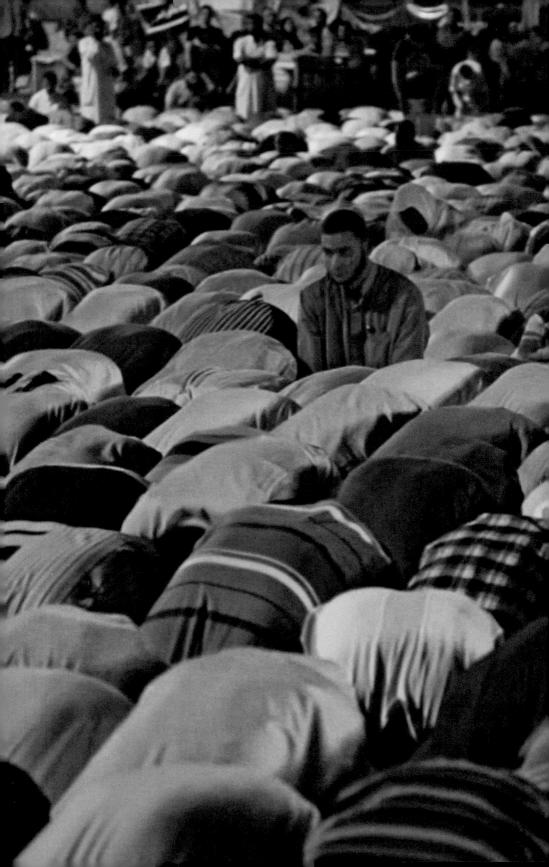

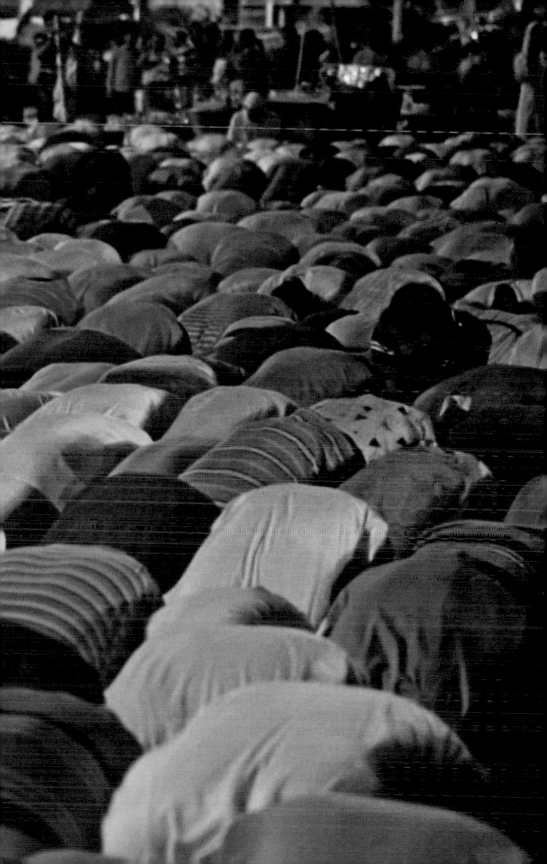

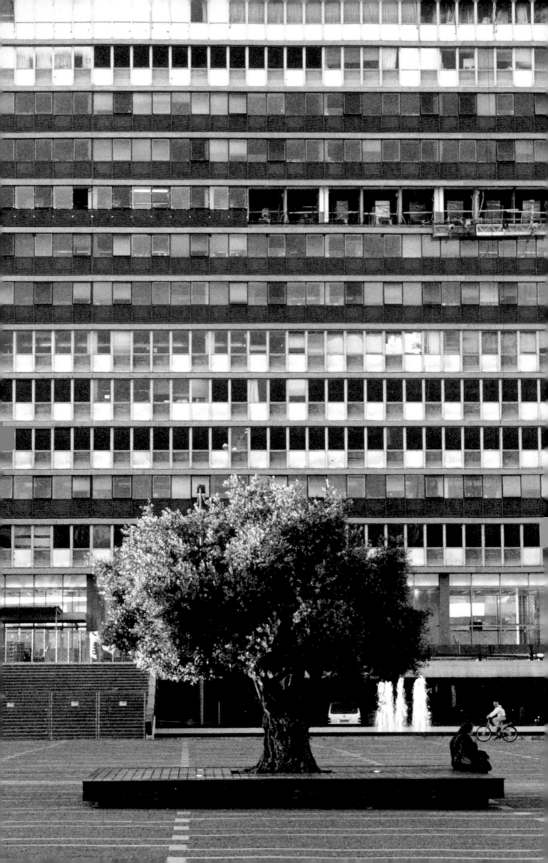

RABIN SQUARE, TEL AVIV: SO EMPTY, SO LOUD

Ari Shavit

RABIN SQUARE IS A RECTANGLE. TWO HUNDRED AND SIXTY METERS long and 160 meters wide, it is paved with dull beige tiles. It has two (rectangular) pools, a controversial memorial monument, and some scattered vegetation—but in the main, it is a vast rectangular plaza. The twelve-story building that rises to the north of the square is also rectangular: Tel Aviv's City Hall is a gray concrete and glass structure, modernist and functional. Rectangular, too, are the unadorned six-story residential blocks that enclose the square. So the agora of Tel Aviv and, to a certain extent, the agora of the state of Israel, is a collection of nondescript rectangles. It has no real architecture, makes no discernible statement, and offers neither welcome nor intimacy.

In the beginning, there was an orange grove here. In 1925 the municipality of Tel Aviv purchased the grove in order to build a hospital. But the hospital was never built, and during the Arab uprising of 1936, the Palestinian orange grove sheltered the Palestinian militants who came from the neighboring Palestinian villages to attack the young Hebrew city. When the violence subsided, the orange grove was turned into a public garden with a pool, a zoo, and an open field nearby. By the end of the 1930s this undefined area, which was then at the edge of

the city, was used from time to time for public assemblies. On October 8, 1945, an anti-British rally gathered here, numbering, it was said, more than fifty thousand people, almost 10 percent of the Jewish population. So the purpose of the land that was to become Rabin Square—the central civic space of Tel Aviv— preceded the square itself by dozens of years.

The first plan came together in 1952. Four years after the founding of the state of Israel, the young architects Avraham Yaski and Shlomo Pozner proposed an uninterrupted horizontal rectangle, abutting the as yet unbuilt vertical rectangle of City Hall. Surprisingly, after only a few years, the two expressed reservations about their plan. Yaski went so far as to call the square he had designed a work of "fascist architecture." To his mind, it was too big, too plain, and anti-urban. "The paved plaza looked to me like a parade ground that would stand empty most days of the year, nothing like a bustling square that gives pleasure to city dwellers day and night," he said in an interview some years later. But in the mid–1960s, when the moment of truth came, City Hall chose to ignore the architects' distaste for their own plan. The social-democratic mayor, Mordechai Namir, was deeply moved by a dramatic letter he had received from the nationalist poet Uri Zvi Greenberg, who opined that the civic square must be "a vast forum where the masses can gather to express their feelings in days of joy and days of sorrow."

And so it was. The square, initially named Kings of Israel Square, was opened toward 1967. Here open-air concerts were held, and military and commercial exhibitions were mounted to highlight the achievements of Zionism. In 1975 the first huge

rally—united and uniting—was held in support of the Jews of the Soviet Union.

But when the big internal debate about occupation and peace began to tear the country apart, the square took on a completely different meaning. At the height of the violent elections campaign of 1981, two rallies, unprecedented in size, of left against right and right against left, were held on consecutive days. And in 1982 a series of Peace Now demonstrations gathered in the square (against the settlements, against the Lebanon war, against Prime Minister Menachem Begin and his defense minister, Ariel Sharon), culminating with a record turnout of four hundred thousand Israelis who descended on the plaza to protest the massacre at the refugee camps Sabra and Shatila in Lebanon and to call for the government's resignation.

In 1995 a hopeful yes-to-peace-no-to-war rally ended with the assassination of Prime Minister Yitzhak Rabin. Paradoxically, the square that was meant to give an almost totalitarian expression to the unity of the Israeli people became a place that, more than anything, expresses the deep divide. While its contribution to the urban texture of Tel Aviv and to the day-to-day life of Tel Avivians is minimal, Rabin Square (renamed for the slain prime minister after his death) has become the rectangular void at the center of the constant political maelstrom that is the state of Israel.

I begin at the northwestern corner of the square. Where the Tel Aviv zoo once stood rises an opulent residential tower, built in the mid–1980s, when Israel began its metamorphosis from a semi-socialist society into a rabidly capitalistic one. Down the Kings of Israel Street, west of the plaza, upmarket and

downmarket stores thrive side by side in a socioeconomic hodge-podge that is both very Mediterranean and very Eastern European. A bar, a hair salon, another hair salon, a kiosk, a sandwich shop. A terrific bookstore. Women's fashion, motorcyclists' gear, another bar, kitchenware, luxury gifts. Buff young men bring their skinny little dogs to the veterinary clinic, while fetching young women sit at the sidewalk café, pecking diligently at their sleek laptops. Fun-loving, normalcy-seeking Tel Aviv is taking advantage of a sunny winter's day to enjoy at the edge of the square all that the square refuses to accommodate.

At the southwestern corner, Gat Cinema. In the 1960s movie lovers would flock here to escape from the harsh Israeli reality into a Hollywood fantasy. Across the street a brasserie, *the* brasserie of Tel Aviv, teems with patrons around the clock, next door to a fabulous patisserie that would not be out of place in the 7th arrondissement of Paris. And then in sharp contrast, a discount minimart, an outrageously expensive chocolaterie, a bank branch. Pandemonium. Like Israel itself: pandemonium. The unapologetic anarchy, garish and full of vitality, that Israel has become. Secular Ashkenazis, ultra-secular Russian immigrants, national-religious, tradition-bound Orientals, a few Arabs. A vivid, excitable, and wonderful tumult that verges on chaos.

At the southwestern edge of the square, Chen Boulevard: Men with dogs flirt with women with dogs. Retirees make their way to a noontime concert, students ride by on green city bikes, lovers share a stolen moment. Under the heavy ficus trees of old Tel Aviv, an almost European calm. But not far from here, the phenomenal ugliness of the residential blocks built hastily in

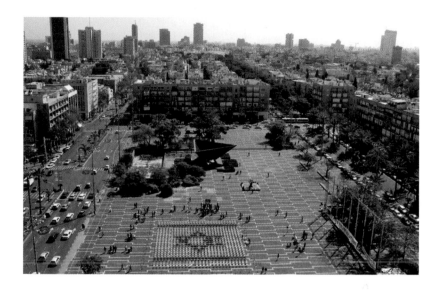

the 1940s and '50s rears its head. The view from the south of the almost empty square brings to mind the hundreds of thousands who gathered here on the evening of November 4, 1995, in the hope of saving their country: the way they raised their eyes to Yitzhak Rabin, the way they listened to him. Sang a song for peace.

I close off the rectangle by crossing the street and returning to the plaza. As I ascend the wide stairs to the terrace on which he stood, I think that our story, the Israeli story, is encapsulated in Rabin's life story. Yitzhak Rabin was born in 1922 into a socialist Tel Aviv; he grew up in the 1930s together with the utopian Hebrew community and hoped to be an agronomist and bring water to the Negev Desert. But in the 1940s he came face-to-face with the Israeli-Palestinian conflict and was recruited. At the age of twenty-six, he buried four of the soldiers in the unit he commanded—and saved Jerusalem. A few months later, he was the operations officer of the division that expelled the Arabs of

Lydda and the Negev from their homes. Against plan and against dream, he was forced to become a professional soldier and a professional officer and a man of war. At the age of forty-five, as the commander in chief of the Israel Defense Forces, he conquered Judea, Samaria, and Gaza in six days. When he reached seventy, he tried to end the conflict in which he was mired all of his adult life. Before exiting the stage, he tried to write a happy ending to the tragic circumstances of the last four decades. And the happy ending reached its zenith on that evening in this square, when those gathered here so loved him, and when he loved them back. Completely out of character—and a little out of tune—he sang the song of peace with the masses. And then he turned around and crossed the terrace. Descended the twenty-six service stairs. Took five steps. And was shot.

So for the state of Israel, Rabin Square is Washington's National Mall, Chicago's Grant Park, and Dallas's Dealey Plaza in one. Here we demonstrated, here we believed, here we lost hope.

I ascend the twenty-six gray concrete stairs and cross the terrace where the representatives of the great white hope had gathered. I stand against the balustrade where Rabin stood a moment before the end. Look out at the void of the rectangular plaza.

The architects were right. The ten and a half paved acres of the central civic square of Tel Aviv are, for the most part, ten and a half wasted acres. Between the murky blue of the rectangular pool just beneath the terrace and the murky green of the ecological pool at the far southeastern corner, there are only a few people. No cafés, no playgrounds, nothing under which to take shelter. Surrounding the rectangle, on every edge, are Tel Aviv's exuberance

and Israel's vitality, but the plaza itself is a sun-bleached urban wasteland. A place to demonstrate, not a place to build.

The irony is profound. In recent years, Israel has evolved into a society in which the individual has plenty of room, but in the country's main square, the individual has no place. Over the last generation, Israeli society has become more vibrant, diverse, and cacophonous than ever before, but the most prominent civic square of this Israeliness is a flat platform of mundane uniformity. And that's why it serves the masses rather than the individual. But even the behavior of the masses here is different than that foreseen by national and city leaders a half a century ago. Because if the politics of the masses of Kings of Israel Square was meant to express unity, the politics of the masses of Rabin Square expresses mostly division.

Whenever the prime minister of Israel leaves his home or office, the vicinity is supposed to be a sterile zone. On November 4, 1995, the area in the vicinity of Prime Minister Rabin was not a sterile zone. But Rabin Square *is* a sterile zone. It does not say anything; nor does it tell anything. It neither consoles the heart nor lifts the spirit. It is barren. So the protest rallies that gather here now and again are also, in some sense, sterile. The protestors here are not standing across from the White House or 10 Downing Street or the prime minister's residence in Jerusalem. They are not marching on the Pentagon, or surrounding Westminster, or massing at the Knesset. All they are doing is gathering at the foot of the terrace of an unimportant municipal building in a square demarcated by nondescript residential blocks. All they are doing is standing on the beige granulite tiles and

waiting for the helicopters from the evening news to document them and estimate their number and report that Rabin Square is again overflowing with protesters. Even when they come out in anguish, their anguish has no address. They do not expect to be heard. This is why they gather in a banal plaza, surrounded by banal buildings, and shout out banal exclamations against a banal political adversary whose hold on power is tenuous at best.

Of course, there have been also some heartwarming moments of jubilation here. When Ehud Barak won the election on May 17, 1999, and when Israel won the Eurovision song contest (1978, 1979), and when Maccabi Tel Aviv won its first Euroleague Basketball championship (1977). But when I stand on the City Hall terrace and look out at the open plaza, I feel forlorn. It is not only the trauma of November 4. And it is not only the knowledge that since Rabin's assassination, the center-left has not been able to raise a leader who will inherit his mantle. It is the fact that, in the end, all the square stands for is feeble, bitter protest.

The bitter protest syndrome reappeared in full force during the dramatic election campaign of 2015. In early March, an anti-Netanyahu rally that gathered here began with a semi-racist speech by a leading liberal artist who expressed an arrogant, deep-seated antipathy toward the religious beliefs and practices of traditional-Jewish Israelis. This rally outraged Likud supporters. It played into Netanyahu's hands and led to a counter-rally in the very same place. Sadly, ironically, the square named after Yitzhak Rabin played a major role in the resounding political victory of nationalist-populist Israel that now casts a long shadow over our future.

For me, despair is not an option. It is not how I was raised. But when I descend the stairs from the terrace, I think about how this place became central to our lives just as our political system became dysfunctional. The rise of Rabin Square is the direct outcome of the fall of the Knesset. Because of the center-left's inability to persuade Israeli society to adhere to liberal values, we were forced to return time and again to the square to protest atrocities. And Tel Aviv's failure to translate its free spirit into a mature sociopolitical culture means that it has only this flat plaza from which to raise its voice against the government on the mount of Jerusalem. But in the end, this kind of protest exhausts itself. After decades of demonstrations, the demonstrations die. So now the square is empty. It is neither Tel Aviv's convivial piazza nor its rhetorical base camp against occupation, against settlements, against national suicide.

The memorial monument is a memorial monument to the victims of the Holocaust. A sophisticated structure of intersecting triangles and pyramids, upright and inverted, derived from the yellow Star of David. But there is no feeling of horror under the Holocaust memorial, no feeling of awe. Young women who could not find shade in the plaza take cover under the inverted pyramid. Mothers who could not find a place to rest park their prams alongside. An elderly Russian immigrant scatters pieces of crusty bread for a flock of skittish gray doves, bereft of peace. All around is a nagging sense that the tragedy may not have a happy end. That long after the murder, this empty rectangle will remain a void.

Overleaf: MICHA BAR-AM

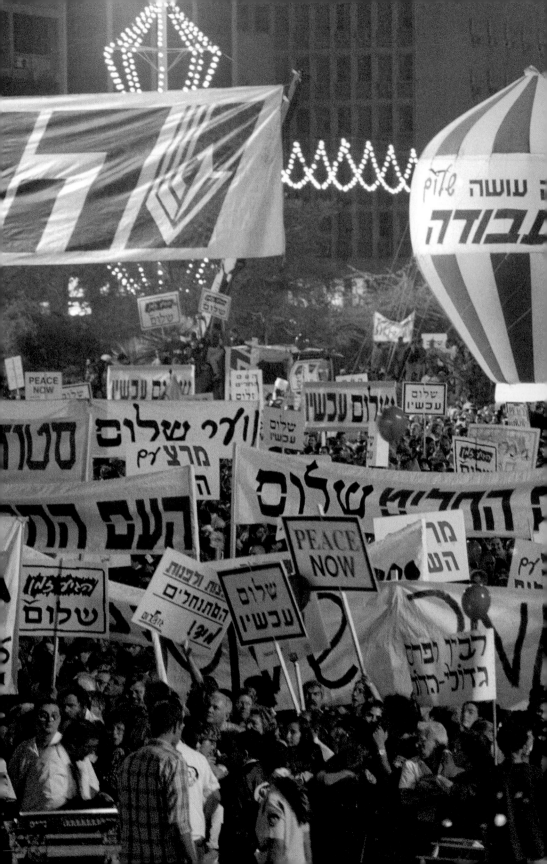

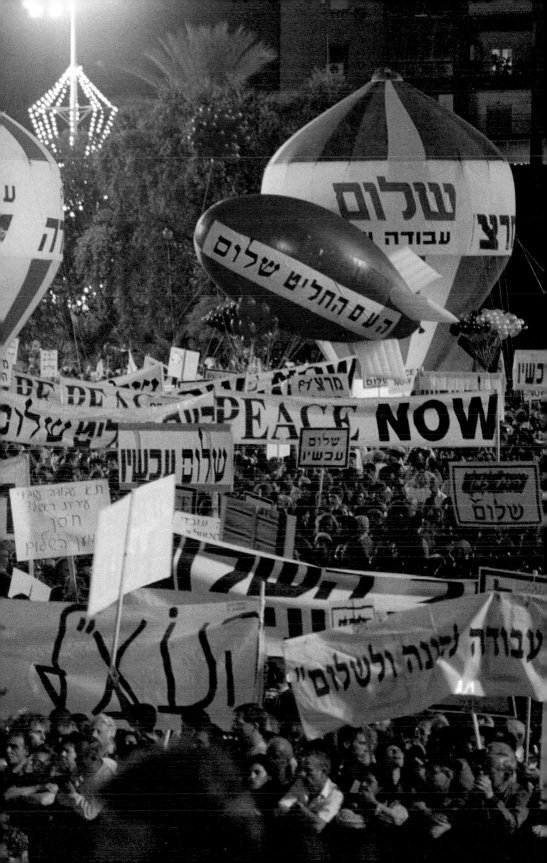

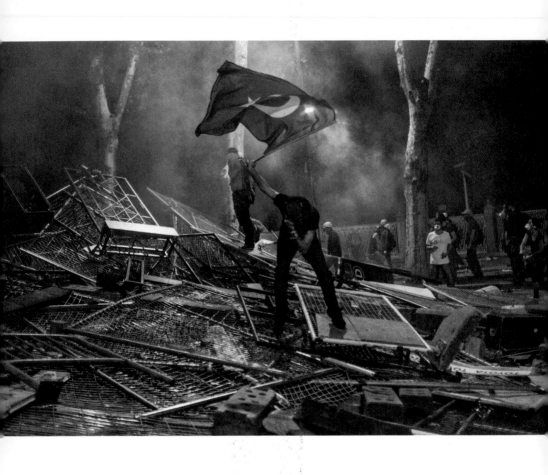

TAKSIM SQUARE, ISTANBUL: BYZANTINE, THEN AND NOW

Elif Shafak

WHEN BYZAS, THE SON OF KING NISOS, DECIDED TO BUILD A NEW city, which would be like no other, past and future, he paid a visit to the Oracle at Delphi. "Where shall I build my remarkable city?" Byzas inquired nervously. The Oracle advised him to find the site opposite the blind. Byzas asked where would that be, but the Oracle assured him that he would know the answer as soon as he saw it. All the more puzzled, Byzas set off on his journey. Upon reaching the Greek town of Chalcedon, he stopped, only then realizing what the Oracle had meant. Across from Chalcedon, on the opposite shore, there was a heavenly place, untouched and "unseen." The people of Chalcedon must have been blind not to appreciate such beauty, Byzas thought. He began to build his city there and then, and he named it Byzantium, after himself.

The world we are living in today is far more "Byzantine"

compared to the world back then. In big cities, clocks resemble octopuses with eight arms, spinning at great speed. Even so, in few places on our planet does time whirl as rapidly and uncontrollably as it does in the city I love, admire, and yet, again and again, evade: Istanbul. The city built upon the ruins of Byzantium.

Istanbul has turned into a trendy place visited by more than ten million tourists annually, a magnet for many people both in the region and beyond. Yet strangely, it remains little understood, its cultural cartography too chaotic, too confusing. It is, after all, a city of mesmerizing contrasts and details. Perhaps there is no such thing as Istanbul. There are only Istanbuls— plural, clashing, competing, somehow coexisting. Behind rusty doors, under broken cobblestones, around the saints' shrines, stories are scattered far and wide, and silences, too. Istanbul has too many tales waiting to be told. Paradoxically, Byzas's city is still, in many ways, unseen.

AS THE NUMBER AND THE SIZE OF CITIES KEEP GROWING ACROSS the world, changing conditions bring about shifts in language and vocabulary. Despite the social and linguistic complexity, however, there are only two types of cities: those where a woman can walk after dark relatively freely and those where she possibly cannot. Istanbul, my old flame, pretends to be the former but, in fact, often falls into the second category.

It is in cities like Istanbul that we are most likely to find ourselves "in the neighborhood of the Other." Yet the city square, the one place where such interaction is most likely to occur, has been dominated by male culture. In Istanbul, streets belong to

men. Public squares belong to men. Feminine energy is systematically suppressed all across the Middle East, and Turkey, though different in many ways, is no exception.

I WAS IN MY EARLY TWENTIES WHEN I DECIDED THAT THE metropolis was calling me from afar, and in order to honor that call, I should leave everything and move there. Years later, the love remains intact but is accompanied by conflicting emotions that only Istanbul can ignite in one's soul.

Istanbul is at once generous and selfish, indifferent and possessive. An old soul with teenage energy. The most crowded city in Europe, the most European city in Asia. As you cross the Bosphorus Bridge, you will see a sign at the one end: "Welcome to the Asian Continent." If you go in the opposite direction, another sign will meet your gaze: "Welcome to the European Continent." I have often thought of Istanbul as the bridge in between, theoretically connecting the two worlds but, in practice, not quite belonging in either, unwelcome anywhere.

Anyone who visits Istanbul today will notice that in several areas the city resembles a massive construction site. In the last decade it has undergone radical transformation and gentrification. Initially, many people supported the growth, happy to see the megacity attracting foreign investors and global capital. Some of its lost cosmopolitanism was also restored. Expats and migrants arrived, visitors from ex-Soviet republics, the Middle East, Central Asia, and the Balkans. An important LGBT movement flourished, organizing gay parades. The women's movement increased its strength.

But the urban growth came with new problems of infrastructure and traffic. At times I think of Istanbul as a giant Matrushka doll: You open one doll and find another lodged inside; you open that only to find another one hiding within. The smallest doll would be where the heart of the city beats frantically: Taksim Square.

In Turkish, the word "taksim"—from the Arabic original—means "distribution." In 1732 Ottoman Empire Sultan Mahmud I required a new system to distribute water to various parts of the city. To this end a stone reservoir was made in the area; it can still be observed today. In the nineteenth century, the world's third-oldest subway line (after London and New York) was opened here, connecting Galata to Pera.

Taksim Square and the areas surrounding it were traditionally the most cosmopolitan parts of Istanbul. Unlike more conservative boroughs, the area around Taksim has always been multicultural and continues to be so. It is here that different Istanbuls become most visible: Byzantine Istanbul, Levantine Istanbul, Turkish-Muslim Istanbul . . . Instead of existing side by side, solid and intact, they have melted into one another.

Taksim Square is primarily a secular space. Throughout the 1960s and '70s, Taksim hosted all the major protests, some of which ended with bloodshed. Although subsequent governments have tried to limit the symbolism of the square by not allowing protesters, deep in the subconscious of the people, Taksim is a political space as much as it is a social and cultural space.

In the middle of Taksim Square is a small park that in

2013 was thrust into global headlines: Gezi. The word has become synonymous with youth and rebellion.

It all started when the AKP government, with Prime Minister Erdogan at the helm, announced his decision to demolish the park and build a shopping mall. One way or another, politicians seemed determined to flatten one of the very few parks left in central Istanbul. When a number of people—architects, environmentalists, academics—tried to voice opposition, they were brushed aside by the government. There is no doubt that had Istanbulites been asked their opinion, the majority would have preferred to preserve the park instead of getting yet another shopping mall.

When the first bulldozers arrived on the site, a group of young environmentalists had already arrived, camping there

with their tents and guitars, determined to stand guard over the trees. At dawn, while the city was still asleep, armored police officers entered the park. The crackdown was aggressive, brutal. Unarmed environmentalists were beaten, their tents set on fire. The next morning the entire country was in a state of shock and outrage when these images of excessive force were shared on the Internet. As in Tahrir Square and in the Euromaidan, social media played a pivotal role.

In just a couple of hours, hundreds of people of all backgrounds took to the streets. Among the unexpected protesters were people from traditional backgrounds, such as clerks or housewives, who showed their support by banging pots and pans from balconies and windows.

In the early days of the protests, there was much hope and good humor on the streets. But the optimism melted fast. Police responded with tear gas and pepper spray, exerting disproportionate violence. As always, violence created more violence. While demonstrations spread to other cities across the country, new groups appeared on the streets, angry and suppressed, ready to resort to violence.

It was a time of mental chaos accompanied by a surge of paranoia. Taksim Square was unrecognizable during those early weeks. For over ten days the protesters had full control of the area, not allowing the security forces to enter. Giant posters were hung from the tallest buildings. Next to a picture of Ataturk, the founder of modern Turkey, smiled the poster of Deniz Gezmis, a leftist revolutionary who had been sentenced to death and executed, and one of Yilmaz Güney, the iconic Kurdish film director

of the 1970s. Like the posters, the people in the square were a mixed bunch. Those who would never come together under normal circumstances found themselves in the same public space, singing, dancing, breaking bread—or simit, bagels with sesame.

The protests went on for weeks. When the dust had finally settled, there were more than eight thousand wounded, three thousand arrested, and eleven dead. There remains in Turkish society, along with an undercurrent of grief, a deep sense of injustice and sorrow. Academics have lost their jobs, doctors have been questioned, journalists have been sued, and artists have been demonized for supporting the Gezi events. Since then Turkish society has never been the same. We are now badly divided into ghettoes—glass ghettoes occupied with angry people who do not talk to each other, not anymore.

WHEN THE GREAT SIXTEENTH-CENTURY OTTOMAN ARCHITECT Sinan would start building a new mosque, he would make sure both the design and the project were in harmony with the city's history and the city's spirit. Sinan was meticulous about his work. At times I cannot help but feel that had Sinan been alive today, and had he seen this untrammeled construction and chaotic gentrification in his beloved city, he would weep.

Still, Byzas's dream city is a gem. Even though the seagulls that fly above our heads are seeing a changing cityscape year by year, the beauty and resilience inherent in the city is here to stay.

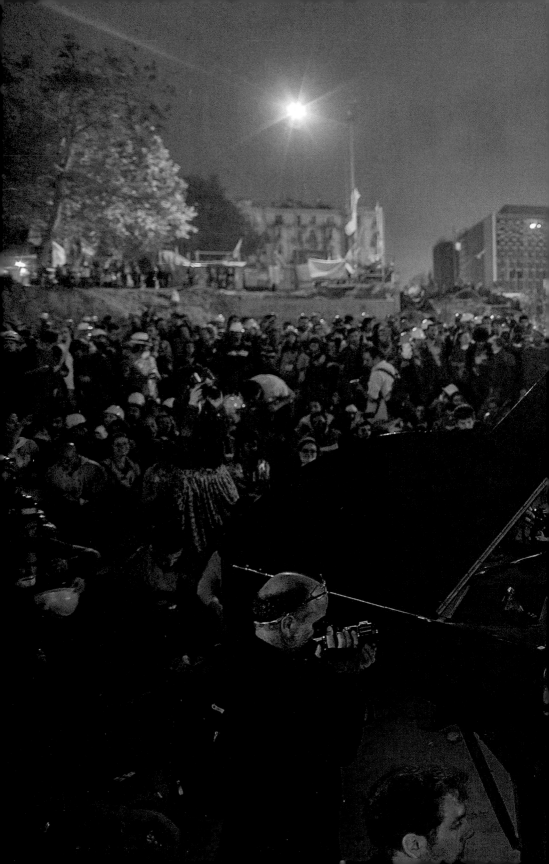

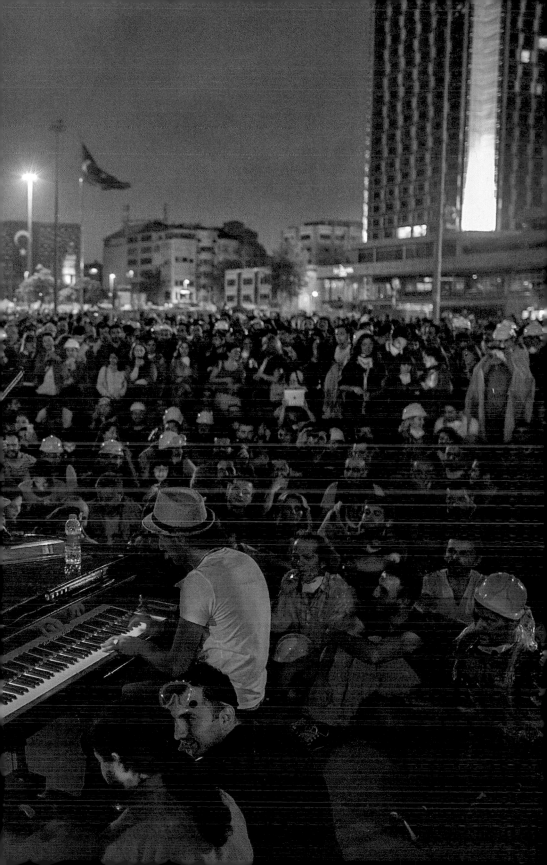

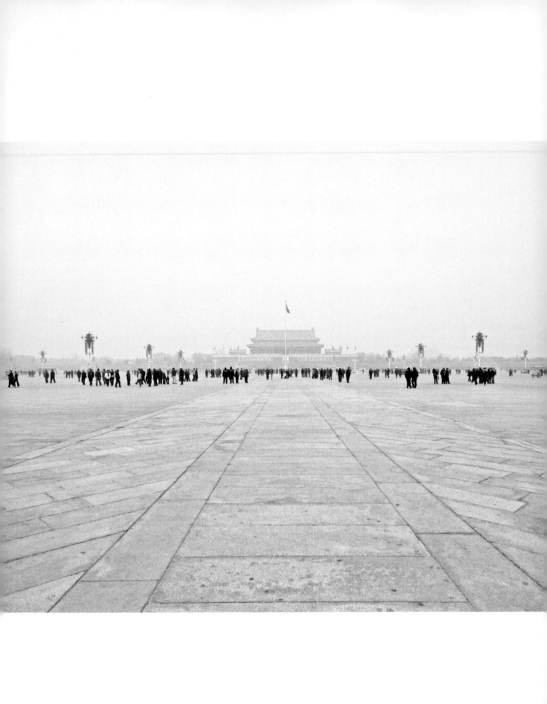

SZE TSUNG LEONG

TIANANMEN SQUARE, BEIJING: IN SEARCH OF HEAVENLY PEACE

Evan Osnos

TO FOREIGNERS, TIANANMEN SQUARE HAS ONE MEANING. TO THE people of Beijing, it has many: the fall of an empire, the rise of a revolution, the pride of a country, and the event so painful that they still speak of it only in whispers. It was the latter that drew me to China.

In 1994 I was a freshman at Harvard, studying contemporary Chinese politics. I gravitated to the newest chapter: the democracy demonstrations at Tiananmen Square five years earlier. The movement had begun on April 15, 1989, when Chinese newscasters reported the death of Hu Yaobang, a popular, open-minded former Communist Party leader who had been driven from power by hardliners. The news of his death inspired fond memorials among students and liberal intellectuals. After four days, students from the Central Academy of Fine Arts, China's top art school, brought a portrait of Hu to Tiananmen Square. The mourners delivered impassioned speeches, and around six P.M., one of them climbed a plinth in the center of the square

and declared that on this day they must do more than commemorate the dead; this, he said, was an occasion to consider China's future.

It was a fitting location for the sentiment; Tiananmen Square had been conceived as the grand symbol of all that China aspired to become—and as a rebuke to the ancient civilization that had come before. For thousands of years, the city of Beijing had venerated the past; it was, in effect, a monument to tradition arrayed across twenty-four square miles. In the fifteenth century, the emperor Yongle had ordered his city planners to design a northern capital for his kingdom. They borrowed the shape of the god Nezha, who was understood to have defeated the Dragon King who lorded over China's northern plains. Where Nezha's heart would have been, the city planners placed the emperor's most sacred dominion, the Forbidden City, protected and encircled by walls that were fifty feet thick. To the east and west, at the tips of Nezha's outstretched arms, they built enormous stone gates. And to symbolize his brain, they called for a glorious passageway, topped with a pavilion, to separate the outer world from the inner sanctum. They called it "the gate of heavenly peace"—*Tiananmen*.

But by the mid-nineteenth century, many of China's progressive thinkers had concluded that the devotion to tradition was a weakness. China had lost its lead in science and commerce and failed to keep pace with the West and Japan. China was invaded—"cut up like a melon," as the local phrase put it—and though a generation of reformers tried to combine the best from abroad with the best of China's traditions, they failed. Their

failure cleared the way for the most radical reformers, the Communists, who called for ridding China of its past as embedded in philosophy, religion, dress, art, and architecture. When Chairman Mao took power in 1949, he climbed to the top of the Tiananmen gate, on the square's northern border, and announced the founding of the Communist state. In his high voice, with the heavy accent of his native Hunan, he declared, "The Chinese people have stood up!"

Tiananmen Square became a symbol of unique political potency, and the students who flooded it on that spring day in 1989 felt an electrifying sense of potential. Another student climbed the plinth and, in his speech, compared the Chinese population to a stone monument that had stood "silently under wind and rain." He called on the people to rise up: "You, my countrymen, have only been taught to submit meekly to oppression."

In the days that followed, the commemorations became protests, and on April 22, the government declared its intention to clear the square. But people responded by turning up in even larger numbers. They erected a tent city, and city residents offered food and water and support. On May 20, the government declared martial law, but the protests grew. At its peak, more than a million people were in and around the square. They carried placards with sentiments from the world over; they put the words of Patrick Henry beside those of Lu Xun, the great modernist. They danced to the Beatles and sang the old Party hymn, "The Internationale." Art students, straddling East and West, built a figure of a woman holding a torch with both hands, a cultural mash-up of the Statue of Liberty and Chinese revolutionary

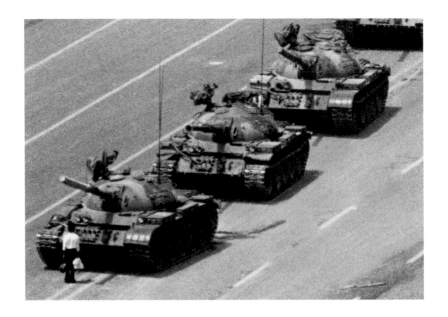

realism, and they called it the Goddess of Democracy. The Party, unnerved, reminded the public that the square was "the heart of the People's Republic and focus of the world's attention."

The bureaucratic jargon contained an ominous message. On the night of June 3—as loudspeakers blared, "This is not the West; it is China"—soldiers and tanks began a deadly march across the capital, firing at protesters and onlookers. It was never clear how many were killed; in the years afterward, estimates ranged from several hundred to two thousand citywide.

The Party had resolved to end the challenge to its rule, even if it meant deploying its army on its own people. As years passed, the Party never publicly questioned that decision—and it prevented others from doing so as well. The Party expunged the history of the Tiananmen Square movement from the Chinese Internet, and it forbade its teaching in school. To the world,

the events of that spring were enshrined in the image of a lone young man in a white shirt, standing motionless before a column of tanks.

IN 1996 I CAME TO BEIJING FOR THE FIRST TIME, TO SPEND HALF A year studying Mandarin. I bought a bike, and at the first chance I had, I rode to Tiananmen. I arrived in time to watch the flag lowered at sunset. It was a weekday in autumn, and the other visitors were mostly Chinese tourists from the countryside. Many had traveled from China's distant reaches. They were members of the fifty-five minorities often overlooked in the world's image of China. There was a group of middle-aged Uighur men in small white skullcaps and leather coats, their heads swiveling to take in the sweep of the buildings around them; a gaggle of Hui Muslim women in brilliant headscarves; Tibetan teenagers with cheeks chapped red by the wind off the highlands. The visitors from Beijing were mostly families. I watched a prosperous-looking mother walking gingerly behind a toddler; she was trying to feed him ice cream and he was wandering, peering up at the passersby, his split-back pants gaping in the wind.

For all of the action on the square, the overwhelming impression was of blankness. It was a space so large and austere that nothing short of a vast occupying crowd could make it feel full. It was not a place for rest or reflection: After the crackdown in 1989, the Party had made sure of that. There were no benches or shade trees. In the summer, the high North China sun beat down, and in the winter, the gusts of wind off the Mongolian steppe swept across the tiles, carrying great swirling eddies of

sand. The scale made every face a speck except one: the monumental portrait of Chairman Mao affixed to Tiananmen Gate— the Great Helmsman peering over us with a Mona Lisa smile.

For me, the emptiness of the square was jarring. I had devoured so much about the events of 1989—student diaries, Party diktats, eyewitness accounts of the demonstrations and the crackdown—that to me, the history felt near and vivid. Before visiting, I'd imagined that the drama of that spring had been so historic, such a powerful mix of exuberance and hope, militarism and suffering, that at least a trace of its energy would remain. But there was nothing.

I pedaled my bike back to the campus where I lived, in the northwest quarter of the city. My roommate, Xiao Si, had been born and raised in Beijing. He was twelve or thirteen years old in 1989, and after a few weeks, I asked him what he thought of the Tiananmen movement. "I really don't know much about it," he said. "And anyway, we shouldn't talk about that." I didn't push; forcing him to discuss a forbidden subject would be selfish and opportunistic. (Foreign students had been advised to tread lightly on "the three T's": Tibet, Taiwan, and Tiananmen.) I never forgot the paradox that he offered: He didn't know much, but he knew not to talk about it.

AS A SPACE AND AN IDEA, TIANANMEN SQUARE HAD EXISTED FOR five hundred years. For most of that time, it was a more modest expanse. When Mao peered down from the gate in 1949, he saw a space large enough for just seventy thousand people. But in the People's Republic that he was creating, the public square,

the *guangchang*, had acquired a sudden new power: Every city and village, regardless of size, needed a public square for the promotion of politics. It served as a stage for celebrations and announcements of the Party's instructions and, when necessary, the revelation and punishment of the people's enemies. Tiananmen was to be the grandest of them all. Mao ordered his planners to create a square that would be "big enough to hold an assembly of one billion."

In a mild taunt to Soviet advisers who had been dispatched from Moscow, the Chinese designers decreed that the new Tiananmen plaza must be even larger and grander than Red Square. As the redevelopment gathered speed, a few brave architects such as Liang Sicheng urged Mao to preserve the ancient city wall and the heart of the old city by erecting a shining new government capital farther west. But Mao rejected that idea; he was a revolutionary, determined to transform Beijing into a secular shrine to Chinese communism. (Liang reacted glumly: "Fifty years from now, someone will regret this.")

The new square was to be studded and surrounded by monuments, museums, and government offices. They set to work under the slogan "faster, better, cheaper," with the ambition to build ten "monumental buildings" in time for the tenth anniversary of the People's Republic. They succeeded, after a fashion. To the east of the square, they built a vast complex housing two museums—one for the revolution, the other for ancient history—completed in just ten months. To the west, they erected the Great Hall of the People, 170,000 square meters of stone and concrete. For all of its revolutionary spirit, some

traditions could not be ignored: The front entrance of the Great Hall was situated slightly off-center, a nod to a feng shui prohibition against building a door that faces a shrine to the dead. The shrine, in this case, was the Monument to the People's Heroes, a granite obelisk rising over a hundred feet from the middle of square "like a needle on an enormous sundial," as Wu Hung, a Beijing-born art critic, put it. Around the base, the Party added white marble reliefs depicting 170 life-size figures: farmers, workers, soldiers, and other revolutionaries. None of them had an identifiable face. Their power, the designers explained, resided in their collective anonymity.

Mao died in 1976, and the square received one more monument—a more literal monument to the dead: Mao's mausoleum, a colossal tomb where the chairman's embalmed remains are on view in a crystal sarcophagus. Each morning tourists line up in a long, slender queue to pass in silence beside the coffin. Wu Hung, the art critic, once observed of the square's eclectic elements, "One rarely finds such a strange assemblage of monuments of contradictory styles in such orderly formation." Tiananmen was, he said, a "war of monuments."

WHEN I RETURNED TO BEIJING IN 2005 TO SETTLE DOWN, I ventured back to Tiananmen and found it virtually unchanged from my first visit nearly a decade earlier: more wide-eyed pilgrims from the countryside; another crop of nervous young parents; the same flag-lowering ceremony each evening by soldiers as unflappable as the guards at Buckingham Palace. The only difference was on the horizon, where the smog created by

China's economic spring now cast an ash-colored haze across the rising skyline. The country's transformation was continuing with ever greater speed. Across the country, China was building more square feet of real estate every two weeks than the entire city of Rome.

Since my first stint in the capital, the national narrative around the Tiananmen crackdown had changed in ways that surprised me. Some, especially those whose family members had been killed, seethed in private; but for most people, it was an abstraction fading into the distance. Many people had effectively adopted the Party's view that the crackdown was a necessary step to ensure China's continued rise. This view was especially popular among the rising generation—the linear descendants of the men and women who had been in the square that spring. One afternoon I asked a young entrepreneur named Rao Jin, who had graduated from Tsinghua University with degrees in engineering and physics, what he thought of the Tiananmen protests. "I was too young to participate in June fourth," he said, using the Chinese shorthand for the movement and the crackdown. "But from what I have heard, many Chinese people at that time joined the demonstrations simply because they felt lost. The economy was in trouble, there were divisions in society, and people at the time would even ask foreign tourists: 'What direction should China take?'" Rao laughed at the image of it. He had come of age in an ascendant China, increasingly sure of itself. Like others his age, Rao had a bumptious sense of national pride. He said, "After all of these years of development, we realize the Western road may not fit China. The efforts of the

government and the people in building the economy, improving the standard of living—*that* is the best way to improve human rights. History has made us more mature."

Year by year, Tiananmen was becoming, once again, a symbol of the Party. In the fall of 2009, I watched as Tiananmen became the stage for China's latest depiction of the future. Every ten years, on October 1—the anniversary of the founding of the People's Republic—the Party held a National Day parade along the northern edge of the square. Under Mao, the parades had celebrated industrial and political might, with great tides of workers and soldiers and students carrying banners with messages like "Down with American Imperialists and Their Running Dogs." But now, on the sixtieth anniversary, it had a subtler message to project: an image of China as a place of order, perfection, and cohesion.

In preparation, the Party had taken no chances. The Beijing Weather Modification Office had launched what it described as the nation's largest campaign to ensure perfect skies: It had fired silver iodide and dry ice into the skies the night before to induce a light rain that cleansed the city overnight, and by dawn, the skies were crystalline blue. Morning light shone on the Fragrant Hills, which were usually bathed in haze. It was a fine day for a parade. The local papers reported that, in addition to deploying ten thousand police officers and security guards, the government had taken measures to prevent terrorism and violent crime: It ordered stores to stop selling kitchen knives as well as model airplanes (in case someone tried to launch an airborne explosive). The ceremony began at ten A.M. President Hu Jintao

stood in the sunroof of a Chinese-made Red Flag limousine as it whizzed along the Avenue of Eternal Peace. He passed tens of thousands of troops standing at attention. The papers said they had been arranged by height, with no more than three inches of variation between them. They had trained for months, by putting needles in their shirt collars, to ensure the perfect posture. To guarantee a flawless television tracking shot, they had learned not to blink for forty seconds at a time. As he passed in his limousine, Hu declared into a bank of microphones: "Greetings, comrades!" The soldiers called back: "Serve the people!"

On came the parade, soldiers and sailors and airmen in full dress, eight thousand in all, as well as a militia formed specially for the parade, composed of young women carrying submachine guns and wearing pink minidresses and white go-go boots. There were massive floats depicting not only the old Mao-era sheaves of wheat and the hammer and sickle but also symbols of the future: wind turbines, bullet trains, nuclear power plants, and a space capsule to signify China's intention to put a man on the moon. When Hu finally climbed atop Tiananmen Gate, he said that for China, the future held "infinitely bright prospects."

Tiananmen was supposed to be the stage where China presented itself to the world, but the longer I lived in China, the less it felt like a part of the nation I knew. The crackdown at Tiananmen was an unhealed wound on the public consciousness. It was impossible to talk about political history without reference to it, but in a café, liberal Chinese friends would reflexively drop their voices to a whisper if they wanted to say anything

critical. As a physical space, the right angles and formality and emptiness felt at odds with the throbbing, slightly off-kilter country around it. Often, after a visit to Tiananmen, I walked home by avoiding the city's vast arteries and heading through the few remaining capillaries, the old alleys (the *hutong*) that lay like a fossilized skeleton of Nezha's form. In the alleys, the buildings were still made of old materials—brick and timber and straw insulation. There were few right angles and there was no open space. Just dense, off-kilter reality.

Away from Tiananmen, off the stage and removed from the officialdom it represented, the Chinese people were negotiating their own encounters with the outside world, on their own terms. I lived in a one-story brick house, and I came to know a local muckety-muck named Liu Yuanchuan, who lived on the next alley north. In his late fifties, he was tall and handsome, with hooded eyes and a Long Feng cigarette drooping from his lip. He owned several small houses and ran the businessmen's association for several blocks around. Though Liu had been born and raised in Beijing, his world consisted of a narrow patch of the capital, and his bearing reminded me of a village mayor's. He had never been abroad, and for him, the outside world carried an abstract mystique. When I arrived, his alley—Wudaoying Hutong—was a slender dirt path lined with old gray-brick homes.

In the years that followed, I watched Liu make jarring changes to his street. He got it paved, and then he installed rows of upward-facing lights that made the alley look like a boardwalk. He invited in restaurateurs with the kind of international

cuisine he wanted to promote—first a Spanish restaurant and then a Greek place. Elderly locals rented their front rooms to shops selling vintage clothing, ironic T-shirts, and stylish fixed-gear bicycles. The *hutong* even welcomed the first tanning salon I'd seen in China, a country where most people avoid appearing as if they work outside. When I had arrived in the neighborhood, Liu's alley contained only one business, a café. Two years later, it had seventy-eight businesses, according to the local paper, which had sent a reporter to assess what it called "the city's newest trendy hangout." Liu was the unlikely kingpin presiding over Beijing's newest trendy hangout. "I don't understand what they sell," he told me. "But it sells."

In Liu's world, as in so much of China in the throes of a furious sprint toward the future, nothing stayed the same for long. There was no plan, no official blessing, no decree—just a vast, unpredictable energy. Between 2011 and 2013, China used more cement than the United States used in all of the twentieth century. And yet Tiananmen Square, like the Party that designed it, remained timeless and unchanged. The apparatchiks had decreed that, after the construction of Mao's mausoleum in 1977, nothing more could be built on the square, and so it remained, as frozen as the chairman's body on view in his tomb. At the dawn of the People's Republic, the square had been a portrait of the future, but year by year, it was becoming a monument to the past.

Overleaf: J. B. RUSSELL

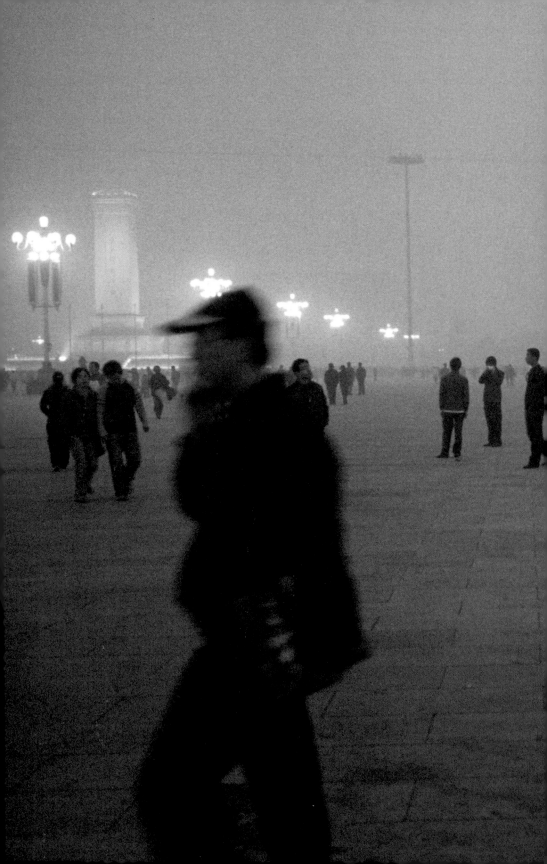

ALEX SIMON

EUROMAIDAN, KIEV:
A PLACE BECOMES A MOVEMENT

Chrystia Freeland

THE MAIDAN USED TO BE MY LEAST FAVORITE KIEV SQUARE. AS Stalin-era public spaces go, it's actually not too bad, not truly ugly like the gray town centers of countless Soviet provincial cities, or the intentionally menacing plazas of the imperial capital. Compared to the golden-domed Byzantine splendor of so much of central Kiev, though, the Maidan always seemed charmless and uninteresting. Many of Kiev's most important landmarks date back to the twelfth and thirteenth centuries, when the city was the seat of the Viking Rurik princes and the capital of the eastern Slavs.

My mother, who lived for a frustrating and exhilarating decade in Ukraine working on legal reform, bought and lived in an apartment on one of the side streets that climbs steeply upward from the Maidan. My mother was born in a refugee

camp in Germany, where her family ended up after fleeing western Ukraine when the Soviet army invaded in 1939. Eventually, they made their way to Canada. They joined a long-established Ukrainian-Canadian community, but this post–World War II immigration was different—my grandparents, and my mother and her sisters and brother, saw themselves as political exiles, with a duty to preserve the Ukrainian idea and a belief that eventually they would return to build it in Ukraine.

My sister and I jointly inherited our mother's apartment after her death in 2007. On a trip to Kiev a few months later, I stayed there and spent many hours in the nearby square with my young daughters. They were bored by the city's labyrinthine tenth-century Monastery of the Caves and the glorious twelfth-century Saint Sophia Cathedral, but they fondly recall the Maidan's glass-domed underground Hlobus shopping mall and the massive McDonald's.

Today the Maidan is the first place I visit when I travel to Kiev. I usually buy a bouquet; there are always flower sellers by the metro entrance in the center of the square. Then I walk up from the Maidan along the alley now known as the Street of the Heavenly Hundred, as Instytutska Street has been renamed, in honor of the protesters shot and killed there by government snipers on February 20, 2014.

The McDonald's and Hlobus still do brisk business, and the Maidan itself is crowded in the summer with outdoor cafés, but it has also become a sacred place for Ukraine and Ukrainians. The Maidan isn't only a square anymore; it is also an idea.

For Ukrainians, the Maidan isn't just a noun; it has become a verb, the act of grassroots democracy. The Maidan is where Ukrainians came together to stand up for democracy and the rule of law in the face of a kleptocratic regime whose leader was prepared to kill dissenters in order to stay in power.

What Ukrainians call their dignity revolution put the country in the sights of a more powerful autocratic ruler, Russian president Vladimir Putin. In the face of that bigger fight, the Maidan has come to stand for democracy in its most urgent sense, as an ennobling set of personal and collective values we must be prepared to die for to defend.

Timothy Snyder, the Yale historian whose book *Bloodlands* (2013) is one of the most eye-opening accounts of twentieth-century Ukrainian history, pointed out that because of the protests the Maidan housed, "the word *maidan* has come to mean the act of public politics itself."

GEOGRAPHY IS OFTEN DESTINY, AND THAT IS CERTAINLY THE case with the Maidan, as it is with Ukraine itself. The Maidan is at the northeast end of the Khreshchatyk, the wide chestnut-lined avenue that is the city's main thoroughfare, named Europe's seventeenth most expensive shopping street in 2010. To the northwest, steep alleys lead up to the cathedral of Saint Sophia, the mother church of the eastern Slavs; and at the southeast end, to the Pechersky quarter, home to Ukraine's government buildings and the grand apartments of its political establishment.

In 1989, when Ukrainians began what has turned out to be an unfinished quarter-century-long struggle against Soviet authoritarianism, this central space was the ideal place for civil society to rally. The Maidan's modern role as the beachhead for Ukrainian democracy began when student demonstrators gathered in what became known as the Revolution on Granite, named after the stones that pave the square.

In tactics that foreshadowed and inspired future insurrections on the Maidan, students pitched tents on what was then known as Lenin Square. That protest and the strong support it earned from much of the city, including the workers of Kiev's largest armament factory, played a big and underreported part in the collapse of the Soviet Union.

But the end of the Soviet Union turned out to be just the beginning of the struggle for democracy, not its conclusion. The USSR dissolved, but many of its successor states, including Ukraine, remained poised between Western-style democracy, the preference of civil society, and Putin-style authoritarianism, which better suited the post-Soviet Ukrainian elite.

In Ukraine, the battleground between these two models was the Maidan. The next standoff was in 2001, when leaked telephone conversations of the Ukrainian president, Leonid Kuchma, linked him to the grotesque kidnapping, torture, and beheading of a leading journalist. Known as the Cassette Scandal, this murderous Ukrainian version of Watergate sparked mass protests centered, of course, at the Maidan.

The Kuchma government survived the demonstrations. But the fight left a physical scar on the Maidan. After suppres-

sion of the "Ukraine without Kuchma" movement, as the 2001 protests were known, the mayor of Kiev abruptly started major construction work on the Maidan. The square had become so powerful that it needed to be fenced off.

Three years after the demonstrations, the Kuchma government manipulated presidential election results to install Viktor Yanukovych, an even more strong-armed successor, which provoked another uprising. This became the Orange Revolution. Thousands camped out on the snow and ice of the midwinter Maidan, and millions across the country supported them.

This time the Maidan won. New elections were called, and Viktor Yushchenko, whose support had been suppressed in the first, fixed vote, became president and returned to the Maidan to take his oath of office. He chose the Maidan because he wanted a concrete symbol of the political reform his election represented. He wanted to show that political legitimacy in Ukraine no longer derived from the Communist Party, or the imperial family, or even the barrel of a gun. It came from the people, and the place that stood for people power was the Maidan. The Maidan had become the incarnation of Ukrainian democracy, the physical spot that represented the people's determination to demand accountability from their rulers.

But that moment, tragically, turned out to be the high point of Yushchenko's presidency. Yushchenko and his allies had been the leaders and figureheads of the triumph of Ukrainian democracy, but in government, they were disastrously incompetent. Indeed, they did such an epically poor job that by the time the

next ballot rolled around, Yanukovych, who had failed to become president by fraud, was elected fair and square. The democratic dreams of the Maidan seemed to be just that—and no match for the brutal, corrupt reality of post-Soviet politics.

Ironically, it was during the Yanukovych era that the Maidan, both the place and the ideals it represents, fully came into its own. Yanukovych assumed power democratically, but he quickly set about creating a regime that was authoritarian and corrupt. Many Ukrainians seethed, but after the whimpering failure of the Orange Revolution, it was hard to believe that Ukrainian society might still see democracy as something worth fighting for.

Then, on November 21, 2013, exactly nine years after the start of the Orange Revolution, Yanukovych reneged on his long-standing promise to sign an Association Agreement, a trade deal, with the European Union. It became a rallying point because it was never just about trade with Europe, or even the distant promise of a path to eventual EU membership. In Ukraine, as in all of the lands of the former Warsaw Pact, Europe has come to stand for the entire political-economic package of Western democratic capitalism: the rule of law, human rights, democracy, and a market economy.

Yanukovych was more venal and more brutal than any of his predecessors, as well as a poor economic manager. But as long as he was negotiating the Association Agreement with the European Union, Ukrainians could see his presidency as just another rough patch on the arduous road to democratic capi-

talism. It might be unpleasant, to be sure, and difficult to get through, but ultimately not an immovable obstacle or a permanent change in direction.

Which was why Yanukovych's November about-face had such a stunning impact on Ukrainians. Yanukovych had been grimly tolerated because he seemed to be temporary: someone that Ukraine, which had successfully transferred presidential power three times in its twenty-three years of independence, could reject in the 2015 presidential elections. By abandoning the European deal at the last minute, and under pressure from the Kremlin, Yanukovych showed that he and his Russian backers had something else entirely in mind—turning Ukraine into a Putin-style "managed democracy," newspeak for not a democracy at all.

What happened next transformed Ukraine and transformed Russia, and it is still reshaping geopolitics. It started with one person: a thirty-two-year-old, bearded, Kabul-born Muslim journalist named Mustafa Nayyem, who was outspoken and daring enough to question Yanukovych on live television about his personal corruption during the 2010 campaign.

On November 21, 2013, Nayyem was covering parliament day-to-day. He told me a few months later that, like many Ukrainians, he thought the reversal on the Association Agreement with Europe was just a bargaining ploy. When he realized the deal was really dead, he was enraged, as were all of his friends on Facebook.

Nayyem decided they needed to do more than write angry

screeds for each other. So early that evening, he posted a call to action on his Facebook page: "Come on guys, let's be serious. If you really want to do something, don't just 'like' this post. Write that you are ready, and we can try to start something." For Ukrainian democrats, starting something was obvious: They went to the Maidan.

Within an hour Nayyem received more than six hundred comments. So he posted a follow-up: "Let's meet at 10:30 P.M. near the monument to independence in the middle of the Maidan."

When Nayyem got to the Maidan, about fifty people were already there. By midnight, there were more than a thousand. By the end of the year, hundreds of thousands of people were gathering there. Nayyem, who was elected to the Rada—the Ukrainian parliament—in post-revolutionary elections eleven months later, didn't realize what he had started in the news story he wrote that day. He didn't even mention the Maidan.

OVER THE NEXT THREE MONTHS, THE MAIDAN BECAME THE most important square in the world. Social media was essential to this revolution's self-organization; it was the instrument that protestors on the Maidan used to summon help at key moments from the rest of the city and the country.

But it was also an elemental physical fight. The protesters built medieval-style barricades using ice blocks. They burned firewood, in addition to old furniture brought in by sympathizers, to keep warm, and tires to muddy the aim of government

sharpshooters. They made Molotov cocktails, using the Internet to figure out how: The most popular search term in Ukraine that year was "Molotov cocktail." They even broke up the cobblestones of the streets around the Maidan and used them as weapons.

The physical Maidan was always the epicenter of the struggle, but the Maidan became more than a single Kiev square. There was, of course, a #DigitalMaidan that provided logistical and political support online. There was an automaidan: drivers who blocked government troops from coming to the plaza and smuggled in the empty beer bottles (for the Molotov cocktails), tires, and wood the protesters needed. Maidans, often called EuroMaidans, were organized in cities and towns across Ukraine and around the world.

Mostly, though, the Maidan became a euphoric, almost sacred place. What transformed it from a place into a movement was that moment, common in all liberation struggles, when individuals personally choose freedom over safety, and when millions of individuals find solidarity and courage and altruism in that collective choice.

My favorite restaurant in Kiev is Pantagruel, an Italian osteria on Golden Gate Place, a shady square more beautiful, more ancient, and more intimate than the Maidan and a ten-minute walk away. Its owner is Sergei Gusovsky, a slim, dapper gentleman who wears fitted Italian suits and rimless glasses. Gusovsky has founded a half-dozen of Kiev's best restaurants and likes to blog and post, usually in Russian or in English, about food and wine, often Italian-inspired.

But during the Maidan, Gusovsky decided that it was wrong to "fill the ether with marketing" and descriptions of the "pleasures of bourgeois life." Instead, he wrote about the transformative power of the square: "What is the Maidan today? It is a city of utopia. It is protected by defensive fortifications and inside govern unwritten laws that allow you to feel that you are an absolutely free person. If you want to work, then by all means! If you are hungry, you are welcome to eat. If you are freezing, you can find warmth. If you are done sitting next to the bonfire, then you can get back to work. If you are tired, go to sleep. When you awaken again, you are greeted again in this honest city. The city is as primitive as it is holy. If you have not been to the Maidan yet, you should definitely come."

The problem with utopia is that it is difficult to sustain. The Maidan has become a physical embodiment of Ukraine's talent for repeated bursts of utopian social action. The question that Ukrainians are still grappling with is whether they have an equal aptitude for the more prosaic work of governance. History suggests not.

Nayyem, who began the revolution with his Facebook call to action, is pressing the new government to take on its oligarchs even as it faces Russian aggression in the east. Gusovsky is still blogging about la dolce vita, Ukrainian-style, but he is also dealing with more prosaic matters like garbage and potholes: He has been elected to the Kiev city council.

If Ukraine is lucky, this will be the ultimate meaning of the Maidan: a symbol of dreams and of euphoria and of sacrifice—

and the place where the quotidian, routine work of building a just society began. That is the paradox of the Maidan—its best legacy will be if it becomes a celebrated site of historical memory, but also if it falls into disuse as a venue for the revolutions Ukrainians hope they will one day soon stop needing.

Following two spreads: ALEX SIMON, YURI KOZYREV

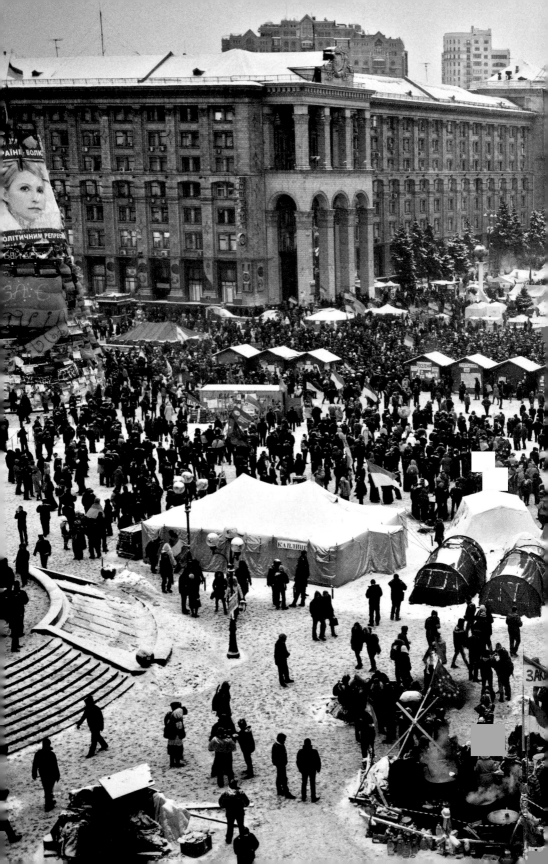

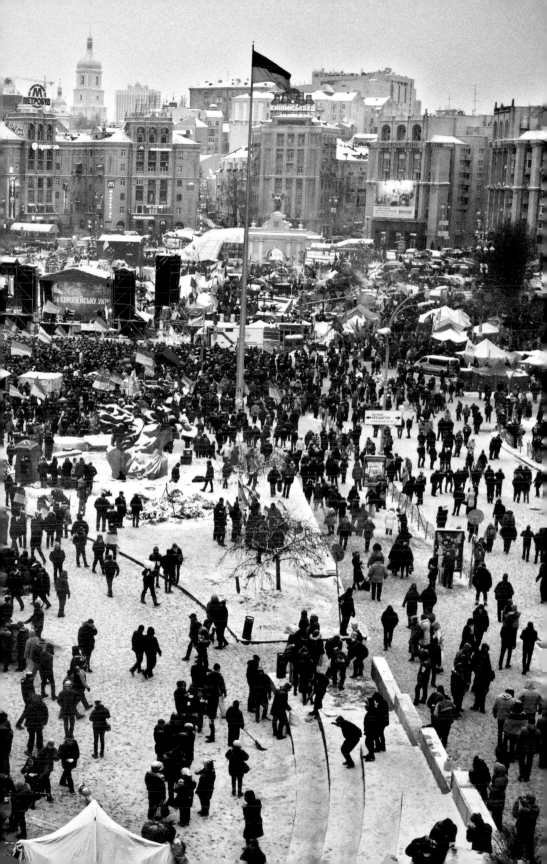

PART THREE
HISTORY: INFLUENCE ON HUMANITY

INTRODUCTION
George Packer

A CITY SQUARE IS A PHYSICAL PAUSE IN THE URBAN LANDSCAPE. It's a deliberate gap that interrupts the mass and clamor of buildings and streets, breaking up the flow of daily business and creating a space where people can come together, by design or happenstance. City squares are planned absences—they're defined, first of all, by what they're not. A city park already has a definition (grass, trees, paths) that tells you how it's to be used: for leisure, for recreation, as a withdrawal from the city, with the illusion of being in nature and often alone. Squares, unlike parks, don't take you out of the city. As an extension of urban life, neither natural nor solitary, they're of the city as well as in it, but with a function that alters through history. Because of their very emptiness, they are full of possibility.

Their essential feature is open space, and their essential

function is sociability. Where much in the modern city is private and inaccessible, squares are for the public. People gravitate to them in order to yak, kibitz, palaver, gossip, argue, show off, watch, eavesdrop, play, protest, hustle, con, love, fight. In the case of Italian *piazze,* French *places,* and Spanish *plazas,* the restaurants, cafés, and shops that line the perimeters encourage the ease of human encounters. But their openness can also give city squares a feeling of desertion. They're places where people with time on their hands hang out—the jobless, the old, the lonely. In *The Death and Life of Great American Cities,* Jane Jacobs quoted an Indiana woman on her town square: "Nobody there but dirty old men who spit tobacco juice and try to look up your skirt." The square in front of the Paris city hall used to be called Place de Grève and was for centuries a place for unemployed Parisians to gather in search of work, which gave French its word for "labor strike."

What determines a square's atmosphere and use isn't its shape or architectural details but mainly its location and scale. Some squares leave the visitor dwarfed and conspicuous, with no comfortable way to linger, as if the message is to keep moving. Look at pictures of the Zócalo, the vast central square in Mexico City, or Red Square in Moscow: huge paved plazas surrounded by beautiful architecture, with hardly anywhere to sit, making the people in them look like clusters of pigeons. Even squares built to a more modest scale can seem like pockets of isolation at the heart of a city, where the urban buzz suddenly goes quiet. I've never felt lonelier than crossing a Tuscan *piazza* at two in the afternoon, nor more spooked than hurrying through Bien-

ville Square in Mobile, Alabama, at four in the morning, at the end of the 1970s.

City squares seem to be waiting for a crowd to fill them up—to assume a collective character and confer a public identity on private individuals. They possess a theatrical quality, as if the square is a stage and everyone in it a performer, even if the assigned role is that of an audience member. Many squares are best known for occasions when large numbers of people assemble there for a single purpose—to celebrate, to remember, to hear music, race horses, salute a leader, overthrow a government, attend a parade or an execution. City squares are where rulers and their people meet, sometimes with unpredictable effects. A gathering of citizens can turn into an obedient herd, a violent mob, or a voice for hope. Squares can become instruments for autocratic control or democratic change.

Being communal, squares reflect the civic culture of a city and a civilization. Times Square—whether the sleazy 1970s version (preserved forever in *Midnight Cowboy* and *Taxi Driver*) or the more recent corporate-neon fantasyland—represents the naked capitalism of New York, open to all comers. That it's not so much a square as a series of intersections surrounded by stores, theaters, and offices, rendered nearly indistinguishable by the ubiquity of advertising, only emphasizes Times Square's fluid, malleable American character. The Place de la République in Paris—whose nineteenth-century grandeur was achieved by the destruction of eighteenth-century theaters and cafés—is a perfect expression of French republican pride, never more so than on January 11, 2015, when up to two million people gathered

there to march for free expression and secularism after the terrorist attack on the weekly magazine *Charlie Hebdo.* In Pyongyang, the manufactured capital of North Korea, Kim Il-sung Square, more than eight hundred thousand square feet in area, is designed for vast military parades and anti-imperialism rallies in which individuals dissolve into an undifferentiated mass of movement and color. Squares are places where people go to shape an idea of society itself. For this reason, they are contested spaces.

FREEDOM'S SPACE

IN THE *ILIAD* OF HOMER, THE GOD HEPHAESTUS FORGES A shield for Achilles that is an image of the world: earth, sea, and sky; fields, animals, and crops; battles and dances; and two cities. In one city,

> the people were gathered in assembly, for there was
> a quarrel,
> and two men were wrangling about the blood-
> money for a man who had
> been killed, the one saying before the people that he
> had paid damages
> in full, and the other that he had not been paid.
> Each was trying
> to make his own case good, and the people took
> sides, each man backing
> the side that he had taken; but the heralds kept
> them back, and the

> elders sat on their seats of stone in a solemn circle,
> holding the
> staves which the heralds had put into their hands.
> Then they rose
> and each in his turn gave judgment, and there were
> two talents laid
> down, to be given to him whose judgment should
> be deemed the fairest.
>
> [Fitzgerald trans., Book XVIII]

The Ancient Greek word for "assembly" in the first line is "agora"—perhaps the first mention of a city square in recorded history. In this scene from Achilles' shield, the agora is simply a public place where a dispute can be hashed out: the rudimentary origin of self-government. As Lewis Mumford observed in his 1961 classic *The City in History,* "Such a place for gathering, possibly under a sacred tree or by a spring, must have long existed in the village: an area large enough so that village dances or games might be held there, too. All these functions of the agora would pass into the city, to assume more differentiated forms in the complex urban pattern."

The Greek agora was a marketplace where people met to talk, exchange news and ideas, buy and sell. Over time it became a location for other activities, a site of law and government as well as commerce—the vital heart of the city. In her essay "Introduction into Politics," Hannah Arendt located the Greek idea of freedom in this physical space: "[T]o the Greek way of thinking, freedom was rooted in place, bound to one spot and limited in

its dimensions, and the limits of freedom's space were congruent with the walls of the city, of the polis or, more precisely, the agora contained within it." The Athenian agora was set off from the acropolis, the higher ground where temples to the gods were constructed. This separation between political and religious power allowed the development of Athenian democracy, however exclusive. The agora re-created the simplicity of the village, where citizens participated in making decisions face-to-face.

In its early history, the Roman Forum, too, was an open-air market. (The primal connection between commercial and civic life in city squares seems almost universal. Wenceslas Square in Prague, where the democratic hopes of Czechoslovaks were crushed by Soviet tanks in 1968, then realized in the Velvet Revolution of 1989, began as a cleared piece of land for the city's horse market. Alexanderplatz, the most famous square in Berlin, started out as a market for cattle. In the sixteenth century, Red Square was called Great Market.) The Forum grew through the centuries, adding a *comitium,* or assembly place, until it encompassed all the architectural features of a great city at the heart of an expanding empire—markets, temples, basilicas, courts, theaters, speakers' pulpits, procession grounds, and the Capitol building, where the Senate met. The Romans combined business, politics, religion, and pleasure in all the city's forums, but especially in the original Forum Romanum, the very nerve center of the empire.

Vitruvius, the Roman architectural theorist, understood that the design of a public square could lead to either claustrophobia or its counterpart, agoraphobia: "The dimensions of

the Forum ought to be adjusted to the audience, lest the space be cramped for use, or else, owing to a scanty attendance, the Forum should seem too large," he wrote in *De Architectura*. As Rome grew into an empire, the nature of its forums changed: Triumphal arches, equestrian statues, and soaring columns that commemorated battle victories were introduced to produce monumental effects. For the Greeks, the architecture of the agora was dedicated to the elevation of the mind and the facilitation of democratic debate. The Roman Forum, on a far larger scale, became a more ordered expression of imperial greatness, even an instrument of political control.

In 44 B.C., the Forum was the stage for one of history's first political revolutions—a primal scene that has haunted the imaginations of rulers and conspirators down the centuries. In Shakespeare's version, Julius Caesar is stabbed by a group of notables when he enters the Senate house, struck down with shocking ease at the very height of his power. Brutus, the reluctant leader of the conspiracy, descends into the Forum to explain the deed to the citizens of Rome, looking for popular legitimacy, and the public temporarily accepts his justification. Then Caesar's friend Mark Antony, a far more eloquent and shrewd public speaker, takes the pulpit and soliloquizes over Caesar's bloody corpse. Within minutes, he manipulates the crowd to believe in Caesar's generosity and to turn against his killers. As Antony intends, the citizens rush off to burn down the traitors' houses and drive them out of Rome. The political lesson is clear: A crowd easily turns into a mob, fickle and volatile; and a public square is a dangerous place, because out in the open, on the

theatrical stage, power can quickly change hands—from Caesar to Brutus and the other conspirators; from them to Antony and the Roman people. The Forum becomes a conductor of electrical current that can switch directions at any moment.

As republican Rome gave way to empire, the institutions of self-government decayed, and the city's baths, vomitoriums, and arenas became the scenes of debauched and unthinkably cruel entertainments. Public life hollowed out and gave way to private pleasures in public places. The Forum became an outdated and nostalgic symbol of traditional patriotism, while the real action took place next door in the Colosseum—as if the Washington Redskins were to locate their stadium on the National Mall, right between the Jefferson and Lincoln memorials.

The fall of the Roman empire ended the classical idea of the public square as a center for civic activity. In the constricted space of the medieval walled city, squares were often limited to the open area in front of the church that controlled it, hosting occasional markets—irregular in shape, approached by narrow, twisted streets, encountered by surprise—as in the *piazze* of Tuscan hill towns. With the rediscovery of the ancient world in the Italian Renaissance, the city square returned as a grand project, planned along Vitruvian principles and ornamented by great artists and sculptors, announcing the secular power and aesthetic sophistication of the local nobility. In classical theory, revived in the quattrocento, the human figure was the source of architectural proportion; the circle and square were seen as ideal geometric forms, represented by the spread-eagled figure of a human being whose extremities describe circumference and

perimeter (seen in Leonardo da Vinci's famous drawing of Vitru-vian Man). In *The City Shaped,* the architectural historian Spiro Kostof wrote: "Italian Renaissance theory began to see radial de-sign, or at least centrally planned schemes, as the diagram of humanist perfection, and went further, in urban-political terms, to equate perfect social order with the humanist prince." The city square was once again a focus of urban planning, but the republican version didn't survive the classical era: In the age of Machiavelli, power was confined to the palace. The ideal city of the Renaissance depended on the benevolence of a tyrant.

The city squares of the seventeenth and eighteenth centu-ries were designed to display the wealth and power of Europe's upper classes. Baroque planning—broad, symmetrical radial avenues that converge on grand rectangles or ovals, surround-ing monumental figures and fountains—reflected the central-ization of power in absolute monarchs and the new riches of mercantile capitalism. What Mumford called "the city of abso-lutism" reversed the claustrophobia of the medieval town and produced "the opposite effect, that of agoraphobia: a horror of emptiness, saved only by the fact that the space would be cut in tatters by the constant movement of vehicles." The Place Royale (now Place des Vosges), begun under Henri IV in 1605, was the first planned square in Paris, and became the model for the res-idential squares of London, with private gardens behind locked gates—Bedford, Bloomsbury, Belgrave, Grosvenor—and, later, Gramercy Park in Manhattan.

So the Baroque city square represented, in one direction, the privatization of public space and the separation of classes in

the growing metropolises of capitalist Europe. In another sense, the grandest squares of Baroque Paris—Place Vendôme, with its equestrian statue of Louis XIV, replaced after the revolution by Napoleon on a giant column; Place de la Concorde, with Louis XV on horseback, later a massive Egyptian obelisk—updated the splendors of imperial Rome for the emerging European nation-state. Even after the revolution (Louis XVI and Marie Antoinette were guillotined in the Place de la Concorde in 1793, and Robespierre after them), the squares of empire and republican Paris—a city remade by the sweeping public works of Baron Haussmann, the Robert Moses of the nineteenth century—were dedicated to the greater glory of France: Place de la Bastille, Place de l'Étoile, Place de la République.

Their counterpart in London was Trafalgar Square, with Lord Nelson in place of Napoleon. In Rome, after Italian unification, it was Piazza Venezia, spreading out beneath the hideous Monument to Vittorio Emanuele II (to heighten the impression of Romelike greatness, Mussolini ordered the construction of the Via dell'Impero between Piazza Venezia and the Colosseum, paving over centuries of architecture, including the ruins of several Roman forums). The National Mall in Washington—which is not a city square but an immense lawn littered with monuments—was designed at the start of the twentieth century to serve the same role of consolidating and asserting national identity, on a scale befitting a rising power. The federal city, after all, was the brainchild of a product of the French Baroque, Pierre Charles L'Enfant. In the absence of a square with sufficient scale

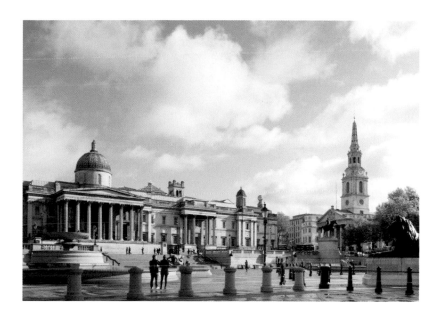

and symbolic grandeur to attract and accommodate hundreds of thousands of people in the American capital, the Mall has played the part of a national meeting place.

Great powers build great squares, and not only in the West. At the end of the sixteenth century, the Safavid dynasty moved the capital of imperial Persia to the central city of Isfahan and built there one of the world's most beautiful city squares— Maidan-e Naqsh-e Jahan, or Image of the World Square. (It was also called Shah Square; after the 1979 Islamic revolution, the name was changed to Imam Square.) A two-story arcade runs along the rectangular perimeter of Naqsh-e Jahan, connecting monumental structures that represent the three main institutions of the Persian empire: mosque, palace, bazaar. It was a vast trading center by day, a place for entertainment at night,

OBERTO GILI

on occasion even a polo ground. As with the Roman Forum, religious, political, and economic activities were all focused on Isfahan's great square, designed by its founder, Shah Abbas, to centralize his power.

In the modern world, very few squares approach the ideal of the Greek agora. Perhaps the closest is the New England town square. A meeting hall, a courthouse, a church, an occasional farmers' market, and an open space around the monument of the Union soldier: It includes, like the agora, the essential activities of democratic society. But a city square that's designed on a scale to express national greatness is hostile to the human intimacy necessary for freedom's space.

CITIES OF ABSOLUTISM

OVER THIRTY YEARS AGO, I LIVED IN A SMALL VILLAGE IN TOGO, on the coast of West Africa. Every few months I took a bush-taxi down to the capital, Lomé, on the Gulf of Guinea, to shop for things at the city's central market that I couldn't get in the village—a good plastic bucket, a kerosene lamp, a piece of bright printed fabric from Ivory Coast for a tailored shirt. The Grand Marché, in an old, crowded part of the city near the beach, was the village market writ large, and I went there to absorb the vitality as much as to do my shopping. The three-story concrete building was dim and hectic inside, without much electric light, and surrounded outside by nearly impassable warrens of stalls and umbrellas where the goods were laid out on rickety wooden tables or the ground: pyramids of mangoes and papayas, kitchenware, cosmetics, secondhand clothes, heaps of dried fish,

cheap pharmaceuticals, the monkey skulls and snakeskins and carved masks of the fetish market. Shoppers sat down in lunch stalls for quick bowls of pounded yam with pepper sauce and cups of millet beer or palm wine. Except for the money changers, who were hyper-aggressive con men, the market was run by women and girls—some of them so wealthy that they were called Nana Benz, for the cars in which they drove to work; others were so poor that they sweated out a living selling cups of cold water from a cooler balanced on their head. With the smell of dead animals and living humans, the heat and pressure of bodies, and the shouting that never stopped, the Grand Marché was an exhilarating and intimidating place, the pounding heart of the city.

Just half a mile away was the Place de l'Indépendance: a huge traffic circle ringing a manicured park, with palm trees, polished paving stones, and reflecting pool; a massive concrete piece of African-modernist statuary in the center, evoking struggle and triumph; a glass skyscraper hotel at one end, with hardly any guests. I can't remember ever setting foot in the Place de l'Indépendance. It was almost always empty—and not only because the fence, with gold-tipped spears, was often locked, or because a gathering of more than a few people would immediately draw the attention of the security forces of one of Africa's most entrenched dictatorships. No one had any reason to go there. The space was so oversize and immaculate that it discouraged human activity—anyone who walked through was a conspicuous intruder. It didn't belong to the city's people. Its character was anonymous and collective—a place built to commemorate Togo's

independence from France in 1960, with annual parades and flags and uniforms, but otherwise without a natural function.

The gap between these two public places tells you something about the nature of civic life in a colony-turned-dictatorship. The market, with traditional features and practical functions, exists separate from and untouched by the modern, symbolic, French-influenced *place*. Official and unofficial life never meet. This is a state without citizens. Lomé's Grand Marché can't accommodate the functions of citizenship: It's too jammed with shoppers, sellers, and goods to serve as a gathering place where large numbers of residents can congregate to talk, listen, argue, demonstrate, celebrate, mourn, demand—to become more than private people in public places.

In newer countries, you often find two types of public square: one that is older, organic, chaotic, and populated; and one that is recent, planned, orderly, and deserted. The first type predates the nation-state and accretes over time to accommodate the habits and needs, mainly commercial ones, of ordinary city dwellers. Its names are maidan, souq, bazaar, market. The second is constructed according to a master plan to embody the idealized qualities of the nation, often with grandiose results. The first thrusts people together in a shared space, a hive of activity. Its essence is accidental and spontaneous. The second leaves nothing to chance. It tells people that they are subservient to the state and, in a sense, irrelevant to it.

In modern cities of absolutism, the square takes on a powerful political role—compulsory collective patriotism, public displays of love for the nation's leader mixed with hatred of its

enemy. In Orwell's *1984*, Winston Smith leaves his job rewriting previously published news stories in the Ministry of Truth and goes to Victory Square, where foreign prisoners of war will be paraded in a convoy of military trucks. But Winston's real purpose is a rendezvous with the dark-haired girl from the Fiction Department. "He wandered round the base of the enormous fluted column, at the top of which Big Brother's statue gazed southward toward the skies where he had vanquished the Eurasian aeroplanes (the Eastasian aeroplanes, it had been, a few years ago) in the Battle of Airstrip One," Orwell writes. "Then he saw the girl standing at the base of the monument, reading or pretending to read a poster which ran spirally up the column. It was not safe to go near her until some more people had accumulated. There were telescreens all round the pediment."

Orwell's Victory Square takes the spirit of the agora and turns it around: Here is where men and women, under the surveillance of the telescreens and the crowd, are radically unfree. In a totalitarian square, there is no real politics because there is no individual initiative. The public place forces everyone to have the same thoughts, to say the same words, uniform, awestruck, and exposed to the withering gaze of the state.

In the late 1930s, Hitler and his chief architect, Albert Speer, planned the rebuilding of Berlin into what Speer called "World Capital Germania." (Hitler had considered building an ideal capital city from scratch, along the lines of Washington, D.C., but he concluded that it would be lifeless.) The design for the new Berlin called for a four-hundred-foot-wide Avenue of Splendors to run along a north-south axis through the heart of

the city—whose old buildings and streets would be swept away— from a triumphal arch at the southern end, past new movie theaters, stores, office blocks, a concert hall, and a Roman-style swimming pool, three miles north to the enormous domed Volkshalle, designed by Hitler himself along the lines of the Pantheon, as a great temple of Nazism. The Volkshalle was to be the largest enclosed space in the world, with room inside for four Saint Peter's cathedrals, containing more than a hundred fifty thousand people. In front of the Volkshalle and surrounded by other monumental buildings of state, including the führer's palace, would be the future Adolf Hitler Platz—a vast area of 3.7 million square feet, five times the size of Red Square, for mass rallies and military parades of a million people.

Hitler understood the volatile potential of a public square—the waves of rage and courage that could suddenly turn on a leader. Anticipating the possibility of civil unrest in Adolf Hitler Platz, he once told Speer, "All the buildings on this square must be equipped with heavy steel bulletproof shutters over their windows. The doors, too, must be of steel, and there should be heavy iron gates for closing off the square. It must be possible to defend the Reich like a fortress." Hitler's vision for Berlin was inspired by ancient Rome and nineteenth-century Paris—the führer thought Baron Haussmann the greatest city planner in history—but he wanted to outdo them both and turn haphazard, disorderly Berlin into a city worthy of world domination. When Speer's father saw the architectural models, he said, "You've all gone completely crazy."

The war put an end to Hitler's plans. When it was over,

the future World Capital Germania lay in ruins. Speer, who had been minister of armaments, was tried at Nuremberg for using forced labor and sentenced to twenty years in prison. On the day after his release in 1966, he was driven through Berlin. "I saw in a few seconds what I had been blind to for years: our plan completely lacked a sense of proportion," Speer wrote in his memoirs. "The entire conception was stamped by a monumental rigidity that would have counteracted all our efforts to introduce urban life into this avenue."

Where Hitler failed, other twentieth-century rulers had more success. In 1958 Mao Zedong ordered a dramatic expansion of Tiananmen Square, in Beijing, to become the largest square in the world at the time (it has since been surpassed), almost five million square feet, with a capacity of five hundred thousand obedient souls. Just as Red Square became the repository for Lenin's remains in 1924, a mausoleum was built in the center of Tiananmen after Mao's death in 1976 for public viewing of the body of the leader. (One difference between old-style autocrats, such as Caesar, Louis XIV, or Napoleon, and their totalitarian successors is the replacement of the marble statue in the middle of the square with an embalmed corpse.) Forty years after Tiananmen's expansion, in 1989, this vast monument to the Chinese Communist Party became the scene of the most serious challenge to its monopoly on power, when popular demonstrations for democracy were crushed and hundreds, if not thousands, of people died.

Baghdad was once a great imperial city, the seat of the Abbasid Caliphate. After the Mongol invasion in 1258, it was

repeatedly destroyed and went into a centuries-long decline so extreme that it's now almost impossible to locate the ancient city's public places. In the twentieth century, Baghdad became the capital of a modern dictatorship. On the eastern side of the Tigris River, Liberation Square (the spirit of *1984* hangs over more than a few city squares around the world) was built to commemorate the 1958 coup that overthrew Iraq's monarchy and installed a military regime. The square is dominated by the Epic of Liberty, a frieze of expressionistic bronze figures representing the hope of the Arab nation.

On January 27, 1969, residents of Baghdad woke to radio announcements of an important event in Tahrir Square. The Ba'ath Party, which had seized power the year before, had uncovered a Zionist conspiracy. The brutalized bodies of nine "spies"—one Iraqi Christian and eight Iraqi Jews: students, clerks, businessmen—were hanging from scaffolds put up overnight around the square, with a sign around their necks identifying their religion and supposed crime. Within hours, a crowd of at least two hundred thousand people had thronged to the square to hear speeches, sing, dance, and spit on the dead. A Ba'ath Party official exhorted them: "Great Iraqi people! This is only the beginning! The great and immortal squares of Iraq shall be filled up with corpses of traitors and spies! Just wait!" In Baroque Paris, public executions in Place de Grève were entertainment. In Ba'athist Baghdad's Tahrir Square, they were a means to consolidate power through hysteria and terror. A Jewish resident of Baghdad named Max Sawdayee witnessed the scene and recorded it in his diary: "they look like nine angels of

death surrounding the big square, as though to prophesy disasters and catastrophes that will befall this miserable country in the near future."

For the next quarter century, as Iraq went from disaster to catastrophe, Tahrir Square and Baghdad's other public places emptied out. "Conspiracies" continued to be uncovered, and "traitors" continued to be executed in public, but when the regime turned on Muslims and even Ba'ath Party officials, the terrorized citizenry lost its joy in mass spectacles and withdrew from public life. When American marines arrived in Baghdad in April 2003, most Iraqis stayed in their homes, but a small crowd gathered to observe or celebrate the new arrivals a mile south of Tahrir Square, in Firdos (Paradise) Square, the site of two large hotels and a mosque. A year earlier, the regime had erected a forty-foot statue of Saddam Hussein in the middle of the square. When regimes are overthrown, statues in city squares fall. It happened to Louis XIV and XV during the French Revolution; to Napoleon during the Paris Commune in 1871; to Lenin in cities across the East Bloc in 1989. And so it happened to Saddam in Firdos Square on April 9, 2003—but it was the marines, not the Iraqis, who pulled the statue down, using a cable attached to an M88 armored vehicle. News footage gave the impression of a popular uprising against the dictator, but the Iraqis in the scene were largely bystanders: This was an invasion, not a revolution. The incident somehow foreshadowed the tragedy of the misbegotten American occupation of Iraq.

The grandeur of public squares in cities of absolutism, scaled to the glory of the state and its leader, contains the very

seeds of revolution. The larger the crowd, the greater the glory, and the danger. The leader presents himself for celebration—Kim Jong-un, still in his twenties, waving from a viewing platform on the centenary of his grandfather's birth while a mass military parade in Kim Il-sung Square confirms the youngster's status as North Korea's leader. But what if the crowd doesn't follow the script?

A SENSE OF SOCIETY

AROUND NOON ON DECEMBER 21, 1989, ROMANIA'S PRESIDENT FOR life, Nicolae Ceauşescu, appeared in a black astrakhan hat on the balcony of the Communist Party's Central Committee headquarters overlooking Palace Square, in central Bucharest. A few days earlier, protests in the city of Timisoara had been met with brutal violence by the army and security police—the first bloodshed at the end of a year of miraculously peaceful revolutions across the Communist East Bloc. One hundred thousand people gathered in the square to hear Ceauşescu—workers brought in by the busload under threat of being fired; handed flags, signs, and youthful pictures of the dictator and his wife; expected to cheer his every word. The speech was televised live across Romania, to show that Ceauşescu—who genuinely believed himself loved by his people—still enjoyed popular support.

But two minutes into his reading of turgid politburo-ese, from the back of the crowd came the noise of people screaming. It rose in pitch until it sounded like a huge flock of birds or the crashing of water against a glass wall. Startled, Ceauşescu looked toward the sound, stopped speaking, and raised his hand

for quiet. The state TV camera that was fixed on him trembled. It was as if, in that moment, with a look of confusion frozen on the dictator's face, the regime was already finished. A security official in a suit and fedora approached Ceaușescu: "Come into the office." Ceaușescu kept repeating, "Hello! Hello!" while tapping on his microphone, like an old man annoyed by a bad phone line. The security heavy shouted, "Someone back there, he started screaming! There! You—don't move!" The noise in the crowd continued, and it began to fill with jeers. At the dictator's side, his wife, Elena, called out "Silence!" again and again, until Ceaușescu told her to shut up. The live TV feed was cut, but it was too late: The whole country had seen the command assembly of the dictator's subjects turn into furious opposition before their eyes. (Witnesses later attributed the initial uproar to a group of protesters on the edge of the square who were hit with tear-gas canisters.)

When Ceaușescu resumed his speech, he tried to appease the crowd with promises of a higher minimum wage. He denounced the "fascist agitators" behind the uprising, but when a group of workers took up the chant "Timisoara! Timisoara!," Ceaușescu had to abort the speech, and he was hustled by bodyguards through the balcony curtain like an actor forced to flee the stage during a disastrous performance. The massed crowd quickly dispersed, and within a few hours Bucharest was in open revolt. The next morning, after another botched speech from the same balcony (met with rocks), the Ceaușescus escaped by helicopter from the rooftop of the building. They were tracked down in the countryside by rebel soldiers, put through a

ninety-minute show trial, and executed by firing squad on Christmas Day, as Nicolae sang "The Internationale" and Elena shouted, "Motherfuckers!"

Bucharest's Palace Square was the exception in 1989. That year, city squares in Eastern Europe came to life peacefully with the voices of people longing to be free. In East Berlin, Alexanderplatz—the center of Berlin night life during the Weimar years of the 1920s—had been redeveloped by the Socialist Unity Party in the 1960s in a style of Cold War kitsch: at one end, the blue glass slab of the Hotel Stadt Berlin, and the House of Teachers, with a giant mural wrapping around the third and fourth floors that depicts work and life in the German Democratic Republic, where everyone seems to be smiling; the TV Tower, with a revolving viewing platform inside a shiny metal ball perched on top of a twelve-hundred-foot concrete column; and the World Time Clock, with a rotating circular map of the world. The ruling Communists turned Alexanderplatz into a windswept pedestrian zone, as if they had been misreading their Jane Jacobs. In an essay on the square, the German writer Georg Diez describes a woman who lived near it: "The square, she says, was always empty, 'just empty, nothing happening there, you just didn't go over there, that's just how it worked.' A hole in the middle of the city."

On November 4, 1989, the hole filled up with more than half a million East Germans. After weeks of illegal peaceful protests around the country, it was the first officially sanctioned gathering that was not under the control of the regime. Speakers did not call for the end of East Germany, only the end of the dictatorship.

When the head of the foreign intelligence service, Markus Wolf, got up to answer their demands and the crowd booed, his hands began visibly to tremble. One dissident turned to another and said, "We can go now, now it is all over. The revolution is irreversible." Once released, public energy of such intensity runs with a logic that belongs to no one person or group—it belongs to history. Few of the movement's leaders imagined or even wanted the reunification of Germany, but five nights after the Alexanderplatz demonstration, on November 9, East Berliners began crossing into West Berlin through checkpoints in the Wall. The smiles on their faces were completely unofficial.

The Velvet revolutions of 1989 set the precedent for the democratic uprisings of the past quarter century. They all took advantage of the unique possibility for mass gathering offered by city squares. In 2000 it was Republic Square in Belgrade; in 2003 Freedom (formerly Lenin) Square in Tbilisi; in 2004 and again in 2014 it was Independence Square (later Euromaidan) in Kiev; in 2011 it was Tahrir Square in Cairo.

In Tehran, the capital of modern Iran, the closest thing to an iconic assembly place is Azadi—or Freedom—Square. It's a large traffic circle fed by expressways, surrounding a fifty-meter concrete tower-arch in a style that could be called Persian-modernist. Azadi was built according to a master urban plan that was drafted in 1968. It's somewhat smaller than the Maidan-e Naqsh-e Jahan in Isfahan, and unlike the Safavid imperial center, it's miles from the hub of the capital, the Grand Bazaar. Half deserted and barely integrated into the life of the city, Tehran's modern squares were built by the shah to glorify the state and

himself. They were never intended to become instruments of genuine popular will, but twice in the country's recent history, Iranians filled the empty spaces of their squares with mass rallies that were not called by the country's rulers: in 1979, when revolution brought an end to the rule of the shahs; and in 2009, when a stolen presidential election triggered days of peaceful protest, known as the Green Revolution, which was violently put down by the Islamic regime. As Iranians, Egyptians, and others have learned, not all revolutions are irreversible.

During the American occupation of Iraq, Firdos Square became a place where Iraqis went to raise their voices—as if the ersatz revolution of April 9, 2003, had planted an idea of real freedom there. In 2004 hundreds of Iraqis protested the kidnapping of Margaret Hassan, an Irish-born aid worker who had worked with children and the disabled in Iraq for decades— the first time people, some in wheelchairs, some barely in their teens, were brave enough to express their revulsion at the terrorism gripping the country (shortly afterward Hassan was murdered). In 2005 thousands of Shia men loyal to the radical cleric Moqtada al-Sadr gathered in Firdos to denounce the U.S. occupation and demand a government based on Islamic law. During the years following, election rallies were often held there. And in 2011, amid the uprisings in Cairo and across the Arab world, Iraqis rallied every Friday for months in Baghdad's own Tahrir Square—this time not to sing and dance for their government but to denounce its corruption and violence. This was the first instance of public protest against an elected power in Iraq's history. But the Friday demonstrations faded or were crushed, like

their counterparts in other Arab countries, as sectarian and ideological divides broke up the new spirit of mass participation.

Is there a civic purpose for city squares where people are already free? Hannah Arendt described freedom not as individual free will but in terms of acting and associating with others. This kind of freedom requires public space. In *What Is Freedom?*, Arendt likened politics to the performing arts, for "both need a publicly organized space for their 'work,' and both depend upon others for the performance itself."

In democratic countries, political life takes place mainly in houses of parliament, government offices, courtrooms, polling places, on TV and Twitter—not in city squares. The great squares of Europe are now beautiful magnets for tourists and locals who want to be out in the open, eat or drink, shop, and take in the human scene. They are sometimes transformed into stages for public entertainment; they rarely lend themselves to public debate and action. People in Beijing, Tehran, Cairo, or Baghdad might well regard this absence as a luxury. When city squares are no longer needed for mass gatherings, perhaps that's a sign of public happiness.

But publics in the democracies are not very happy—at least not as publics. In the United States and other countries, polls register record levels of estrangement from democratic institutions. There are many reasons, but one that's not often considered is the decline of public places as forums for public life. By this I don't mean just political activity but the state of being connected to strangers in a common enterprise that requires time and effort.

My neighborhood in Brooklyn is safer than many small towns. Everything Jane Jacobs prescribed for cities is here—diversity of uses, eyes on the street. The resurrection of New York and other American cities is a singular achievement of recent years, but it would be hard to claim that it's been accompanied by a resurgence of civic life. Tocqueville's description still applies: "Each person, withdrawn into himself, behaves as though he is a stranger to the destiny of all the others. His children and his good friends constitute for him the whole of the human species. As for his transactions with his fellow citizens, he may mix among them, but he sees them not; he touches them, but does not feel them; he exists only in himself and for himself alone. And if on these terms there remains in his mind a sense of family, there no longer remains a sense of society."

In the first days after the September 11 terrorist attacks, Manhattan below Fourteenth Street was open only to people who could prove they lived there. Union Square, between Fourteenth and Eighteenth streets, became the closest accessible public space to the site of the catastrophe. And without ever being so designated, Union Square became the focal point of the city's grieving. People showed up spontaneously to tape pictures of missing loved ones to fences and statues; they brought flowers and lit candles, carried signs, chalked messages on the pavement, said prayers, and lingered for hours—because they wanted to be with others, with strangers, to whom they felt a sudden tie. An extreme moment returned the city square to its central role in public life. Nothing else could take its place.

Inevitably, over time, the crowds and memorials disap-

peared. Union Square went back to being a transit hub, a dog walk, a farmers' market, an outdoor shopping mall at Christmas.

Ten years to the week after the attacks, and two miles south, a few hundred protestors took over an obscure little square in the shadows of lower Manhattan's skyscrapers, right across from Ground Zero, called Zuccotti Park. They were protesting the role of the big banks in the financial crisis, and they adopted the name Occupy Wall Street, which quickly went viral over Twitter. Zuccotti Park was privately managed by a property company that was required to keep it open to the public twenty-four hours a day. This gave the protestors the idea of spending the night on the square's granite pavers, and the next night, and the next.

Zuccotti Park was renamed Liberty Square by its occupiers, in homage to Cairo's Tahrir Square, scene of the Egyptian revolution earlier that year. The sidewalk along Broadway became an assembly place where the occupation and the public encountered each other—a continuous forum for sign waving, readings, conversations, arguments. A sign held by an old man in a golf cap and sport coat read: "For: Regulated Capitalism. Against: Obscene Inequality. Needed: Massive Jobs Program." Another said simply: "Something Is Wrong." The middle of the square was given over to the various functions of the occupation—a kitchen under a tarp, a comfort station with essential supplies, a library, a video studio, a recycling site where people composted food waste and pedaled a bike to generate battery power. At the western end, opposite Ground Zero, an anarchic drum circle pounded out noise day and night. Around the

square, hard-core occupiers—some of them homeless—staked out spots for sleeping bags and pup tents.

The occupation dominated public attention in New York for two months in the fall of 2011. It created spin-offs around the country and the world. At times thousands of people thronged Liberty Square. Tour buses put it on their routes, and countless New Yorkers ventured downtown, if only to see. I went almost every day for weeks, sometimes without intending to, and as I mixed with my fellow citizens, I saw them and I felt them. Perhaps because Ground Zero was so close, I kept thinking about the days after September 11. Liberty Square awoke vague hopes, vague longings, in me and many others. But it couldn't last.

The noise and crowds became a nuisance to the neighborhood, and there were reports of public urination and defecation. As the occupation wore on and the chronically homeless settled in, fights became common, especially at night. City officials were impatient to clear the square, but negotiations went nowhere. The occupation finally ended with a police raid in mid-November, when the leaves on the honey locust trees were starting to yellow, and Zuccotti Park returned to its normal use.

Liberty Square held a strange appeal. It had to do with the sense that something was wrong, but even more, with the phenomenon of the square itself. Raggedly, half-consciously, it took on the spirit of the agora. Here was a modern city square used for its ancient purpose. Not just commerce or entertainment, not private pleasure in public space, but the purpose of democracy face-to-face. It turns out to be a fundamental need.

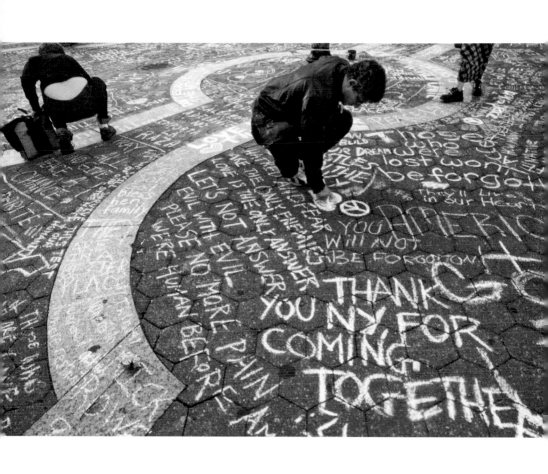

SUSAN MEISELAS; *overleaf:* JEROME SESSINI

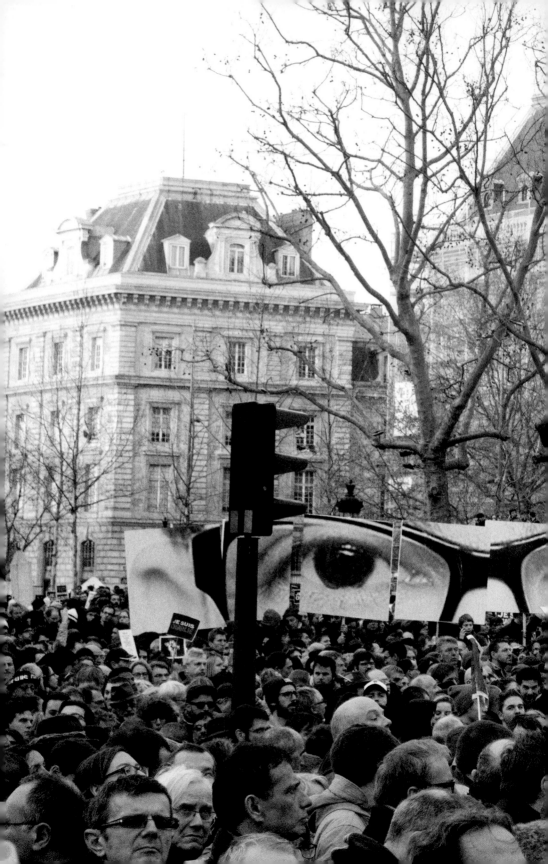

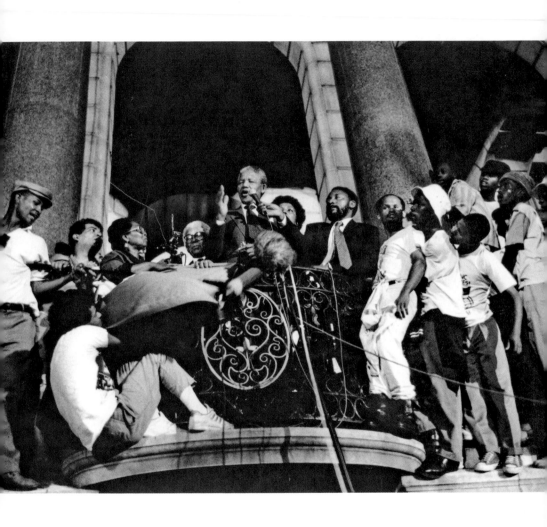

CHRIS LEDOCHOWSKI

GRAND PARADE, CAPE TOWN: A SPEECH FOR THE AGES

Richard Stengel

THE FIRST THING NELSON MANDELA DID AFTER GETTING OUT OF prison was to get lost.

On a bright January afternoon, after twenty-seven years behind bars, Mandela strode confidently out of Victor Verster Prison in Cape Town, his wife, Winnie, at his side, a smile on his face and his ex-boxer's right fist clenched above his head. Surrounded by a crowd just this side of hysterical, he got in a borrowed Toyota Cressida to head to the Grand Parade in Cape Town, where he was to speak to the world for the first time in all those years. The only problem was the driver became so panicked by the crowds swarming the car—Mandela later told me the banging on the roof sounded like a giant hailstorm—that he accelerated onto a highway and drove wildly for twenty minutes or so before Mandela and others persuaded him to slow down, get off the highway, and pull over. When he finally did stop, they found themselves on Tantallon Road, a narrow tree-lined street in the pleasant all-white suburb of Rondebosch, a little over four miles from the Grand Parade. They stopped to regroup and try to figure out how to get to the city's iconic square, where more than a hundred thousand people were waiting.

In fact, they were parked in front of the home of Vanessa Watson, a researcher in urban studies, who was inside sitting in front of her television, waiting—like everyone else, including a global television audience in the hundreds of millions—for Mandela to emerge on the Grand Parade. A friend came in and told her that Mandela was not at the Grand Parade at all but parked in front of her house. She was skeptical, to say the least. But she grabbed her one-year-old twins, a boy in each arm, and marched into the front yard. There was Mandela in the backseat of the Toyota. She gave him the power salute with her right hand (without dropping her son), and he beckoned for her to come over. Mandela rolled down the window and politely asked, "May I hold your baby?" Vanessa Watson's one-year-old son Simon was the first baby he had held in twenty-seven years.

MANDELA FINALLY MADE IT TO THE GRAND PARADE OVER THREE hours late. He ascended to the small graceful balcony of Cape Town City Hall, a sandstone-colored colonial building completed in 1905 that commanded the entire square. So many people wedged themselves on the narrow balcony that it would have been comical if not for the fear that it would collapse. By this time it was dusk, and Mandela overlooked a crowd of happy but very restless people. He was handed his speech in a binder. Realizing that he had left his reading glasses at the prison, he borrowed his wife's oversize glasses, raised his right hand in a fist, and called out: *"Amandla!"* (Power!) The crowd responded: *"Awethu!"* (The power is ours!)

Two days before, when South African president Willem de Klerk told Mandela that he was going to release him, De Klerk wanted to fly Mandela to Johannesburg. Mandela said no. He wanted to walk out of prison in Cape Town. In a curious way, he felt that Cape Town, South Africa's loveliest and most diverse city, was his home. After all, he had spent the last twenty-seven years of life in and around Cape Town. For almost half that time, he could see it winking in the distance from the shores of Robben Island. He identified with it. He had longed for it. He had yearned to walk around it as a free man. He wanted to greet his people there. De Klerk reluctantly agreed.

So, the planning began. After nearly three decades in prison, Mandela had one day's notice that he was being released. He knew he had to give a speech. A speech that would be seen by all of South Africa and billions of people around the world. What would he say? Where would he give it? For that latter question, there was really only one place: the Grand Parade, the heart of the heart of Cape Town.

In South Africa, Cape Town is often referred to as the Mother City, because in many ways it is the soul of South Africa. Johannesburg is larger but charmless. Durban is fun, but insular. Cape Town tumbles down from Table Mountain to the Indian Ocean and is heart-stoppingly lovely. It is the country's most diverse city, with large populations of blacks, whites, and the so-called native colored population. It has art and music and is conspicuously laid-back. It was also, at the time Mandela was released, boiling over with anger and frustration at apartheid.

———

THE FIRST WESTERNERS—MERCHANTS FROM THE DUTCH EAST India Company—arrived in Cape Town in the seventeenth century and promptly built a fort on what is now the Grand Parade. They called it the Fort of Good Hope, and it included space for crops and cattle. Surrounding the fort was a sixteen-foot-high wall to protect them from lions and other predators, setting the building template for three hundred years of white South Africa history. White South Africans loved walls. Walls meant safety and security. Walls kept the animals and the indigenous people out. Every year the walls seemed to grow higher and sturdier, and beginning about twenty-five years ago, they were topped with razor wire and elaborate alarm systems.

The area became known as the Grand Parade because it was where military parades were held from the earliest days through the beginning of the twentieth century. South African troops did their exercises and training there. Its role was military, commercial, and judicial, or what passed for it. In the nineteenth century, it was the scene of slave auctions and public hangings, all in line with the rigid Calvinist authority that then prevailed. Its later use as a protest area against apartheid was presaged when it was used for marches in the 1800s by local residents upset at British plans to dump unwanted convicts from England at the Cape.

City Hall, which is the centerpiece of the Grand Parade, was built in 1905 out of honey-colored limestone imported from Bath, England. Pretty much everything else about it was imported from

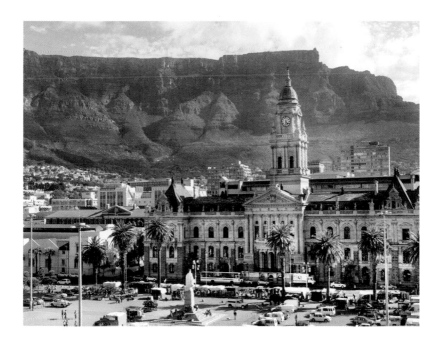

England, too, including all the windows, doorknobs, and an organ with 3,165 pipes. It's often described as Italian Renaissance architecture, but that must be by people who haven't really looked at the building. It's pretty much fussy Edwardian colonial British architecture; it even has a stubby version of Big Ben atop it.

Of course, the African National Congress—Mandela's political party—could have chosen a black township for Mandela to speak. And Cape Town had a vast one—Khayelitsha. But it would have been deeply impractical. The townships have no infrastructure and hardly any electricity. Even in 1990, no people of color were legally allowed to reside in downtown Cape Town. But in choosing the Grand Parade, Mandela and the ANC were choosing the place that symbolically stood for Cape Town. At

the time of his release, it was a city that stood for apartheid but also for the Rainbow Nation that Mandela believed South Africa could become.

The even simpler reason is that there was just no place else in Cape Town that could accommodate tens of thousands of people. The Grand Parade could because the Grand Parade was essentially a parking lot. A multiple-football-field-sized parking lot, and a particularly ugly one, at that. Imagine a vast parking lot in front of the White House or Buckingham Palace or the Taj Mahal. Cape Town City Hall should have a great green lawn stretching in front of it, or a manicured French garden, or even a three-story fountain, as was once contemplated by the city's fathers. Instead, it is set in a flat paved expanse that doubles as a market a couple of times a week—and not a high-end market but one of scruffy men in front of tarpaulin tents, hawking cold drinks and fish and chips and sausages and samosas and woven baskets and all manner of African tchotchkes.

But this was where Capetonians gathered. Only six months before, some thirty thousand people—black, "colored," white—marched in the Grand Parade in support of the end of apartheid. For years, the Grand Parade had been a place of protest, sometimes violent, sometimes peaceful—but always the stage for the city's most important events.

But I'm not an expert in how the Grand Parade fits into the life and architecture of Cape Town, so I called someone who is: a distinguished professor of urban studies at the University of Cape Town, Vanessa Watson.

Watson lives in the same suburb where she was living

when Nelson Mandela dropped by her house on his way to the Grand Parade. The baby boy whom Nelson Mandela held is now a twenty-four-year-old law student. Watson speaks in a firm voice with a strong South African accent. She says it was logical that the ANC would have chosen Grand Parade: "It's the largest and most important public space in Cape Town. It's the most iconic meeting place. The obvious choice. "

She describes the parking lot as "unfortunate" and notes that the Grand Parade was close to the coast until a major land-fill in 1940 put it significantly farther away. In 1990—and still today—it was a bit bedraggled, with nothing like the grandeur that it ought to be able to muster.

As a scholar and an advocate on urban planning, Watson is very keen that African cities not emulate the glass-and-steel boxes of the West. She notes that as gorgeous a city as Cape Town is, it is also ranked by the UN as one of the most unequal cities in the developing world. The city has Africa's most expen-sive real estate, while one quarter of the houses in the townships lack running water. At the end of our conversation, I ask if she ever talked to Mandela after that day. She says she saw him a few times but never talked to him again. Still, her boys' lives were shaped by that singular summer afternoon they were too young to remember.

When Nelson Mandela ascended to the balcony of City Hall, no one had heard him speak in twenty-seven years. No one was sure what he looked like. Under apartheid law, it was then illegal to possess a photograph of Mandela. He was no lon-ger the forty-year-old firebrand who went to prison in 1961. He

was no longer a young man. He was seventy-two. His hair was flecked with gray. He was more slender than the burly, bearded revolutionary who went to Robben Island. But he was tall and imperially slim and had a kind of grace and presence—someone called it a combination of African royalty and English aristocracy. His posture, like his suit, was impeccable, and his smile was, well, luminous.

The scene on the balcony looked a little like a Marx Brothers skit—impossibly crowded, disorganized, everyone looking a little too self-important. Mandela, in a trim gray suit with a white pocket square, was an island of calm. There was no podium. No stage, no natural center. Cyril Ramaphosa held a microphone in front of Mandela. "*Amandla!*" Mandela said in his foghorn-ish voice. The crowd roared in return.

And then Mandela began reading from the text: "Comrades and fellow South Africans, I greet you all in the name of peace, democracy, and freedom for all. I stand here before you not as a prophet but as a humble servant of you, the people. Your tireless and heroic sacrifices have made it possible for me to be here today. I therefore place the remaining years of my life in your hands."

He mostly kept his head down, adjusting his wife's glasses every once in a while. He dutifully saluted and paid tribute to many people at the outset of the speech. He was always scrupulous about formality. I used to tell Mandela that he was a far better speaker when he was not reading a text, when he was speaking spontaneously, or when he smiled or got angry. He would look at me like I was hopelessly naive and superficial—he was

generally more concerned about the text of the speech than the audience's reaction to it. And on that day, that speech, he wanted to make sure it was right. As he said over and over that day and the days that followed, "I am a loyal and disciplined member of the ANC." And he tried to appear so. In his first speech to the world, he wasn't prepared to wing it.

On that day, he had one great task: to project calm and control and resolve. White South Africans and the Nationalist government needed to see that Mandela was a man they could do business with, not a demagogue or a firebrand. Black South Africans needed to see that he was resolute and not out of touch with the struggle. Prison had prepared him for this day. Prison had changed him. It had steeled him. It had given him and made him appreciate self-control. Mandela thought political leaders should speak with reason and moderation: that they should be measured. South Africa was at a knife's edge—it easily could have descended into civil war—and he did not want to incite anyone to violence. This was his first day of freedom in almost three decades, and he wanted to stay in control.

His speech was seen all around the world. It lasted half an hour, and as with everything else in our culture, people saw bits and pieces of it, snippets on the news. What people wanted to see was not only what he looked and sounded like but what kind of leader he was. And no matter how short the excerpt, everyone saw something they recognized in an instant: He was "measured." He was a revolutionary in a three-piece suit.

Mandela's speech was also part of a long tradition. At its essence, he was the man in the arena—a lone individual in front

of a great crowd in a great public square on a great occasion. There's something about a speech outdoors in front of thousands of people that is indelible. It is the speaker against the elements, against nature. Indoors, even in arenas, the space is closed, more manageable. Outdoors, it's hard to control where one's words go. It is said that Demosthenes used to practice speaking on the beach to try to project his voice over the roar of the waves. The projection of the sound on the Grand Parade was pretty terrible. Thousands of people could not hear a word Mandela was saying. So the crowd stirred, and cheered, of course, but mostly, they watched the gray-haired ex-prisoner with the oversize glasses in the distance.

From Pericles' funeral oration to Lincoln's Gettysburg Address to Obama's speech at the Siegessäule in Berlin, men—and women—have been speaking in city squares to great crowds of people. There is a great historical nexus between cities and democracy, between squares and civilization. The Latin root for the word "city" is *civ* or *civis,* which is also the basis for "civic," "civilization," "citizen." The city is the foundation of civilization, and the heart of the city is the square. The speaker in the square is talking to the "demos," the people, which is the root for "democracy." It is men and women speaking to the "polis," the collection of citizens that is the root of the word "politics." It is the history of how we rule ourselves as human beings.

Mandela spoke for thirty minutes. He had started as the sun was setting, and now it was night. The only light came from the torches in the crowd and the bright halos of the television cameras. He spoke of the struggle, of democracy and freedom,

of the necessity of universal suffrage, of a united and democratic and nonracial South Africa. He proclaimed: "Our march to freedom is irreversible."

When he looked up from his text, it was dark. The crowd had settled down, but people were milling about. There was still a restless energy. And they were still not yet free. Now the speech was over, the lights and cameras were turning off. Mandela put down his glasses, looked out at the crowd, and said in a very firm voice: "I hope you will disperse with discipline. And not a single one of you should do anything which will make other people say that we can't control our own people."

Mandela's speech was nothing like Martin Luther King's famous "I Have a Dream" speech, with which it is sometimes compared. It was not soaring or emotional or cathartic; it was not meant to be. Instead, it was a sturdy bridge between two worlds, two eras in history, between a repressive past and a more democratic future. Over the next decade, Mandela would expertly navigate that bridge and usher in a democratic, nonracial South Africa. Just as the Grand Parade itself had made the transition from a place of slave auctions to a tableau for freedom, great speeches are often seen as signaling the end of an old world and the beginning of a new one. Often that is only in retrospect, but in the case of Mandela's speech on the Grand Parade, it was happening in real time—at a very dangerous time—in front of tens of millions of people around the globe who were witnessing a transition to a new world. Mandela's speech at the Grand Parade was the first window into that new world.

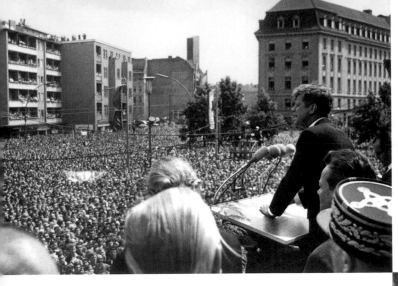

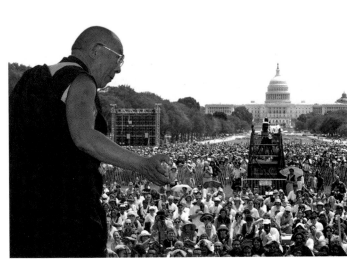

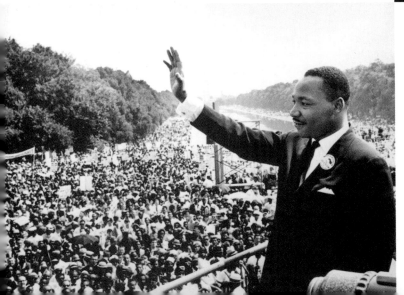

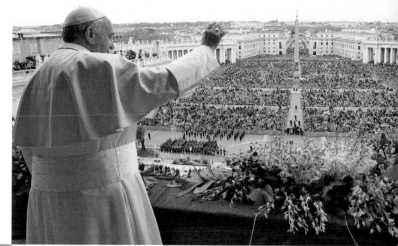

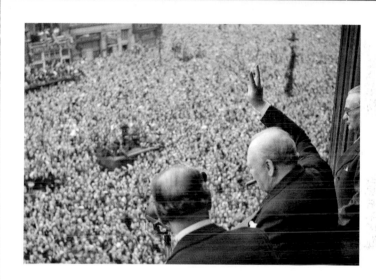

OBERTO GILI

RESIDENTIAL SQUARES, LONDON: A MEANDER THROUGH SPLENDOR AND SQUALOR

Andrew Roberts

> A black shrill city, combining the qualities of a
> smoky house and a scolding wife; such a grisly city,
> such a hopeless city, with no rent in the leaden
> canopy of its sky.
>
> —Charles Dickens, *Our Mutual Friend*

PERHAPS MORE THAN ANY OTHER EUROPEAN CAPITAL, LONDON
has always presented a startling juxtaposition of splendor and
squalor. Even today, when extravagant skyscrapers such as the
Shard are transforming the city's skyline, it is still possible to see
London's history in its streets—medieval buildings built over
Roman ruins next to Georgian townhouses and Victorian civic
pomposities. The architecture of London might be viewed as the
objective correlative to the conundrums of the English constitu-
tion, imprecise yet solid, curiously formless and yet possessed,
over centuries of precedent, of an intangible security. In con-
trast, continental absolutism might persuade of greater aesthetic
advantage, yet the ordered regularity of Paris, for example, lacks
precisely that variety in which Charles Dickens and William Ho-
garth, those most metropolitan of British artists, rejoiced.

Leicester Square, where a young William Hogarth moved

in 1733, epitomized even then the London environments that the painter made his own, the tumbling anarchy of the ancient city set against the clean elegance of the newly fashionable Palladian style. To either side of Oxford Street, the landscape presented a curious combination of urban grandeur and semi-rural grubbiness. In the ramshackle sprawl of eighteenth-century London, the city's squares therefore acted as markers in the ever changing cartography of social class. Leicester Fields, as the site was first known, lies just to the west of Covent Garden, occupying four acres in the parish of Saint Martin's. It is named after Robert Sidney, the second Earl of Leicester, who began building on a house at the north end in 1630. When Hogarth arrived, Leicester Square occupied a unique point in the nexus of metropolitan ambition; it was where mundane existence ended and aspiration began:

> In cold wintry sun, a person who made his way through the drunks and spilled vegetables on Long Acre . . . might emerge onto the Square as from a forest of wild animals into a tranquil glade.
>
> —Hannah Rennier, *London Historians Series,*
> "Hogarth in Leicester Square"

Hogarth was to live on the square for thirty years, becoming a fixture as he took his early-evening constitutional in his red cloak, accompanied by a small dog. From here, he made the city his canvas. Greedy London was bursting its boundaries, swelled by great drafts of luxury, bulging westward from the confines of the old city to the stucco facades of the squares constructed

for the rich. Joseph Addison observed how every corner of the nascent empire was ransacked to produce the fashionable dress and accessories of a single grand lady, how the city was dizzy for pleasure, balls and masquerades, china and chocolate, dancing masters and hairdressers, exquisite furniture, delicate perfumes, for everything novel and fine. Yet from Leicester Square, Hogarth could see another London, that of pickpockets and procuresses, Swedish, Dutch, and French painters crammed into cheap, filthy lodgings to the south of the fields, the despairing inmates of the workhouse around the corner on Castle Street. In Leicester Square, Hogarth painted *The Rake's Progress* and *Industry and*

WILLIAM HOGARTH, *GIN LANE*, 1751

Idleness; he captured the deceptive splendor of fashionable life in *Marriage à la Mode* and the appalling consequences of poverty in the squalor of the notorious popular print *Gin Lane.*

By the 1760s, when Sir Joshua Reynolds moved in at number 47 (and singularly failed to invite Hogarth to his smart soirees), Leicester Square had reached its peak of fashionability. The widowed mother of George III, Princess Augusta, was installed at Leicester House, with the Duke of York next door at Savile House and two of the king's brothers occupying numbers 28 and 29. Yet the area remained haunted by the raffish

ALVIN LANGDON COBURN

uncertainty of Hogarth's pictures, the sense that seemingly solid backdrops were about to swirl into chaos. Designed as a grand residence, Leicester House was nonetheless fronted not by walls and gates but by four "sordid" wooden shops, and despite the building's later occupation by Frederick, Prince of Wales, the area never quite achieved the status of subsequent aristocratic developments. Leicester House was demolished in 1791, and in the nineteenth century, Leicester Square became an entertainment venue, as it remains today. Native Londoners seldom visit the square now, leaving it to tourists and visitors from out of town, yet the area retains a certain Hogarthian spirit, an excess of life both alarming and vigorously joyful.

Hogarth's legacy is also audible in Dickens's work, that same energy and precision in the drawing of scenes and characters, the refusal to refine deformity (either moral or physical) but, rather, a relish of it. Like Hogarth, Dickens uses London's geography, in particular its squares, to map the minute class gradations of his nineteenth-century city. In *Nicholas Nickleby*, Mr. and Mrs. Witterley "look down on Sloane Street and consider Brompton low," while conceding that as residents of Cadogan Place, they do not occupy "precisely the same footing as the high folks of Belgrave Square."

Unlike the majority of developments for the wealthy, Belgrave Square was a relatively late architectural arrival—until 1824 the area was known as the Five Fields, a country district "intersected by mud banks and occupied by a few sheds" (John Timbs, *Curiosities of London,* 1867). Five Fields was considered highly insalubrious, until the architect Thomas Cubitt ascertained a

method for draining the land and engaged with the Marquis of Westminster to cover large portions with new houses for affluent Londoners. Belgrave Square took its name from a village near the marquis's family seat at Eaton Hall in Cheshire. Forty-four splendid stuccoed houses, divided into four terraces, were designed by George Basevi, and most were occupied by 1840. Belgravia was thus born of a builder's speculation and soon attained the pinnacle of smartness that it retains to this day. Nineteenth-century writers immediately bemoaned its expense and pretentiousness: "The pleasant country homes of England are despised, their occupants . . . content to resign their prominence," lamented W. S. Gilbert (of Gilbert & Sullivan fame) in 1870.

Nowhere was grander than Belgravia, and nowhere more extravagant. Residents were warned that they would require "Fortunatus's purse" to keep house there, while even aspiring servants refused to wear livery, as it did not suit their "society." For much of its twentieth-century existence, and in the present, the square has been occupied by embassies, including those of Germany, Romania, Austria, Serbia, Spain, Portugal, Bahrain, Norway, and Turkey. Though it may once have been the haunt of aspiring celebrity criminals, contemporary observers swiftly characterized Belgrave Square's chief attribute as being a rather deathly somnolence:

> So great is the change from the roar and rattle, the crowd and confusion, the stream of omnibuses and cabs and men and women that fill the length of Piccadilly and Knightsbridge, to the quiet, stately, wealthy, aristocratic,

and somewhat dull-looking district known as Belgravia. In this picture an attempt is made to represent a view of Belgravia about that time of the afternoon when the nearest approach to movement and liveliness takes place. Even then a certain unruffled calm seems to prevail everywhere.

—Richard Doyle, *Bird's Eye Views of Society,* 1864

From squalid to soporific, the problem with Belgrave Square remains that it is *dull.* When in 1938 the fledgling publisher George Weidenfeld arrived in London as a Jewish refugee from Austria, he made his way to Belgrave Square carrying the scribbled address of a boardinghouse in his pocket. A fashionable party appeared to be under way, but Weidenfeld was confused by his chilly reception. The policeman on duty in the square cleared up the mystery for him. It was not the home of Chips Channon, the society MP and diarist, that he sought, but a cheap hotel on Belgrove Street, not far from the district known as Bloomsbury. Decades later, George—by then Lord—Weidenfeld was to publish Channon's diaries, and his flight across Oxford Street echoed an earlier literary escape, that of the young Virginia Stephen, soon to be Woolf, from stuffy Kensington to the Bohemian freedoms of Fitzroy Square.

Fitzroy Square, now part of a conservation area, is often considered one of the most beautiful of London's squares, embodying the ambitions of the eighteenth-century Whig aristocracy to create healthful, open city architecture where a shared symmetry of vista might promote social harmony. Nonetheless, it has always possessed a somewhat raffish reputation, perhaps

inevitably, as it is named for Charles Fitzroy, the illegitimate grandson of Charles II by his mistress Barbara Villiers, Countess of Castlemaine. The square was developed by his descendants in the eighteenth century, with terraces by the Adam Brothers, and soon became one of the capital's most fashionable address-es. However, the strained economic atmosphere produced by the Napoleonic wars halted progress on the square, leaving the north and west sides unfinished, rendering it a "resort of the idle and profligate," according to a report in 1815 by the Squares' Frontages Committee, an organization so marvelously pedantic that it might have been named by Dickens himself.

Eventually completed in 1835, Fitzroy Square, and the dis-trict of Bloomsbury as a whole, was by then dubious, if not ne-farious: like Belgrave Square, a sometime resort for criminals. When the twenty-five-year-old Virginia Stephen and her brother Adrian moved to number 29 in 1907, they were still shaking off the trepidations of their Victorian upbringing. They had made the move to Bloomsbury proper some years earlier, but it took a visit to the local police station and an assurance that the an-archists' academy at number 19 had closed down to convince them of Fitzroy's security. Virginia loved her new home. "All the lights in the square are lighting," she wrote, "and it is turning silver grey, and there are beautiful young women still playing tennis on the grass." During the four years that she lived there, she completed her first major novel, *The Voyage Out,* which in-troduces the character of Clarissa Dalloway, protagonist of her most metropolitan work, *Mrs. Dalloway.*

Fitzroy soon became a hub for the Bloomsbury Group:

The painter Duncan Grant kept a studio at number 22, Roger Fry's Omega workshops were at number 21, and John Maynard Keynes occupied number 26. An earlier artistic generation was represented by George Bernard Shaw, who had lived with his mother for a year in 1898 at number 29. The plaque on his house reads, "from the coffers of his genius he enriched the world," but however splendid his literary reputation, the Shaws' domestic situation was apparently sordid. Lucinda Shaw, like many Bloomsbury women, preferred to occupy her time in more ethereal pursuits than housekeeping—in her case, communication with the spirit world. Virginia kept up the tradition, working in "frightful disorder, almost squalor," and though she and her brother revived their earlier tradition of Thursday evenings, when figures who were to become some of the country's leading intellectuals gathered for conversation, the catering was dismal. Herring and tripe featured on the supper menus, where there was supper at all, for as Duncan Grant gloomily recalled in a 1970 broadcast: "There was little to eat or drink. In those days, drink wasn't considered necessary. There was always coffee to start with . . . and buns perhaps to eat. But nothing very much. Wouldn't have done at all now."

Back in Belgravia, fashionable dinners served *à la Russe* consisted of two soups, two fish dishes, and four entrées, with two "removes" and at least a half-dozen entremets. No wonder Fitzroy dishes such as "Studio Omelette" or "Turkish Citrus Fruits with Pork Chops and Crushed Sage" felt like adventurous modern escapes from Edwardian stuffiness, though for the servants without whom the Bloomsberries wouldn't have

considered existing, life below stairs continued in Dickensian, if not Hogarthian, conditions (Jane Ondaatje Rolls, *The Bloomsbury Cookbook*).

Fitzroy Square was one of the most playful, happy periods in Virginia Woolf's time. Toward the end of the war, she and her husband, Leonard Woolf, moved to Hogarth House in Richmond. The Woolfs' publishing house, the Hogarth Press, was named for the property, and it was from Hogarth House in 1929 that Virginia wrote *A Room of One's Own*.

THE GREAT LONDON SQUARES—WHICH ALSO INCLUDE SAINT James's Square, Bedford Square, Grosvenor Square, Portman Square, Russell Square, Trafalgar Square, Soho Square, Parliament Square, and Berkeley Square—represent the highest form of civilized urban life in Britain and her commonwealth. The Whig aristocrats—who so often brought them into being from the seventeenth to the nineteenth centuries—perceived a new design for living, one that would mix open discourse, so vital for the new democracies that were evolving, with polite social intercourse between the sexes. They encouraged in the common areas they shared a burgeoning, and largely new, sense of community, albeit one largely restricted to the upper-middle classes who could afford houses around their perimeters. The day of the vast central London landowning empires were by no means over—as the continued existence of the Grosvenor, Howard de Walden, and Cadogan Estates today will attest—but they were capable of coexisting generally contentedly with the propertied classes on whose properties theirs abutted.

Class consciousness existed in minute gradations, of course—this was England, after all—but it didn't lead in London to the kind of sanguinary excesses seen during the French Revolution. No British squares featured guillotines in them, as did the Place de la Révolution (today's Place de la Concorde). The British aristocracy had shown its capacity to evolve in part by promoting the garden square revolution in a way that the ancien régime aristos plainly hadn't, and as a result, they survived. As well as being a cultural, social, and economic phenomenon, therefore, the London square was a political one, too.

In his elegiac 1941 song "London Pride," Noël Coward sang of how:

> In our city, darkened now,
> Street and square and crescent,
> We can feel our living past
> In our shadowed present.
> Ghosts beside our starlit Thames
> Who lived and loved and died
> Keep throughout the ages
> London Pride.

The squares of London were "darkened" then because of the wartime blackout, but they nonetheless represented the brightest hopes and achievements of the Whig enlightenment. In the present day, free of those shadows, they still do.

Following two spreads: OBERTO GILI

239

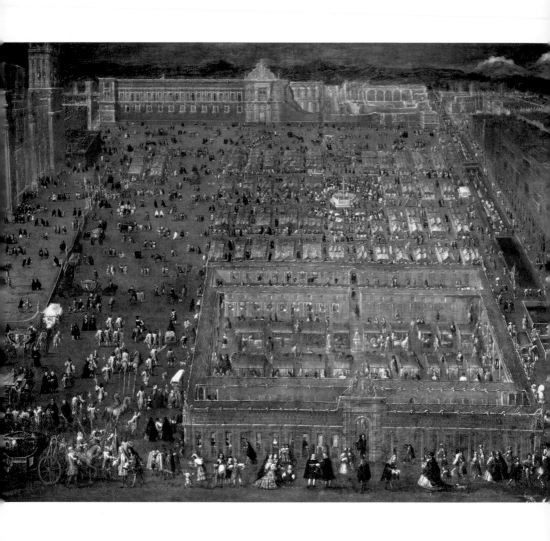

CRISTÓBAL DE VILLALPANDO, *LA PLAZA MAYOR DE MÉXICO*, 1695

ZÓCALO, MEXICO CITY: ON SACRED GROUND

Alma Guillermoprieto

IN MY FIRST CHILDHOOD MEMORY OF CHRISTMAS, THE GREAT plaza of the Zócalo, infinite in its sweep and grandeur, is alive with lights of every color that seem to float in the night, describing arcs of holly, poinsettias, Christmas bells. Like me, they seem suspended in midair. I am levitating in a state of wonder, one hand in the larger ones of each parent, who keep me safe from the crowd. Nearsighted, I cannot tell that the floating lights are embroidered on a net suspended above the majestic avenues that skein out from the plaza. I see only the dark expanse of an esplanade large enough to contain a city: the happy shadows of other families floating by, holding their own dizzy, chattering children by the hand, the massive darkness of the cathedral to one side and the colored lights in space. As a special treat, I am allowed a lollipop, a giant swirl of colors as glowing as the lights, but I am

too stunned to do anything but hold it in my fist and reach out again for my father. Later, at home, we will remember this night as an achievement, a pilgrimage safely accomplished: My father has taken his family to see the Christmas lights in the Zócalo.

For my cousins and me, the Zócalo is the center of the universe, and ignorant though we may be at our small age, we are not wrong. The very spot where I stood marveling at the lights was the beating heart of a vanished world, the seat of a most powerful empire, the sacred navel of a civilization that had not four but five points to its compass; east, west, north, south, and up-down, the axis mundi. At the center of this quincunx, surrounded by water, was the great island-city of Tenochtitlan, capital of the all-powerful Mexicas, and at the center of the island was the navel of the world, the grand ceremonial plaza with its magnificent painted palaces and temples and the twin pyramids dedicated to the gods of rain and war, totemic gods of the Mexicas, whom we know today as the Aztecs.

At the heart of the ancient world, the great cosmic dances took place on high holy days: hour upon hour of rhythmic clockwise and counterclockwise shuffling and stomping prayer; a hundred dancers chanting hymns, breaking and forming circles and snaking through the plaza, stamping on the ground to make the earth deities listen, feathers shivering on elbow circlets and headdresses to make the wind take note. And finally, a shaman offering a human heart at the summit of the pyramid-mountain, a life offered so that life might continue.

In 1519 the Spaniards came bearing Christmas, guns, and disease. The conquistadors drained the lake, tore down

the pyramids, destroyed the statues, burned the sacred books, enfiefed the remaining population, and built the grandest city of Old or New Spain on the Aztec ruins. The great palaces of Hernán Cortés and his men were faced with quarried stone from the pyramids of Tenochtitlan.

And so the Zócalo emerged: the National Palace facing west, the cathedral to its right, the twin municipal buildings opposite, and on the eastern face, commercial buildings and the grand, creaky Hotel Majestic. In its early years, the Zócalo was a proper if oversize plaza, with fountains and statues. There was a market for the silks and porcelains brought over on the China boat.

In my childhood, trolleys circled the square, which was ornamented with greenery and clipped hedges. By the mid–1960s, the plaza had assumed what is perhaps its rightful shape; a vast, flat, sterile surface: forty-seven thousand square meters in which the main decor is provided by the cheerful, noisy people who like to crowd themselves into it—it takes a hundred and fifty thousand or so to make the plaza pop. Sometimes they simply *pasear*—stroll and rubberneck and eat ice cream and chat. Sometimes they listen to groups like Los Tigres del Norte or the venerable rock band Maldita Vecindad. Often they demonstrate against the government and/or in favor of an opposition leader. But mostly, they come to feel their wealth in numbers. For young Mexicans, a Zócalo packed back to belly with their brethren is a satisfying achievement in itself.

As an adolescent, I haunted the Zócalo and its environs, always with the dizzy awareness that I was stepping on layers

of history, on sacred ground: Here are the streets that were once canals, there is the site of the pre-Hispanic market that is still standing. My friends and I loved the neighborhood of La Merced, right behind the plaza, with its noisy sellers and ancient warehouses, each one stacked to the roof with every variety of loofahs or dried chiles, or cactus paddles or plastic buckets, tin braziers—*anafres*—or wheelbarrows or tomatoes. We were drawn by the mystery of the decaying palaces in the neighborhood, so many of them turned into *vecindades* (squalid multifamily residences) with latrines in a second or third courtyard toward the back, once palatial rooms toward the front, a whole family now crowded into each, and in the blue light of dusk, a woman in the first courtyard preparing her *anafre* to make quesadillas to sell, fanning the fragrant coals as we waited impatiently for a first taste of corn, chile, squash blossoms to kindle a light in the cave of our mouths.

A skip and a jump from the plaza was the place I most loved to visit: the Museo Nacional, a former palace stuffed to the rafters, like the warehouses in La Merced, with pre-Hispanic pots and gods and sacred masks, a marvelous jumble where I could always find some treasure in the display cases—a tiny jade mask, a funny earthenware jar in the shape of a fat little dog—that I could visit time and time again. The museum was just behind the National Palace, which was the former palace of Hernán Cortés, built in turn on the rubble of the palace of the great emperor Moctezuma. I made friends with artists and poets, and in the section of the palace that was open to the public,

they traveled slowly with me along the Diego Rivera murals and taught me how to look.

The palace was still, in a sense, the navel of the world then; it was the seat of office of our remote, all-powerful president, and most of the building was off-limits. Like Moctezuma before him, the president was largely invisible as he conducted the nation's affairs, but there was a public viewing once a year on the night of September 15, when he presided over our country's most important political ritual. The date commemorates an uprising by the native-born *criollos* of Spanish descent against the Spanish crown, a revolt that, after many bloody years, finally led to Mexico's independence. Our liberty bell—tolled at midnight in the little town of Dolores by the radical priest Miguel Hidalgo to start the uprising—hangs now above the central balcony of the Palacio Nacional.

In my memory, the name of the man who was president the year I went to the September 15 ceremony is irrelevant. What

MÁXIMO PACHECO, *EL ZÓCALO* (DETAIL), C. 1929-36

mattered then was, once again, the great stage of the Zócalo, the place where we went to become Mexican: the happy multitudes—many times larger than the crowds of my childhood—the mariachis playing on makeshift platforms at the four corners of the plaza for exuberant folkloric dancers, the multicolored streamers and eggshells filled with confetti, the corn on the cob roasting on *anafres,* and then the silence that fell at eleven o'clock sharp as the president appeared on the central balcony of the palace, clasping the Mexican flag in one hand.

This was the moment. *"¡Mexicanos!"* he cried. *"¡Vivan los héroes que nos dieron patria!"* Long live the heroes who gave us a nation! *"¡Viva Hidalgo!" "¡Viva!"* the crowd roared back. *"¡Viva México! ¡Viva México!"* And along with tens of thousands of my compatriots, I roared *"Viva México"* until I lost my voice, while the president clanged and clanged the liberty bell.

It's harder to be so patriotic these days: My country is no longer so innocent; presidents are no longer sacred; corruption, violence, and despair seem to have overtaken the land; and the Zócalo now is an edgier place on Independence Night, but even so, I have friends—full-grown adults, experts in irony—who make the pilgrimage to the Zócalo to yell "Viva México" with everyone else in the crowd.

After an earthquake destroyed much of downtown Mexico City in 1985, the president increasingly worked at home, at the official residence of Los Pinos, on the back end of Chapultepec Park. There were practical reasons for the change: Every time he set out for home, traffic wound itself up into knots, and helicopters were dodgy alternatives. But it's also true that he was joining

an exodus from the Centro Histórico—the colonial center of the city initially confined to the island of Tenochtitlan. Starting with the cathedral, many buildings were sinking and tilting into the marshy ground, specialty tradesmen and traditional shops were being priced out by supermarkets and chain stores in roomier neighborhoods beyond the former lakeshore, and most government ministries had already moved to modern headquarters many stories high. Even the wonderful objects in the Museo Nacional were gone, housed now in the awe-inspiring Museo de Antropología, also in Chapultepec Park. The world had shifted center, speeded up. The Zócalo was old and empty of magic. I moved more than walking distance away and rarely ventured there.

For the first time in many years, I went back to the Zócalo this Christmas season. Mostly, these days the plaza is a staging ground for protest demonstrations—indeed, the entire expanse is often covered for weeks with the tent cities of protesters from other states. This year in particular, there has been no lack of subject matter for protests: The economy refuses to grow, underemployment is the best most people can find, China manufactures even the traditional Mexican crafts with which we decorate our altars for Day of the Dead, electoral fraud is suspected in almost every election, everyone knows someone who was a victim of violence, and one day in September, forty-three students were brutally kidnapped by local police in the town of Iguala, never to be seen again. In the sorrowful demonstrations that filled the Zócalo not once but four times, demanding that the students be found, one question seemed to linger: What happened to the Mexico we used to know? It seemed to me during those bitter

days that the sense of self and of destiny, the uniqueness of our visual world, our cordial habits, our *muy buenas noches* and *muchísimas gracias,* the old sense of the Zócalo's grandeur as a symbol of Mexico's place in the world and of our self-respect, all were gone with the missing students.

Instead, what there was on this Christmas Day, in a country where it never snows, was an enormous ice-skating rink, along with many thousands of people waiting to get in, standing in a line five deep that snaked all the way around the plaza. There were three rinks, actually; one each for adults, children, and the elderly, a lone representative from the last group could be spied making his way slowly across the ice, helped by friendly assistants. There were also two toboggans, with sleds, and a white box that resembled a monumental latrine, inside which, after a two- or three-hour wait, people could lace themselves into free, massively pre-used skates. Some five million visitors had already visited the rink by that date, and another half a million would wobble onto the ice by the end of the holiday season. My people, I thought: so many of us, and always more and more!

I watched the massive line inch forward, whole families oblivious to the grandeur all around them, entirely cheerful, excited, focused on the thin ice they were about to walk on. I watched them creep around the edge of the rink on their skates, grasping the handrail for dear life, laughing and falling, falling and laughing. The new Mexicans: hungry, like all modern people, for the experience of the exotic.

Next to the cathedral, obscured from view from the vantage point of the skating rink by the hideous white box and the

toboggans, is an open pit where the ruins of the Great Pyramid of Tenochtitlan are slowly being excavated. On this afternoon the few people in the Zócalo not interested in skating stood gazing down at the pit, silent for minutes on end: *Did my ancestors once walk here?* Directly across the square, two *danzantes,* who adorn themselves with feathers and execute a shuffling approximation of Aztec dance in return for coins, performed without an audience and stopped to rest next to a small reflecting pool. The shallow water holds life-size bronze statues of a shaman and four of his fellow Mexicas, caught mid-gesture at the very moment when they realize they have arrived at the place of prophesy: the small island with an eagle on a cactus devouring a serpent, where their totemic god has said they are to settle and become great. It's a wonderful monument, and every time I pass the group, I marvel that the lifelike figures do not have eyes that see; that they have not been watching us, their descendants, as the years and decades float by, open-eyed and openmouthed in wonder now at the insane city where we live out our riotous lives, and at the great public square where we all still sometimes dance together, their battered ghosts and us.

Overleaf: THOMAS HOEKPER

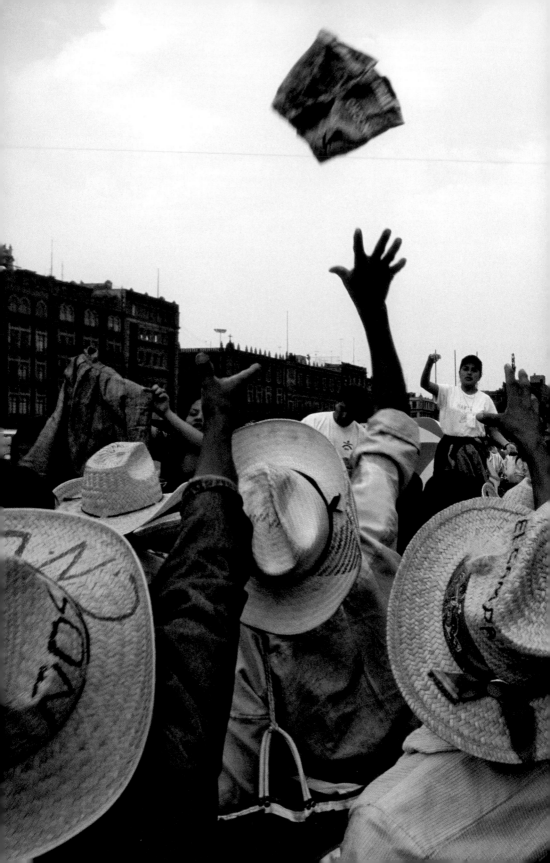

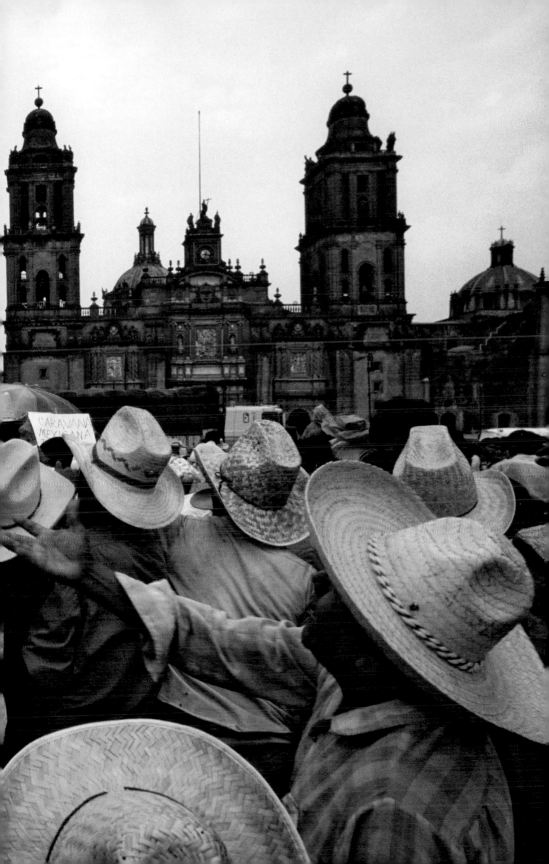

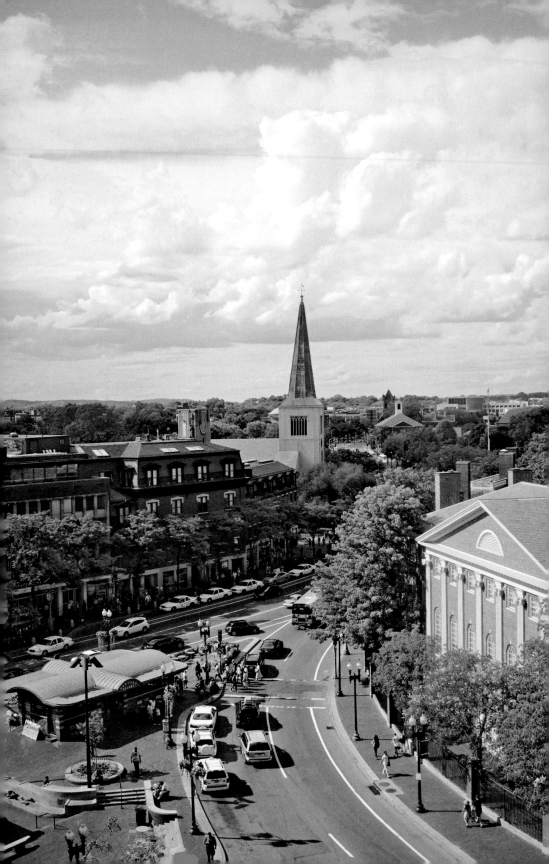

HARVARD SQUARE, BOSTON: A CITY CHANGES, ITS HEART ENDURES

Ann Beattie

ONE THING YOU WILL NOTICE EVENTUALLY, IF NOT IMMEDIATELY, is Harvard Square's flatness—whereas Boston is a city of hills. There seems no inherently representative angle from which to take a definitive photograph, as the square actually isn't square at all. Which speaks well for a place.

We lack the Italian's idea of informal gatherings for the evening *passeggiata:* the lazy, leisurely perambulation that takes a while even to pronounce. Our own congregations tend to be either spur-of-the-moment or reserved for annual rituals like New Year's Eve in Times Square or Fourth of July parades. Yet Harvard Square always has enough going on that people pause to hold up the cameras of their cell phones for a few shots that aren't selfies.

The square itself is small-scale, and seen from overhead,

Photographs by CHRISTOPHER CHURCHILL

Harvard Square resembles the diagram of a nerve reaching into finer fibers, much like the less traveled streets in and around an urban nucleus, and a lot of sky spreads above. Present-day etiquette means that people look straight ahead, avoiding eye contact. If Bill Cunningham passed through on his bicycle—to a New Yorker, Harvard Square would no doubt seem like a day in the country—he'd have an eye for this season's Harvard Square style: To my eye, the dress is diverse yet so conventional that people appear to be in a kind of time warp, with their braids and Wayfarers, their backpacks, sandals worn with socks, summer dresses with thickly embroidered bodices, and baseball caps.

Knowing that a major Ivy League university is its backdrop, one can easily perceive Harvard Square in terms of what it isn't: It's the anti–Harvard Yard; no life of the mind is expected (assuming you jaywalk carefully); many of the people could be anyone, so you can't be sure if you're seeing a philosophy professor with pumped-up muscles or a visiting builder from Vermont.

I went there on a recent July day, getting together with an old friend who's nicknamed UB. He's lived one square away from me in Cambridge since not long after we met in the late 1970s. Water bottles in hand, we walked and reminisced about what used to be where; he told me that the Garage, an indoor mall of restaurants and stores, really used to *be* a garage, and furthermore, his father used to park there. He said—with what I thought was respectful perplexity—that the square had a "quirky, almost indefinable idiosyncratic quality that persists despite the removal of so many of the old quirky, idiosyncratic

establishments." "Quirky" is the right word for the spirit of the place, partly because while every new generation has stamped it, certain things (not only people's attire but their habits and desires, at least as reflected by commerce) do seem recognizable as a part of the yesterday that initially appeared radical, whose subsequent iterations have never quite erased the spirit of the original—or even tried to. The past permeates the present, though certain stores and restaurants—gathering places within

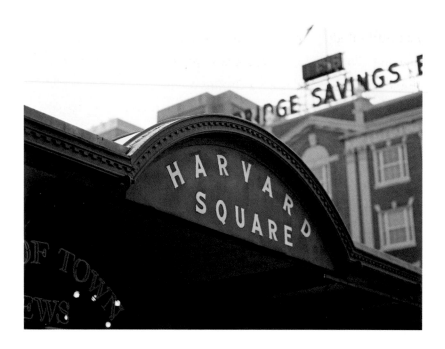

gathering places—are gone. The mixture of old and new is slightly disorienting and sometimes dazzling, proclaiming the place's timeless adaptability. The remembered images are like a sort of flip-book of your youth, letting you move through the succession of yous you have been.

Many people animate the square, as do squirrels, birds, and leashed dogs. The nearby parks get boring even for these creatures, apparently. But they aren't the place itself, which remains just the same when they go away, with its cement sidewalks and low, unintimidating architecture; its nearby tunnel that sends buses and cars away from the congested center; its anonymous-looking subway entrances and exits; the nondescript "Pit" carved out like a small-scale arena with a few steps, intended for informal performances. Of course, Anywhere, U.S.A.,

has infiltrated: chain drugstores, Au Bon Pain, Starbucks. The beloved WordsWorth bookstore is gone, and Reading International as well. The amazing Grolier poetry bookstore (where the Cambridge police were sent in the 1950s when Allen Ginsburg appeared to read his banned poem, "Howl") has survived, but is no longer a retail store. There's no Brigham's ice cream, though it has been replaced by stores with trendier flavors.

I lived at the edge of Cambridge for a mere year and a half, but I can still return and melt into the place. You can still be within Harvard Square's microcosm and go to one of the big newsstands—Nini's Corner or Out of Town News—to get news of the larger world and find out what's happening in Alaska or buy a copy of French *Vogue*, and, across the street, choose between jars of capers or cornichons at Cardullo's, just as Julia Child did when she was debating what to serve with the evening's pâté.

IT'S ALWAYS INFORMATIVE TO THINK OF A PLACE NOT ONLY AS what it is but as what it isn't. With the Big Dig surrounding Boston for so many years, the areas within its parameters became somehow smaller and reduced in scale, Harvard Square continuing to bloom as its own amaranth. It's definitely *not* a place of faded glory. The square—usually not spoken of in precise terms but as a general area that encompasses everyone's personal line of demarcation—is crowded though not chaotic. There are still enough alleyways and shortcuts to give the illusion that there's something left to explore. We're all familiar with the way we navigate familiar areas: We look for the landmarks at the same time we want to think the place is "ours," that we have some

information, or memory, or anecdote, or some unstated desire about a place—perhaps unstated even to ourselves—that makes it both public and personal, both real and exposed, yet still private. Either perception impinges on the other, but that's another thing we're familiar with: not having to reconcile our daily, tuned-out movement down a busy sidewalk, or through a park, or a square, with the same place that sometimes appears in our dreams; the place we can see as being entirely different when we return after dark. The dynamic changes; the light affects your mood and perceptions. There's no simple description of place unless we tune out contradictions and ignore inherent mystery.

As a time capsule of America, we would unearth in Harvard Square the disparity of wealth; the omnipresence of vehicles; a vast number of earphones and iPhones; dirty puddles glistening on the ground, as well as tiny puddles of pureed chestnut and balsamic reduction squirted onto plates in one of its fancy restaurants. There's no end to what this place listed on the National Register of Historic Places might show us about ourselves and our proclivities, our desire for the new—as long as the old doesn't irrevocably disappear.

PUBLIC SPACES ARE ALL ABOUT WHAT CAN BE SEEN AND WHAT'S invisible. The person at the information kiosk can guide you to what's apparent but can't reveal the dynamics or the community's assumptions about what the square should be. However cutting-edge some of the small stores might be or wish to be, the visitor is never overwhelmed by the architecture or intimidated by the clamor that often exists elsewhere in Boston. Driv-

ers are almost mannerly. There's a rustle of tree leaves, and a real romantic might be moved to think of Longfellow, and the "spreading chestnut tree" near the square, under which his village smithy worked.

Above us is that New England sky, so often confused and confusing: bright sun; sudden clouds; a drop in temperature that can rise even quicker than it fell. You take these changes for granted—or you do if you have a sweater or an umbrella and a bottle of water.

Rain or snow or sunshine, all subtly unite us, as does the presence of a person who has emerged from the T (the first-in-the-nation underground train, replacing the streetcars pulled down Massachusetts Avenue by horses since 1854), standing still in a square, passively requiring others to eddy around her. A great day! Blue skies! Harvard Square!

Then move along, because you'll have to.

ALISON YIN

THE VIRTUAL SQUARE: HACKER SQUARE

Gillian Tett

IN THE SPRING OF 2013, ON A LUMINOUS MAY DAY, I VISITED the campus of the mighty Facebook company for the first time. I was startled. To the outside world, Facebook is a company best known for bold innovations on the Internet. But the central square—known as "Hacker Square"—is a striking physical, real-world experiment, too.

On one side of the square, there are open-air seats and benches designed to enable the employees to mingle in the balmy California air. Overhead, architects have placed bright orange footbridges, painted the same color as the Golden Gate Bridge; the idea is to keep employees moving between buildings, to collide with one another, to spark innovation. Facebook is a company that hates silos—so much so that the footbridges have supermarket-style doors that automatically open to let people pass. On the street level, there is an open-plan glass-windowed office exposed to the square, with a sign declaring "Do Not Feed the Animals"; this is where Facebook cofounder Mark Zuckerberg himself works.

In the center of the space, in the spot where a fountain

or statue might be found in an Italian plaza, there is a small yellow crane. Zuckerberg and the other engineers first stumbled on this piece of metal in the early days of Facebook, in an earlier warehouse office, and started using it as an impromptu stage for their so-called hackathons, or all-night coding rituals. Later, when Facebook became ultra-successful and moved to its smart new campus, Zuckerberg brought the yellow crane as a reminder of Facebook's improvised roots. When I visited, hundreds of computer engineers wearing hoodies and jeans were assembled around the crane, preparing for another hackathon, with all the intensity of a tribe gathered around a sacred shrine.

As I watched the crowd, two thoughts popped into my mind. First, anyone who walks across Hacker Square cannot fail to notice that this is a company where huge effort has been put into the design of physical space. Zuckerberg and his colleagues know that architecture matters; our public places are where we swap ideas, display our identities, interact with humans—and, above all, define and create social groups. Hacker Square reflects and reproduces the Facebook dream, as expressed in concrete, plastic, and yellow metal.

The second point is that Hacker Square tells only half the tale. For though companies such as Facebook have spent a lot of time and money designing their physical space, these days people do not just interact and establish identities in "real" squares, of either the corporate or the civic type. On the contrary, the type of social media platform that the Facebook engineers are building is becoming a second key place where humans congregate each day. The idea of public space, in other words, now extends to

the Internet, or places such as blogs, social media sites, and other platforms. These cyber platforms have not traditionally been viewed as "squares." However, in the modern world, they have many of the same functions: for instance, forging identities, creating social groups, conducting commerce, and rallying around ideas. Indeed, for the younger generation of digital natives, these virtual-hacker squares are arguably as important—if not more important—to their daily lives as traditional plazas.

But though these cyber squares are rising in importance, what is perhaps equally striking is that most people give little thought to the question of how these meeting places are designed. This is partly because virtual squares are so new; it may also be because cyberspace tends to feel very ephemeral and transient. Unlike "real" squares, platforms such as Facebook do not carry the weight of tradition and history; they are not "set in stone" but can be constantly remolded each day. And yet in spite of this malleability—or perhaps because of it—the design of these virtual squares matters. So the question that needs to be asked is this: Do we like the type of public spaces that companies such as Facebook have built for us? Do they meet our needs in a healthy way? Or is there a better way to public cyberspace? Above all, are we willing to let these crucial design decisions simply sit in the hands of computer scientists—like those I saw roaming across Hacker Square?

I FIRST STARTED TO PONDER THOSE QUESTIONS IN A PERSONAL way in the year after my first visit to the Facebook campus. My eldest daughter had recently turned ten and had received her

first mobile phone. Like most tweenies, she was dazzled by the possibilities that little piece of plastic and metal could unlock; if I left her unchecked in her room, she would spend long periods of time tapping her screen, connecting with her friends. To my surprise, she did not care for Facebook. "That's for old people," she tartly observed (defining "old" as someone over the age of twenty). Even Twitter was considered passé. But she loved Instagram, the picture-sharing website owned by Facebook; her friends congregated there online, swapping ideas and photos, exchanging news, making plans, having rows, meeting new people—or simply saying hi.

I was unsure what to make of this. As a nervous mother, I regularly checked Instagram to see what she was doing. The contents seemed utterly banal: Translated out of emoticons and acronyms, the messages were variants of "Hi," "How are you?," "Just fine," or the innocent chatter tweens might make if they bumped into friends on a street or hung out in a town square. But I was uneasy. At best, cyberspace seemed a huge waste of time; at worst, dangerously murky. Either way, I could not fathom why my daughter wanted to spend so much time there, just saying "hi!"

But then I met danah boyd (who prefers to not use capitals in her name), a self-styled digital anthropologist. Boyd, a charismatic dark-haired woman with an easy manner, was trained (like most anthropologists) to study the human condition by observing how people live, work, think, and interact. Instead of conducting her research in the type of locations that anthropologists used to study—such as far-flung jungles, harsh deserts, or exotic

mountains—boyd has spent the past decade studying teenagers' use of cyber technology, initially through independent academic research but more recently as an employee of Microsoft.

That has led her to draw several striking conclusions. First, boyd believes that teenagers use their mobile devices in a different way from adults. People who are not digital natives tend to use Internet devices in isolation from each other and separate out the physical and cyber worlds. But teens congregate around phones in groups and read messages together. They huddle across screens. They send messages to each other while physically standing next to each other; if they meet, they talk about what they have read online. Second—and perhaps more important—the way teenagers move in cyberspace has to be understood in the context of their physical lives. A century or so ago, teenagers, tweenies, and even children had (by today's standards) huge physical freedom: They could roam around towns and were often permitted to travel huge distances without adult controls. They could use public space to do what kids have always done: create a subversive world with its own rituals and language that adults do not entirely understand—and grow up.

Today this freedom to roam in a physical sense has diminished; children's independent geographical boundaries have shrunk. Fearful parents these days often prevent children from wandering around in a spontaneous way; they are ferried around in cars, tied up with organized activities, and kept away from public spaces—such as squares—to keep them "safe." So instead of congregating with friends at a mall, behind a bike shed, in the streets, or in a wood, teens are now hanging out

online, in virtual space. "Social media might seem like a peculiar place for teens to congregate, but for many teens, hanging out on Facebook or Twitter is their only opportunity to gather en masse with friends, acquaintances, classmates, and other teens," boyd observes. "More often than not, their passion for social media stems from their desire to socialize." And—perversely—the controls that parents place on teens to keep them safe actually encourage this. "Teens told me time and again that they would far rather meet up in person, but the hectic and heavily scheduled nature of their day-to-day lives, their lack of physical mobility, and the fears of their parents have made such face-to-face interactions increasingly impossible."*

Boyd's book pierced my heart. I realized that I had spent my tweenie and teen years running around the streets, playing with my friends with gay abandon; in England in the 1970s, when I grew up, children used to hang out in the village squares and greens with considerable freedom. But for my daughter and her friends, who live in twenty-first-century New York, the cultural mores feel entirely different. So after I read boyd's argument, I stopped fretting quite as much about Instagram—and started looking for ways to give my children more physical freedom.

Then another question started to haunt me: If children and teens *are* growing up assuming that cyberspace is going to be a key public space to meet, who gets to design the architecture for that? People in my generation know what a shopping

* danah boyd, *It's Complicated: The Social Lives of Networked Teens* (New Haven: Yale University Press, 2013), 21–22.

mall, sports field, or town square looks like; we know how humans react to that space. But does a place such as Instagram or Twitter or Facebook encourage people to meet in a healthy way? Or does it make them retreat into cliques? In other words, can virtual squares be a force for civic good—or do they present subtle dangers instead?

BIZ STONE, ONE OF THE COFOUNDERS OF TWITTER, IS SOMEBODY who has been confronting these questions for much of the last decade; indeed, they prompted him to create the iconic social media platform in the first place. The origins of Twitter go back to the spring of 2007, when Stone, a cheery former graphics designer from Boston and blog entrepreneur, traveled to Austin, Texas, to take part in the South by Southwest trade fair. Stone had recently teamed up with other entrepreneurs to develop a fledging message group that enabled friends to send short dispatches to each other, and they planned to unveil this at the convention. On the third night, Stone went down to Austin's infamous Sixth Avenue to meet his friends for margaritas. But the bar was so crowded that he decided to leave—and used his fledgling messaging service to arrange an alternate meeting spot. He expected just a couple of people to appear. But since the messaging platform was "open"—in the sense that it admitted anybody who wanted to participate—the message was widely read, and a mass of people had congregated at the other bar.

Stone looked at the crowd of young techies and suddenly had a vision of people "flocking" together, like birds. By exchanging messages, he realized, people could congregate around a

single idea, piece of news, or picture. Sometimes this caused them to meet in real life (as in the bar); often, though, they just rallied around an idea or piece of news. Either way, Twitter created, in some sense, a virtual square. "I just loved the idea of flocking—people flocking together," Stone later observed. "I realized then that Twitter could be this incredible force for good, to get people to come together."*

The Twitter platform turned into a big hit. In one year, the platform had attracted such a vast membership that it was hosting one million tweets a day, and by 2010 the volume of daily tweets had jumped to twenty-five million. Just as Stone had hoped, Twitter was an extraordinarily powerful way to rally people around single issues, pieces of news, or ideas. But as the traffic and user base rose, something notable occurred: The volume of Twitter traffic became so overwhelming that it was impossible for anyone to keep an eye on any more than a minute fraction of these different rallying points. Stone had imagined Twitter as a unifying force where vast crowds of people could come together. And in the early days, users did tend to move as a pack. But the bigger the platform became, the greater the tendency for users to fly apart, because the conversation was fragmenting in numerous different ways.

As the trend became more ingrained, social and computer scientists tried to work out what this meant for wider society. In 2009, for example, a team of academics at Georgia Tech, led by Sarita Yardi, analyzed the Twitter traffic that erupted after an

*Interview with the author.

anti-abortionist shot George Tiller, a Kansas physician who conducted late-stage abortions. Yardi wanted to understand whether social media was causing people to become more or less polarized.* She duly analyzed eleven thousand tweets discussing Tiller's death, and the results were intriguing. In direct bilateral conversations between Twitter users—i.e., people who had replied to a specific message—Yardi and boyd found that more than two thirds of messages sent were between people who held the same views. In the other third of cases, people engaged with others who held a different view. This did not seem to spread mutual respect; on the contrary, in these exchanges people tended to become more, not less, polarized. "Replies between like-minded individuals strengthen group identity whereas replies between different-minded individuals reinforce ingroup and outgroup affiliation," Yardi and boyd observed.

In early 2013, a group of computer scientists based at the Qatar Computer Research Institute in Doha studied how Twitter was affecting political debate in Egypt in the aftermath of the Arab Spring.† After collecting seventeen million tweets dispatched between the summers of 2012 and 2013, they concluded that the different "Islamist" or "secular" groups were often

* Sarita Yardi and danah boyd, "Dynamic Debates: An Analysis of Group Polarization over Time on Twitter," Special issue on "Persistence and Change in Social Media," in *Bulletin of Science, Technology and Society* 30(5), October 2010.

† Ingmar Weber, Venkata Kiran Garimella, and Alaa Batayneg, "Secularist Versus Islamist Polarisation in Egypt on Twitter," Qatar Computing Research Institute, 2013.

polarized—but still bumped into each other online, as a result of hashtags. What was really interesting was that the level of polarization seen on Twitter tended to foreshadow what was happening in the "real" world: When political fighting broke out on the streets, it went hand in hand with growing fragmentation of the Twitter debate. What happened in Cairo's Tahrir Square overlapped with trends in the virtual cyber squares.

A similar pattern seems to play out on Facebook. In 2012 Facebook let an academic named Eytan Bakshy, then a Ph.D. student at the University of Michigan, analyze how Facebook users disseminated news to each other.* His research showed that social groups often huddled together in discreet tribes, staying in their comfort zone and sticking with people they knew well. It also showed that if a novel piece of news entered the network, people would share it with a very wide circle, including contacts with whom they only had weak social ties. This meant that individuals occasionally bumped into worlds on the web that were outside their comfort zone. In other words, when faced with a choice, Facebook and Twitter users tended to huddle with like-minded people; but from time to time they encountered other crowds as they wandered around in cyberspace. In that sense, then, virtual hacker squares are rather like their real-life variants: We can use them to rally as a group; or we can simply huddle with our tribe. It all depends on whether we are willing to lift our eyes and look around at the bigger view.

* Eytan Bakshy, "Rethinking Information Diversity in Networks," Facebook.com, January 17, 2012.

———

IN EARLY 2015 I MADE ANOTHER TRIP TO FACEBOOK'S HACKER square. By then, I had started to make peace with my daughter's forays into cyberspace: As long as she stayed in "squares" that seemed fairly "safe" (such as the Instagram accounts of her friends) and did not spend too long there, I would let her explore. My attitude was similar to the approach taken by my own parents in the physical streets: I was allowed to roam a bit, but only to known locations, and I had to be back at a certain time. Was this the right policy for either my daughter or society as a whole? I had to admit to myself that I did not really know. Physical architects have been designing "real" squares for centuries, even millennia; cyber architects have existed barely two decades. The long-term implications of the Internet revolution are still unclear.

But as I stood in the warm California sunshine, watching the computer scientists huddle together on the plaza or move across those orange footbridges, I realized that perhaps the real message of Hacker Square is that we have to look at the "real" and "cyber" world in symbiosis. We cannot put the Internet genie back in the bottle. But the more time we spend in disembodied cyberspace, the more time and money we must spend thinking about the architecture of the "real world"—if nothing else, because our children are growing up in an environment that will be radically different from what we have known or can put on a drawing board.

Overleaf, top to bottom: INSTAGRAMS BY SIMON WATSON, FRANCESCO AMOROSINO, VUTHEARA KHAM, AND OLIVIA INGE

ACKNOWLEDGMENTS

WORKING WITH AN EXCEPTIONALLY talented and collegial team of people is as great a pleasure and privilege as can be. Having the chance to do it a second time was beyond my dreams, but that's exactly what's happened with *City Squares.* Our core group came together for my first book, *City Parks;* they're also involved in this one. The generosity of spirit with which they all work is exceptional. My deep and affectionate gratitude to them all.

Jonathan Burnham, publisher of Harper, is also my editor. His insights are profound; his guidance, invaluable.

Mary Shanahan, the book's art director, has an original and creative eye. She approaches each project with a fresh perspective, highly attuned to its particular intent and meaning: I think this shines through.

Maya Ziv, a senior editor at Harper, works with flair, innate talent, and knowledge of the written word. We've pored over many texts together, so I know her work well.

Oberto Gili photographed the squares in London, Paris, and Rome. The unique, timeless quality of his photos jumps off the page.

Lynn Nesbit was first my friend, then my agent. She is legendary for her fairness to all and great care and consideration for her writers. I completely understand why.

Michael Steger of Janklow & Nesbit oversaw the complicated task of bringing all the writers together under one roof. He has an erudite mind, so I often went to him for a fresh viewpoint and ideas.

MANY PEOPLE ENHANCE A BOOK. The encouragement and enthusiasm of friends has done that. As has the inimitable Bob Silvers, whose motto, "Go for the very best," has stayed with me from our first lunch. Thank you, Bob. Special thanks to Bonnie Tsui. Also to Richard Plepler. They both helped in significant ways as I was getting this book off the ground. Special thanks also to Lucy Albanese and Hannah Wood of Harper. I appreciate the help of Stephen Doyle, Adam Flatto, Paul Holdengraber, Sumit Joshi, Shirley Lord, Roxana Marcoci, and Ivan Shaw.

Thank you to six insightful and determined photo researchers: Emily Bauman, Samantha Cassidy, Toby Greenberg, Frannie Ruch, and James Wellford. Special recognition to Tasha Lutek. You've all made a marked difference.

Thank you to the illustrious photographers who allowed us to include their work. All photographs are credited on pages 286 and 287.

And, of course, my appreciation to the brilliant and distinguished group of writers. They signed on with enthusiasm and gave their best, I do believe. An unexpected pleasure has been developing friendships with several through our work.

Like all efforts of my professional life, this wouldn't and couldn't have happened without the love and support of my family. I dedicate this book to them—my husband, Don, who is also a dream reader; and our children, William and Serena. They mean the world to me.

I wish I could enjoy a meal with each of you in the public square in Van Gogh's Arles!

ABOUT THE AUTHORS

DAVID ADJAYE, OBE

David Adjaye is the founder and principal architect of Adjaye Associates. He is the 2015 recipient of the Eugene McDermott Award in the Arts at MIT. Currently the John C. Portman Design Critic in Architecture at Harvard, he has previously taught at London's Royal College of Art, where he had previously studied, and has held distinguished professorships at the universities of Pennsylvania, Yale, and Princeton. Awarded the OBE for services to architecture, he also received the W. E. B. DuBois medal from Harvard University. www.adjaye.com

ANNE APPLEBAUM

A columnist for the *Washington Post* and *Slate*, Applebaum directs the Transitions Forum at the Legatum Institute in London and is an adjunct fellow of the Center for European Policy Analysis. She is the author of *Gulag: A History*, which won the Pulitzer Prize, and *Iron Curtain: The Crushing of Eastern Europe, 1944–1956*, which received the Cundill Prize in Historical Literature. Both books were nominated for the National Book Award and have been translated into multiple languages. www.anneapplebaum.com

ANN BEATTIE

Author of nine novels and ten story collections—most recently *The State We're In*—Beattie has been featured in four O. Henry Award collections, John Updike's *The Best American Short Stories of the Century*, and in Jennifer Egan's *The Best American Short Stories 2014*. In 2000, she received the PEN/Malamud Award for achievement in the short story. She is a member of the American Academy of Arts and Letters and of the American Academy of Arts and Sciences.

CHRYSTIA FREELAND

Canadian minister for international trade, Freeland is also a journalist and author. She was a stringer in Ukraine, deputy editor of the *Globe and Mail*, and has held positions at the *Financial Times* ranging from Moscow bureau chief to U.S. managing editor. As an activist Ukrainian-Canadian, she is the author of *Sale of the Century* and the award-winning book *Plutocrats: The Rise of the New Global Super-Rich and the Fall of Everyone Else*. Since 2013, Freeland has been a member of Canada's Parliament.

ADAM GOPNIK

A staff writer for the *New Yorker*, Gopnik has won the National Magazine Award for Essays and for Criticism three times, as well as the George Polk Award for Magazine Reporting, and the Canadian National Magazine Award Gold Medal for Arts Writing. His work has been anthologized many times, and he is the author of the nationally bestselling *Angels and Ages: A Short Book About Darwin, Lincoln, and Modern Life*. He is a recipient of the Chevalier of the Order of Arts and Letters from the French Republic. www.adamgopnik.com

ALMA GUILLERMOPRIETO

Born in Mexico City, Guillermoprieto is a journalist and essayist whose work has appeared in the *New Yorker*, the *Washington Post*, *Newsweek*, and the *New York Review of Books*. She is a MacArthur fellow, a recipient of the George Polk Award for Foreign Reporting, and the author of two memoirs, *Samba* and *Dancing with Cuba*, as well as two collected volumes of her work.

MICHAEL KIMMELMAN

The architecture critic for the *New York Times*, Kimmelman was its longtime chief art critic. He is the author of several books, including the national bestseller *The Accidental Masterpiece: On the Art of Life and Vice Versa*, a regular contributor to the *New York Review of Books*, and has been recognized with numerous honors including the Brendan Gill Prize.

JEHANE NOUJAIM

An Egyptian-American documentary director and cinematographer, Noujaim's critically acclaimed films include *Startup.com*, *Control Room*, *Rafea: Solar Mama*, and *The Square*, which was nominated for an Academy Award and earned widespread praise at the Sundance and Toronto film festivals. She was the recipient of the 2006 TED Award. www.noujaimfilms.com

EVAN OSNOS

Author of *Age of Ambition: Chasing Fortune, Truth, and Faith in the New China*, which won the National Book Award and was a finalist for the Pulitzer Prize, Osnos is a staff writer at the *New Yorker* and a fellow at the Brookings Institution. Previously, he worked as Beijing bureau chief for the *Chicago Tribune*, where he was part of a team that won the 2008 Pulitzer Prize for investigative

reporting. His work has been widely anthologized, and he has also contributed to *This American Life* and PBS's *Frontline*. www.evanosnos.com

GEORGE PACKER

A staff writer at the *New Yorker*, Packer is the author of five nonfiction books, including *The Assassins' Gate: America in Iraq*, which was among the *New York Times*'s ten best books of the year in 2005 and the winner of the New York Public Library's Helen Bernstein Book Award, and *The Unwinding: An Inner History of the New America*, which won the National Book Award for nonfiction in 2013. He is also the author of two novels and a play, *Betrayed*, which won the Lucille Lortel Award for Outstanding Off-Broadway Play in 2008.

DAVID REMNICK

The editor of the *New Yorker* since 1998, Remnick's books include *Lenin's Tomb*, *King of the World*, and *The Bridge*.

ANDREW ROBERTS

A Visiting Professor at London's King's College, and the Lehrman Institute Lecturer at the New-York Historical Society, Roberts is also a *New York Times* bestselling author whose books have been translated into eighteen languages. He appears regularly on radio and television around the world. His most recent book, *Napoleon: A Life*, won the Los Angeles Times Book Prize for Biography and the Grand Prix of the Fondation Napoléon. www.andrew-roberts.net

ELIF SHAFAK

An award-winning Turkish author with books published in more than forty languages, Shafak is also a political scientist, activist, and public speaker. She has written for major publications around the world, including the *Financial Times*, the *Wall Street Journal*, the *New York Times*, the *Guardian*, and other publications. A founding member of the European Council on Foreign Relations, she was awarded the Chevalier of the Order of Arts and Letters by the French Republic. www.elifshafak.com

ARI SHAVIT

A prominent Israeli columnist and writer, Shavit is the author of the *New York Times* bestseller *My Promised Land: The Triumph and Tragedy of Israel*, which was one of the *Economist*'s best books of the year for 2013. He serves on the

editorial board of *Haaretz* and is also a leading commentator on Israeli public television. www.arishavit.com

ZADIE SMITH

English writer Zadie Smith has written four award-winning novels, including *White Teeth*, *On Beauty*, and, most recently, *NW*. A professor at New York University, Smith is also the author of an essay collection, *Changing My Mind*.

RICHARD STENGEL

Stengel is U.S. undersecretary of the Department of State for Public Diplomacy and Public Affairs. He was previously managing editor of *TIME*. He has also taught journalism at Princeton University, his alma mater. He collaborated with Nelson Mandela on the South African's autobiography, *Long Walk to Freedom*, and then wrote his own book about the experience, *Mandela's Way: Lessons on Life, Love, and Courage*.

RORY STEWART, OBE, FRSL

A British academic, author, diplomat, documentary maker, and politician, Stewart is the minister for the Environment in the British Government. The author of three books, including the *New York Times* bestseller *The Places in Between*, describing his solo walk across Afghanistan, and a recipient of the OBE, he also founded the nonprofit Turquoise Mountain in Kabul and served as director of the Carr Center for Human Rights Policy at the Harvard Kennedy School. www.rorystewart.co.uk

GILLIAN TETT

The U.S. managing editor of the *Financial Times*, Tett contributes weekly columns covering a range of economic, financial, political, and social issues. In 2014, she was named Columnist of the Year in the British Press Awards and was the first recipient of the Royal Anthropological Institute Marsh Award. Her first book, *Fool's Gold*, won Financial Book of the Year at the inaugural Spear's Book Awards, and she has just published her second nonfiction book, *The Silo Effect*.

ILLUSTRATION CREDITS

Sam Abell/National Geographic Creative, *64–65*

Francesco Amorosino, Instagram, thousands dance the tango in honor of Pope Francis's birthday, St. Peter's Square, Rome, *278, bottom*

Aquila, Piazza del Duomo, *9*

Eugène Atget, Place des Vosges, 1898, ©The Museum of Modern Art/Scala/ Art Resource, NY, *45*

Misha Bar-Am/Magnum Photos, peace rally where Prime Minister Yitzak Rabin was assassinated, Rabin Square, Tel Aviv, November 4, 1995, *138–139*

Walter Bibikow/SIME/GMAIMAGES, *82*

Alo Ceballos/Getty Images, Washington Square Park, New York City, *11*

Christopher Churchill, *256, 259, 260, 264–265*

Alvin Langdon Coburn, Leicester Square, 1906, ©George Eastman House, International Museum of Photography and Film, *232*

Charlie Cole, Tank Man, Tiananmen Square, Beijing, June 5, 1989, *154*

Philip-Lorca diCorcia/Trunk Archive, Djemaa el-Fnaa, Marrakech, *ii–iii*

Daniel Etter/Redux Pictures, *140*

Gezi Park, Taksim Square, ©Viki-Picture/creativecommons.org, *145*

Oberto Gili, *xvi, 20–21, 38, 47, 50–51, 66, 80–81, 110–111, 193, 228, 240–241, 242–243*

Peter Hirth/Redux Pictures, *58*

Thomas Hoepker/Magnum Photos, Zapatista protest, Zócalo, Mexico City, 1995, *254–255*

William Hogarth, *Gin Lane*, 1751, ©The Trustees of the British Museum/Art Resource, NY, *231*

Olivia Inge, Instagram, Fitzroy Square, London, *279, bottom*

Wassily Kandinsky, *Red Square in Moscow*, 1916, photo by Erich Lessing/ Art Resource, NY, *52*

VuTheara Kham, Instagram, Place du Théâtre, Paris, *279, top*

Josef Koudelka/Magnum Photos, Wenceslas Square, Prague, August 1968, *92, 101*

Yuri Kozyrev/Noor, *180–181*

Francesco Lagnese, courtesy Elyse Connolly Inc., *90–91*

Lam Yik Fei/GI News/Getty Images, artist Davide Martello brought his self-made grand piano to Taksim Square and played for 14 hours alongside the protestors, *148–149*

Chris Ledochowski, South Photos/ African Media Online, *214*

Sze Tsung Leong, *Tiananmen Square, Beijing*, courtesy Yossi Milo Gallery, New York, *150*

Lisa Limer, *87, 219*

Susan Meiselas/Magnum Photos, Union Square, New York City, September 15, 2001, *211*

Máximo Pacheco, *El Zócalo*, c. 1929–36, courtesy Dallas Museum of Art, *249*

Aldo Pavan/SIME/GMAIMAGES, *63*

Matthew Pillsbury, *Fausto in Washington Square Park*, Washington Square, New York City, courtesy Benrubi Gallery, New York, *19*

Robert Polidori, Times Square, New York City, *182*

Andrew Quilty/Oculi, *22, 29, 35, 36–37*

J. B. Russell, *164–165*

Jerome Sessini/Magnum Photo, Place de la République, Paris, January 11, 2015, *212–213*

Amit Shabi/Redux Pictures, *133*

Alex Simon, *166, 178–179*

The Square, film stills:
Ahmed Hassan/Square LLC, *112*
Square LLC, *117*
Jehane Noujaim/Square LLC, *124–125*
Muhammed Hamdy/Square LLC, *126–127*

Thomas Struth, *Times Square Billboard*, New York City, *xiv–xv*

Simon Thollot, 128

Vincent Van Gogh, *Café-Terrace at Night*, 1888. Photo by Erich Lessing/Art Resource, *281*

Victory parade, Red Square, Moscow, June 24, 1945, courtesy RussianArchives.com, *95*

Cristobal Villalpando, *La Plaza Mayor de México*, 1695, ©Corsham Court, Wiltshire/Bridgeman Images, *244*

Massimo Vitali, *Venezia San Marco, xii*

Simon Watson/Trunk Archive, Piazzetta di San Marco, Venice, *73*; Instagram, luminaria San Domenico, Piazza San Gennaro, Praiano, *278, top*

Alison Yin, *266*

Speeches in Squares, 226–227:
(Left to right, top to bottom)
John F. Kennedy, Rudolph Wilde Platz, West Berlin, June 26, 1963, ©Max Jacoby/Landearchiv Berlin.

Benito Mussolini, Piazza Venezia, Rome, ©Imagno/Getty Images.

Pope Francis, St. Peter's Square, Rome, AP Photo/L'Osservatore Romano.

The Dalai Lama, the Mall, Washington DC, July 2, 2000, ©Khue Bui/AFP/Getty Images.

Eva Peron, August 24, 1951, ©Hulton Archive/Getty Images.

Winston Churchill, Whitehall, London, VE Day, May 8, 1945, ©Imperial War Museum.

Martin Luther King, Lincoln Memorial, Washington DC, August 28, 1963, ©Central Press/Getty Images.

Vladimir Lenin, Sverdlov Square, Moscow, ria-novosti/afp photo ©afp/Getty Images.

Barack Obama, Victory Column, Tiergarten Park, Berlin, ©Reuters/Jim Young.